a guide to
computer animation

for tv, games, multimedia and web

marcia kuperberg

with contributions from

martin bowman

rob manton

alan peacock

Focal Press OXFORD AMSTERDAM BOSTON LONDON NEW YORK PARIS
SAN DIEGO SAN FRANCISCO SINGAPORE SYDNEY TOKYO

Focal Press
An imprint of Elsevier Science
Linacre House, Jordan Hill, Oxford OX2 8DP
225 Wildwood Avenue, Woburn, MA 01801-2041

First published 2002

British Library Cataloguing in Publication Data
A catalogue record for this book is available from the British Library

Library of Congress Cataloguing in Publication Data
A catalogue record for this book is available from the Library of Congress

ISBN 0 240 51671 0

For information on all Focal Press publications visit our website at: www.focalpress.com
For additional resources related to computer animation visit www.guide2computeranimation.com

Trademarks/Registered Trademarks
Computer hardware and software brand names mentioned in this book are protected by their respective
trademarks and are acknowledged.

Cover design and book layout by Marcia Kuperberg

Printed and bound in Italy

contents

Chapter 1

by Marcia Kuperberg

Chapter 2

by Rob Manton

Chapter 3

by Marcia Kuperberg

Techniques and stages of creating 3D computer

Chapter 4

by Alan Peacock

Animation for multimedia and new media 91

Chapter 5

by Martin Bowman

Chapter 6

by Marcia Kuperberg

Chapter 7

by Marcia Kuperberg

The art and craft of telling a story: narrative and

Chapter 8

compiled by Marcia Kuperberg

Project briefs, self-tests, tutorials and resources

acknowledgements

from Marcia

Heartfelt thanks to my husband, Louis, for his loving support and for putting up with me over many months of spending every spare minute working on this book.

To Markus Manninen and Andrew Daffy of FrameStore CFC who took the time to write their personal perspectives on recent work, to gather imagery and let me peer over their shoulders.

To Susan Scarlet, a.k.a. 'aerial acrobat', of 3 Ring Circus and her colleagues Elaine Cantwell and Matthew Hall who provided case study material. Susan has been the pivot point of my communication with this L.A.-based company, always responding promptly and warmly to my constant emails.

To Sharon Traer of Aardman Animations and Phillip Campbell of 5th Dimension for their help in providing material.

To Larry Lauria, currently Professor of 2D Animation at Savannah College of Art and Design, Georgia, who provided such great animation artwork and instructional drawings for Chapters 1 and 7.

To Kenny Frankland, currently working as a Games artist/animator at Jester Interactive, in Mold, North Wales, UK. Kenny created all the delightful Bot chapter openers and other robot images. His humorous emails lightened many a long evening!

To Martin Bowman, Rob Manton and Alan Peacock who took time out of their pressured working lives to write great chapters about their specialized fields.

Last but not least, to Marie Hooper and her team at Focal Press who gave us all unstinting support and advice to help bring this book to print.

from Martin

To Faraz Hameed and Gwilym Morris for their technical assistance on character animation in computer games, for creating many images for this chapter and for their critical judgement generally.

To Marcia Kuperberg and Tony Hinds for their suggestions and advice about the text.

To Barry Smith for many of the screen grabs of Playstation art and for his time and knowledge.

To Steph Koenig, Raff Cecco and Jolyon Myers of King of the Jungle for the reproduction of art from their games, much of which is very conceptual and would never ordinarily be seen outside the company and for allowing me to show others how a computer game is created.

To Linda Sherif, without whose PC many of the images in this chapter would have been impossible to create. Thanks very much for letting me prevent you from getting any work done!

Finally, to Alison Orr, without whose love, support and patience, this document would still be in an incomplete state.

from Rob

Thanks to Jane Poynor at the Shell Film and Video Unit, and to Dan Branigan and Dave Reading for the use of their artwork.

A big thank you to Debs for doing more than her fair share while I was busy working on my text, to Hattie for the birthday cakes and to Joffan for the big smiles which make the early mornings bearable.

Finally, thank you to Barracuda for the strong coffee without which this section wouldn't have got finished.

from Alan

To JH, and the others who know.

introduction

Marcia Kuperberg

Marcia was born in Sydney, Australia, where she studied fine art while working as a Typographic Designer in two large advertising agencies, before arriving, wide-eyed, in London in the swinging 60s.

Wanting to make a record of her tours, she commandeered her (then) boyfriend Louis' 8 mm camera and became hooked on making 'movies', graduating to Super 8 with intricate home editing and recording kit, and later onto 16 mm.

This led to a desire to learn movie making professionally, so in the mid-1970s she spent two happy years at the London International Film School, one year making live action 16 mm and 35 mm films and another studying animation and creating 35 mm traditional hand-drawn animation films. Several of her short films have won prizes in international film festivals and have been shown on TV.

She worked as a designer and Art Director for Avon during the 1980s before changing gear again and moving into education.

While teaching design, animation and computer graphics at West Herts College, she also found time to be a student again and gained a teaching qualification (CertEd) and a higher degree (MPhil), working under the late, great Professor John Lansdown at Middlesex University, the latter degree involving research into the merging of video and computer graphics techniques.

Who is this book for?

If you are mad keen to learn animation and want to know how to practise your art across a range of digital media including computer games, this book is for you.

If you have experience of traditional animation and want to know more about applying your skills in the digital arena, this book is very much for you.

If you have an interest or background in art and design and want an introduction to animation that will be useful to you in today's digital world, you've picked the right book.

If animation is your hobby and you need to broaden your perspectives and your skills beyond your particular software, you, too, will gain lots from this book.

But in fact, strangely, this book was written with other students in mind, who don't necessarily want to be specialist animators as such, for example, those I teach here at West Herts College who are on media production courses ranging from 'vocational A levels' (AVCEs), through to undergraduate students (those on BA Honours degrees or Higher National Diploma courses) right through to those post graduate students who are in their mid-twenties to early thirties who perhaps originally studied fine art or design, or media studies with little hands work and who now want a better understanding of production, especially in digital media.

These students – maybe you are one of them – are from different backgrounds and are at different levels in the educational sector but they all have one thing in common: they need to understand the thinking, visualizing and the processes of creating digital images that move.

Teaching computer graphics and animation on such media production courses where 'animation' or 'multimedia' is one subject or element, has shown me that you cannot learn 'animation' – digital or otherwise – in isolation from other media production techniques such as video production. For animators to achieve their full potential they need all the visualizing skills and understanding of a film director.

The book therefore includes information on writing a synopsis, treatment, script and storyboard, and on characterization and conveying narrative. It's a book covering a very broad area and hopefully you'll find much in it of interest and reference in your explorations into this field.

contributors

Martin Bowman

Martin Bowman has worked in computer graphics for five years. He has a BA (Hons) degree in Imagemaking from West Herts College. During his time there he changed from creating traditional art to creating digital art. He soon discovered that PCs were more fun than pencils, but also less reliable!

His first position was as an architectural visualizer, which taught him never to trust an architect. He has also taught 3D computer graphics at various colleges, a job he enjoyed as nothing is more fun than teaching students who want to learn.

After teaching, he moved into the field of computer games, assuming that making games all day would be much easier than teaching. He worked as an artist on *Edgar Torronteras' Extreme Biker* for the PC, as well as *Galaga, Destination: Earth* for the PlayStation and PC. He was promoted to Lead Artist in 2000 and managed a team of artists in two countries working on the PlayStation2/Xbox/PC game *Groove Rider*, which is due sometime in 2002. He is now Lead Artist on *Lord of the Rings* at Pocket Studios for the Nintendo Gameboy Advance Console.

In his small fragments of spare time he is a fanatical photographer with an obsession about Belgian bands, is attempting to learn Dutch, and spends much of his life trying to persuade everyone to eat more chocolate. It's good for you, you know.

Rob Manton

Rob Manton has spent the last eleven years both creating and teaching computer graphics and new media.

An Engineering degree from the University of Cambridge and a passion for creating images provided a starting point for a career that has encompassed video, multimedia and web development and more recently, computer game design. A career that has spanned the creative disciplines required to design and animate, with scientific and mathematic skills ranging from matrix manipulation to object orientated programming.

When he started work in 1990 producing artwork and animations for corporate video, the equipment required cost as much as a modest flat and would have filled most of the kitchen. In the space of a decade, hardware and software have developed to such an extent that stunning real time 3D computer graphics are now available on the games console in the bedroom of the average teenager. During this period the core of computer graphics theory has remained largely consistent, though the tools used to deliver it have improved beyond belief. This set of core ideas, which provide the key to understanding the significance of developments in the field, are the substance of Rob's chapter.

Rob is a part time teacher on degree and post graduate courses in digital media production at West Herts College.

Alan Peacock

Alan is a teacher, practitioner and theorist working with interactive media and narrative forms. He has been involved with computers in the art and design field since the early 1980s. He is familiar with a broad range of digital technologies and processes and has a particular interest in the use of sound and the spoken word in interactive artworks.

Recently, his work has been included in exhibitions in the UK and in Germany.

His creative output includes sound installations and constructed interactive objects that use generated and manipulated sounds alongside samples of voices from other sources. These works are often about making sense by forming narratives from apparently random fragments, and the act of listening.

He leads an MA programme in Digital Practice at the University of Hertfordshire, teaching on the Hyperfictions strand and contributing to several undergraduate programmes that include interactive hypermedia in their curriculum.

He says that without Kuiper Belt and Oort Cloud his contribution to this book would not have been possible.

This book is dedicated to my dear husband, Louis, who first introduced me to making movies many years ago.

chapter 1

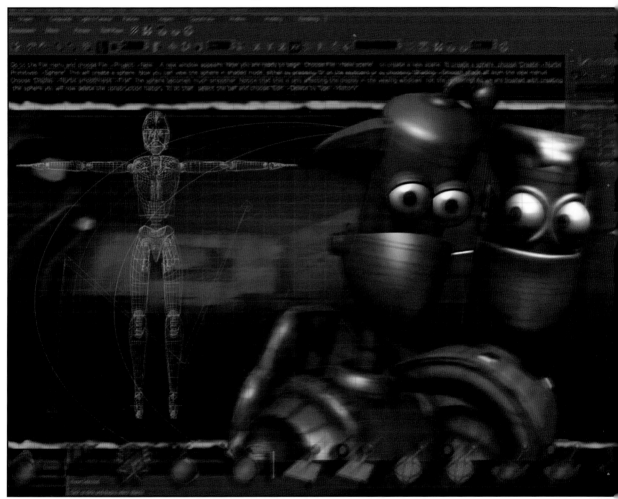

exploring the background, tools
and techniques of computer
animation

by Marcia Kuperberg

Chapter 1
by Marcia Kuperberg
Exploring the background, tools and techniques of computer animation

INTRODUCTION

The first part of this chapter puts animation in context, and in the second part you'll learn important animation concepts that will have a bearing on all the animation you produce. When you have finished reading this chapter you will have a basic understanding of:

• How we perceive moving images.

• How animation has evolved over the centuries from simple toys to today's mass entertainment media.

• The impact of computers on animation and how 'digital convergence' affects you, the animator.

• Concepts of movement to help you create more effective animation.

Animation is inextricably bound up with other technologies, most notably cinematography – itself springing from photography and especially the discovery of a means of capturing a rapid, sequential flow of images: 'moving' pictures.

There is magic in making drawings move. As a child you probably also created your own mini animations by making flipbooks: you drew an illustration on one page, drawing it again in the same position on the next page but moving an element or two, and so on until you had filled up many pages – then, the best part, flipping them to see your illustrations magically come to life. You can try it here (fig. 1.2). The

Fig. 1.1 Thaumatrope, side one: bird. Flip to see it in its cage.

magic's been known about and exploited for many hundreds of years. The ancient Egyptians developed optical toys. In the 13th century, an English monk by the name of Roger Bacon studied optics and experimented with the optical illusion of movement and focusing light through a small aperture – principles we use today for photography. In the early 16th century, Leonardo Da Vinci drew diagrams of the Camera Obscura to study and measure the reflection of light and perspective. He contributed to the evolution of the moving picture by theorizing on the use of a pinhole camera in relation to the human eye.

PERCEPTION

When a series of separate sequential images are momentarily placed in front of our eyes – such as when we use our flipbook – they appear to blend together and we no longer perceive them as separate but as a single blended moving image.

This optical illusion is again due to the physiological phenomenon known as persistence of vision. But what exactly is 'persistence of vision'? It is simply that the retinas of our eyes retain the image of what we see for a fraction of a second after the image has been removed from our sight. It is this fact that allows us to perceive animation or motion pictures when in reality what we are viewing is a series of static images. Strange, isn't it, that the huge industries that rely on moving images – animation and motion pictures for cinema, TV, games, new media and Internet – are only possible because of this small quirk in our human 'visual apparatus'?

We speak of a series of images being placed in front of our eyes in rapid succession. But how 'rapid' need this be to achieve the effect of a single moving image? That depends upon the individual but most people find that four images viewed per second appear to be clearly separate. Increase the speed to eight per

Fig. 1.2 (above) Use the corner of this book as a flipbook (if you don't mind a dog-eared appearance!). Hold all the pages together between thumb and forefinger of your right hand (near this top right-hand corner, just below the line). Now, using your left hand, flip from back of book to the front. See the little man walk.

Fig. 1.3 The little man walking on the spot as you flipped through the book is an eight-drawing walk cycle. © Larry Lauria.

Fig. 1.4 Thaumatrope, side two. The 'Thaumatrope' named by its inventor, Dr John Ayrton Paris, an English physician, was an optical toy put on sale in 1825. It consisted of a flat disc, each side of which had a complementary picture, e.g. on one side, a bird and on the other side, a picture of a birdcage. When spun by means of strings attached to each side, the bird merged with the cage and appeared to be within it.

Fig. 1.5 Eadweard Muybridge.

second, and the images may blend together to some extent, but will seem very jerky. At twelve images per second, the illusion of continuous movement is much better. Most of the Disney hand-drawn animation movies were shot at this speed: each frame shot twice and projected at the standard cinematic rate of 24 frames per second. In certain circumstances, such as when an object or character crossed the screen horizontally – especially if the background had a number of vertical lines, e.g. a picket fence – the projected movie appeared to 'strobe'. For this type of sequence it soon became apparent that 24 f.p.s. produced a better, more fluid effect. Whereas the standard cinematic rate of film projection is still 24 f.p.s., TV images are 25 f.p.s. (PAL European system) and 30 f.p.s. (NTSC American system).

Using the principles of persistence of vision to create the illusion of movement was one step in understanding the process of making movies. The other two main areas of understanding and technology that needed to be joined to this were the creation of a mechanism to shoot 'moving pictures' and finally a reliable mechanism to project these images.

THE MECHANISM TO MAKE MOVING PICTURES

From the mid-1900s the race was on to convert what today, we might term 'glorified toys', using the principle of persistence of vision, into a moneymaking entertainment medium. Many contributed along the way:

Those who invented photography

Joseph Nicephore Niepce, who in 1827 invented the very first film, using bitumen-coated pewter plate to capture the shadowy image of a rooftop near his window (it took eight hours to form), and William Henry Fox Talbot, an Englishman who in the1840s took the next leap forward to create photography by producing images (using a wooden-box camera) that could be reproduced. He used paper coated with silver salts to produce a single image in the form of a negative – so that many more positives could be printed, the same basic process used today.

Those who analysed motion through imagery

Eadweard Muybridge (fig. 1.5), the photographer, who conducted experiments to analyse different types of movement of humans, birds and animals (fig. 1.6).

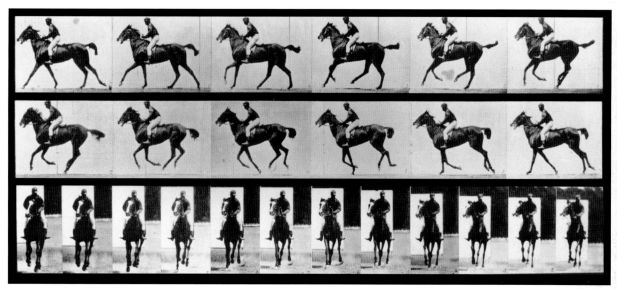

Animation students and artists interested in frame by frame movement still refer to Muybridge's images to analyse frame by frame movement.

Those who devised a mechanical camera which could capture movement

The actual discovery of a way of making moving pictures using a photographic process was made by the American inventor, Thomas Edison, and his young assistant, William K. Laurie Dickson.

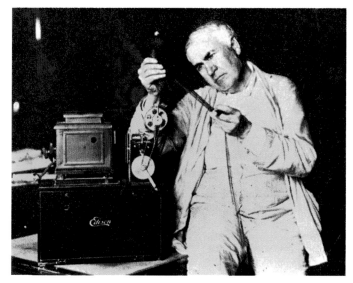

Fig. 1.6 One experiment Muybridge conducted in 1880 involved placing 24 still cameras linked by trip wires at carefully placed intervals along a race track: when a horse stepped on the wire, the shutter was triggered. Here are the resultant images, still used as reference for animators today.

© 1887 Eadweard Muybridge, courtesy of Kingston Museum and Heritage Service, Surrey, UK.

Fig. 1.7 Edison is shown here, looking over some film in the library of his laboratory around 1912. The machine is an Edison 'Home Projecting Kinetoscope'. Film was passed over a magnifying glass to enlarge the pictures.

Dickson began working on the project under Edison's guidance in 1888. They managed to make a movie camera which was able to take steady pictures, which they called a 'Kinetograph'. No-one working in the field of creating moving pictures could possibly anticipate the impact that the movie industry would have in the next century. Nevertheless, Edison was well aware that the next logical step after the movie camera was to create a mechanical means of projection. It's easy for us to judge priorities in hindsight, and unfortunately, Edison asked Dickson to put aside the work on this project in favour of what he thought a better 'money earner' at the time – their 'kinetoscope', a coin-in-the-slot peepshow. Dickson later expressed regret that this left the field open to all and the Lumière brothers soon stepped in with their own movie projection system. Only later did Edison put the finishing touches to his 'home projecting kinetoscope' (fig. 1.7).

Those who made group viewing possible

Emile Reynaud was an artist, showman and inventor who was a contemporary of Muybridge, working in Europe. He invented a device that was a major step forward from the 'kinetoscope' in that an individual no longer had to peer through a peep hole or slot to see the illusion of movement: it allowed a group to see moving images that were reflected in rapid succession onto a prism by revolving mirrors. He called it a 'praxinoscope' (fig. 1.9) and had it patented in 1877. Later, in 1892, he developed a further advance – his 'Theatre Optique', whereby images could be projected onto a screen and thus seen by a larger audience. Images were no longer confined to a short strip within a cylinder, they were painted onto a long ribbon that was wound from one reel to another. This projection equipment had two major defects: 1) it was fragile and 2) it had to be hand turned by a skilled operator, that ended up having to be Reynaud, himself.

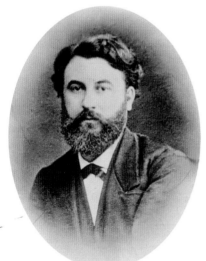

Fig. 1.8 Emile Reynaud: artist, showman and inventor, invented the praxinoscope (fig. 1.9) that allowed group viewing of moving images reflected from the revolving mirrors.

Fig. 1.9 Praxinoscope.

Those who were finally able to project movies

The Lumière brothers made the breakthrough of creating a means of mechanically projecting photographic images. The brothers ran Europe's largest factory producing photographic materials. Their film, called *La Sortie des Usines,* was

presented to a scientific society in Paris in 1895 and showed workers leaving their factory. It was the first film to combine use of live action photography with mechanical projection. Louis Lumière, himself, gave credit to those whose experiments in analysing motion through imagery had contributed to his success, particularly Muybridge and Etienne-Jules Marey, who had been experimenting into the movement of abstract shapes photographed onto glass plates (fig. 1.10). At the same time, he pointed out that none of the instruments made by these men was able to achieve animation of more than about thirty images in projection.

BIRTH OF THE MOVIE INDUSTRY

The first cinematograph screenings organized for a paying public took place in Paris on 28 December 1895 and were an immediate attraction, showing in London's West End a few months later. Within a year, Queen Victoria saw films made

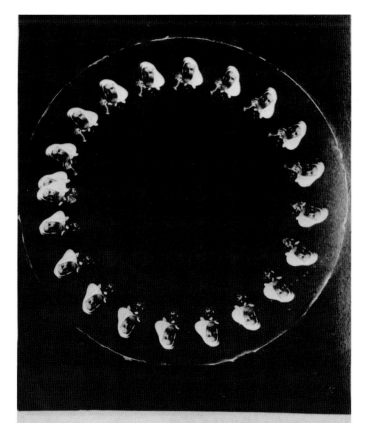

Fig. 1.10 Etienne-Jules Marey experimented into movement of images photographed onto glass plates. His work was acknowledged by the Lumière brothers as contributing to their breakthrough in projecting images to make movies.

by the Lumière brothers at Windsor Castle, which were accompanied by a full orchestra. These very early films were projected at 16 frames per second and were about 50 feet in length, lasting about 50 seconds. Within a few years the average length of films had increased, together with the number of cinemas and other exhibition venues.

The movie industry was born: movies had suddenly become a novel form of mass entertainment throughout Europe and the USA. At this time audiences saw little difference between live action (real scenes shot with a movie camera) and animation (drawn or painted images photographed frame by frame). The fact that light and shadow on a screen created scenes and people that moved was enthralling enough.

In December 1937 Disney introduced the first full-length feature animation to a marvelling audience – the entirely hand-drawn, colour *Snow White and the Seven Dwarfs*. In 1998, some sixty years later, the Disney Studios, with Pixar, achieved another milestone with the first full-length feature 3D computer animated film, *Toy Story*. This time, although the computer-generated toys looked exactly like real toys, the challenge was not so much to create the illusion of reality but to endow the 3D toys with individualistic character and personality, as was so clearly achieved with *Snow White*. Good characterization is often more difficult to achieve in 3D animation than in 2D work. Read Chapter 7 for more information on character animation.

From 1902 to 2002 and beyond we have seen the massive growth of an industry – and the growth of audience expectations. Initially people were enchanted just peering through a slot and seeing a cycle of hand-drawn images moving. Then they were enthralled by the vision of real things and people moving on a large screen. Now they expect to see the impossible happen and look utterly real.

TRADITIONAL ANIMATION PRODUCTION TECHNIQUES

Hand-drawn images on paper and cel

In the early days of animation, each drawing was completed on paper. The use of transparent pieces of celluloid, known as 'cels', transformed the process of traditional animation allowing for longer, more elaborate productions. The means of hand painting between predrawn outlines created the look that became associated with cinematic animation: flat colours for characters which were outlined with thin black

Fig. 1.11 (opposite) Hand-drawn sketched poses of the cartwheeling girl drawn by Larry Lauria. At a later stage Larry would turn them into numbered, sequential, registered images for animation, 'cleaned up' to become outlined images suitable either for scanning into a computer for digital inking and painting or, as in this case, for hand painting (fig. 1.12) by means of magic markers and crayons.

Fig. 1.12 This character (see other poses opposite) has been hand coloured by magic marker between the black outlines. Additional shading has been done using coloured crayons.

Images on this spread © Larry Lauria 2000.

lines. Using cels meant that non-moving parts of the characters did not have to be redrawn each time the frame was photographed. Each frame to be shot then consisted of a layered sandwich – the bottom layer being the painted paper background with up to seven cels used on top (more cels could have affected the density of the painted colours when filmed).

The first stage of producing traditional cel animation remains the 'drawing on paper stage'. Pegbars are used with hole punched paper to ensure correct registration of each drawing. The drawings are then shot, frame-by-frame, or more likely – to save artists' time – double framed, i.e. each drawing is exposed twice. The resultant developed film allows the animator to check character movement, the 'action' in draft form, when changes can be easily made. This is known as a 'pencil test' or 'line test'.

The drawings are later cleaned up with excess lines removed and then given to tracers who place registered cels over the paper and carefully trace the images with black outlines. These are passed to the painters, who paint between the lines with special animation paint on the reverse side of the cel so brush marks are not visible.

After a further cleaning process to ensure no fingerprints are left on the cels, they are transferred to the rostrum camera which has a single frame facility and is mounted vertically on a stand with polarized lights to eliminate reflections from the cells. The cel 'sandwiches' are then placed, registered by means of a pegbar, on the bed below the camera in the precise numbered order specified in the dopesheet (another name for this is 'exposure sheet' or 'Xsheet'), the bottom layer being the background. Those handling the cels wear cotton gloves so as not to leave fingerprints which may show when filmed. Each frame of film is then exposed until each shot is complete – all in all, a very time and labour consuming process.

Although the use of cels is redundant for large-scale productions, they are still used for specialized 'art' productions shown at film festivals or for student productions. Computer-controlled rostrums greatly aid pans, zooms and other camera movements. Often cels are combined with drawings on paper using a variety of media such as magic markers, crayons, photographs and cutouts. Unless the film is destined for cinematic distribution, video, being a much cheaper production process with the advantage of instant replay, is likely to be used instead of film.

2D COMPUTER ANIMATION

One of the first ways that computers helped to speed up this process was the use, initially by larger animation studios, of scanners to transfer the cleaned up pencil tests to digital systems. No more need for all that hand tracing and outlining in ink. Once computers became more powerful with increased memory, the digitized drawings could be played back in real time to test the action. Then, each digitized line drawing could be digitally painted. Digital compositing (layering) techniques meant that a number of animators could work on different parts of a scene at the same time. When finished, all the layers were composited digitally over the backgrounds. Complicated camera movements such as combination zooms with pans within a scene presented no problems to a computer's virtual camera. These computerized techniques essentially duplicated the stages of traditional animation production.

Nowadays, there are a number of 2D computer software programs that speed up all aspects of 2D animation as described above. Drawings can be originated either by hand or directly into the computer using the animation program or another image creation program such as Adobe Photoshop or Illustrator. Two leading 2D animation programs used in Britain and the US are Animo and Toonz. Others, popular in various parts of the world, include Retas!Pro and MediaPegs. Toonboom is a 2D animation program that is a vector-based, resolution independent system. This means that when existing digital images are enlarged, they maintain their original clean lines unlike raster-based imagery which, when enlarged, becomes more 'pixelated'.

There are also programs that specialize in particular types of 2D animation, such as cutout animation. Examples here are CelAction and CreaToon. Flash is a very popular, vector-based software package originally designed for animation on the web. With the continuous addition of updates it is fast becoming more of an all-purpose 2D animation tool.

Even with the aid of programs such as Animo or Toonz, the traditional first stage of drawing on paper, registered by the pegbar, is still preferred by the majority of traditional character animators. They much prefer the immediacy of pencil and paper. The other stages of inking, painting, backgrounds, compositing and camera movement can be left to the computer, but of course, the computer is only a tool and the creative force always lies with the artist.

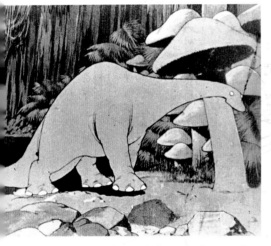

Fig. 1.13 *Gertie the Dinosaur*, by Winsor McKay, 1914.

3D COMPUTER ANIMATION

3D computer animation software added a whole new dimension of creative possibilities to animators and filmmakers, particularly in making impossible things seem real. Unlike 2D animation, once a character has been modeled in 3D, it can be viewed realistically from any angle as in real life (fig. 1.14). The achievement of artificially creating objects that match the appearance of those in real life is known as photorealism and this was originally the main aim of most 3D programs. Great efforts are continuously being made to improve a program's ability to simulate reality through what it can offer the animator in the areas of its modeling capabilities, lighting, use of textures and surface materials and rendering (colour renditions of scenes) of the final images. One wonders what Winsor McKay, creator of the charming, line drawn *Gertie the Dinosaur*, 1914 (fig. 1.13), would have made of today's fearsome 3D dinosaurs.

Fig. 1.14 Triceratops (created in Maya). © 2001 Aardman Animations, by Steven Elford.

Fig. 1.15 *The F-cru: Frutina
characters* (© 2001 5th Dimension)
*who feature in a wide range of
media for this frozen fruit drink.*

Fig. 1.16 *3D animation of Frutina
characters for CD-ROM and video.*

DIGITAL CONVERGENCE

Bringing it all together

From this potted history, you can see that simple forms of animation have existed for hundreds of years. Motion pictures – live action shot with a movie camera – are a relatively recent phenomenon, and projected animation became a part of this entertainment medium. Before long, live action and cinema 'cartoons' began to take separate paths and animation was perceived as a parallel entertainment form alongside that of live action movies. But, as with other areas of communication and entertainment, the advent of digital technology has, yet again, changed animation's place in the movie world.

There are many forms of visual communication: print, television, video, films, and 'new media' (though it is hardly 'new' anymore): multimedia, DVD and Internet. Because they

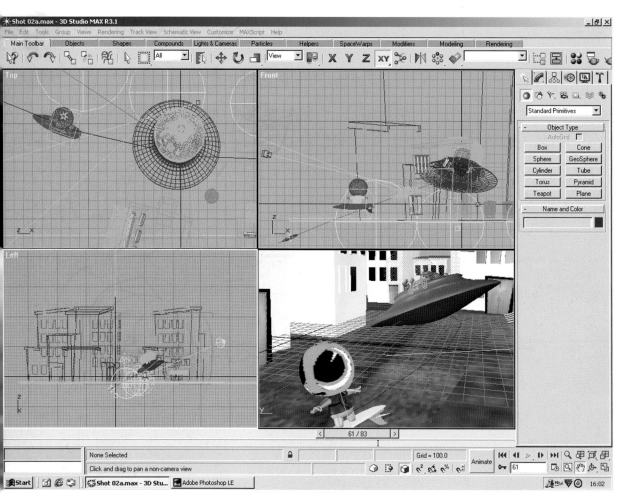

have evolved at different times in different ways, each form – like animation itself – has grown up with its own conventions.

The onslaught of digital technology into all forms of communication really began in the industrial marketplace in the 1970s. It made itself visible in the '80s, and really took off into mass-market 'desktop' technology in the '90s. Computers have become cheaper and ever more powerful in the new millennium. In hundreds of ways, they have blurred the boundaries of what were once thought discrete industries.

Design studios used to deal mainly with designing for print. Post-production facility houses dealt with video editing and producing soundtracks. Multimedia companies specialized in providing content for and authoring CD-ROMs and then began branching out into designing websites and creating DVDs; animation studios produced animation that found its way into all these media. The thing they had in common was

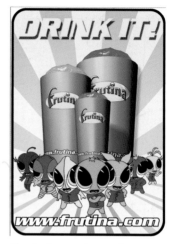

Fig. 1.17 Printed poster for Frutina.
Fig. 1.18 Website for Frutina.
© 2001 Fifth Dimension.

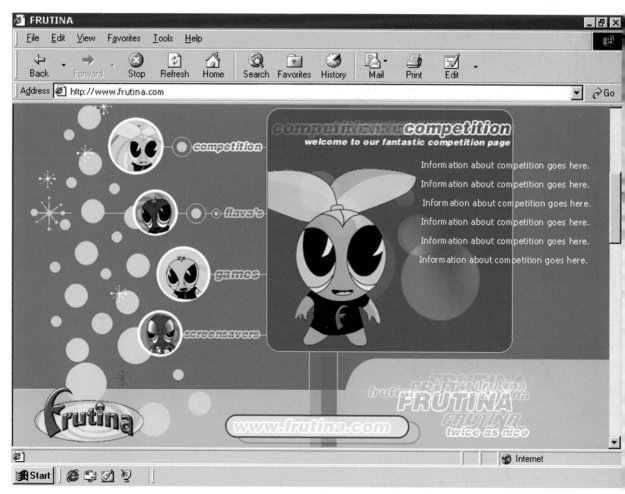

that they mostly all dealt with various combinations of text, images and (except for print) sound.

It is easy to see why there has been so much convergence within these industries if we look at a simple example of two software packages that most of us are familiar with: Microsoft Word (for word processing) and Adobe Photoshop (for image manipulation). Say we have some text – a message or a story – that is produced in Word and illustrated by, say, a photograph and an illustration produced in Photoshop. In the case of the illustrations, Photoshop can be used equally well to create imagery for a variety of media: e.g. manipulation of scanned drawings for print, drawings and backgrounds for 2D animations or to create backgrounds or texture maps for use on 3D models for 3D animation. In the case of the text, we no longer have to re-key it every time we need it for a different end product. Usually, we can import the text from our original word processing package into whatever specialist software package requiring it, be it for print, web or title for video/TV.

Regurgitating the material

So much of what is produced – image, text and sound – can be regurgitated for use in a variety of media. This is also the case with animation. The same imagery and animation can be used for TV, video, film, website, DVD or CD-ROM – with resolution and frame rate adjusted to allow for the different requirements of each medium. These requirements are explained in Chapter 2.

The strange thing is that there seems to be an ever-increasing range of software coming onto the market, despite the fact that many packages are capable of so many functions for different end products. Much of this new software takes account of what other software is already well established; it is designed to 'plug-in' or to be used together with the master package to achieve a particular effect or to improve the speed of producing various effects. Sometimes it's better for two independent software companies to strike a deal to their mutual advantage. An instance of this is when the plug-in that users have to buy in addition to the main package becomes so popular that the add-on is swallowed up by the master software and becomes part of its next upgrade, helping it maintain or improve its position in the marketplace. Read the case studies in Chapter 6 to see how a number of packages are used together to achieve their end results.

ANIMATION: THE ART OF MAKING THINGS MOVE

Understanding animation concepts

If you have art/design training or experience you will recognize that whatever the final image to be produced, there are certain common considerations that form part of the creative process of producing a still image. These are the use of shape, colour, tone, contrast, texture and use of space, i.e. composition, or in filmic terms, framing. These will also play a part in animation, which consists, after all, of a series of images.

For now, however, we are dealing with the one big difference: movement. *Although computers have altered the way animation is produced, most of the actual principles of producing convincing movement remain the same as those used by traditional animators for so many years.* Regardless of whether you are using a 2D or a 3D animation package, understanding and applying these principles will be of enormous help in the animation you create. First it helps to be reminded of Newton's Laws of Motion and then translate them into concepts that you can use in your animation.

Fig. 1.19 One can really feel the movement in this sketch by classical animator, Larry Lauria, former head of Animation at the Disney Institute and currently 2D Animation Professor at Savannah College of Art and Design, Georgia.
© Larry Lauria 2000.

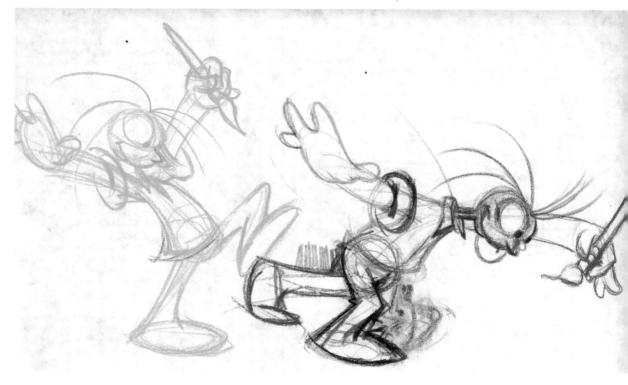

Newton's Laws of Motion

• Every object has mass (weight) and will remain at its natural state of inertia (i.e. not moving) unless a force is applied to move it.

• The greater an object's mass (weight), the greater the force that is required to move it.

The really important thing to bear in mind is that when you're animating, although *you* may know how big or how heavy an object or character in your scene is meant to be, and you may draw or model it accordingly, its size and/or weight is only really made apparent to your audience by the way you make it move or be moved. For example, if a character picks up a box, your audience will know how heavy it is meant to be by how much effort your character is seen to expend in lifting it.

Fig. 1.20

• Once an object is moving, it tends to keep on moving unless it is stopped by another object, or unless it is gradually brought to a halt by friction. An example is the car in fig. 1.20. It has reached cruising speed but when it is stopped by crashing into the text, it crunches up not just because of hitting the text but because its back half is still moving forward along the smooth road, even after impact. A ball rolling along a smooth path will keep on rolling much longer than the same ball rolling along a rough path. A heavy object will be slow to get started moving and slow to stop; lighter objects will move more quickly.

1

Fig. 1.21

2

Overlapping action

When you think about animating any action of anything, you could break it down, like

Newton, into two parts: starting and stopping. What you must bear in mind is that when a body in motion comes to a halt, not

3

4

all parts stop at the same time. Various parts will

5

finally halt their motion at different times to other parts. Look at fig. 1.22. First the girl gets ready for the jump by bending her knees and crouching – see drawing 3 (anticipation). She then launches into the jump, lifting her arms. At the height of the jump (drawing 8), her skirt has lifted, but has not yet reached its highest position (drawing 9, lifted by air resistance on her downward path). As she lands, her feet may stop first (drawing 10), but the rest of her body will still be moving downwards: her upper body and arms, her hair, her clothes. Each part will finally come to rest at different times. This effect, following the laws of motion, is what we call 'overlapping action'. Your animation will appear dull and unnatural if you ignore this.

Fig. 1.22

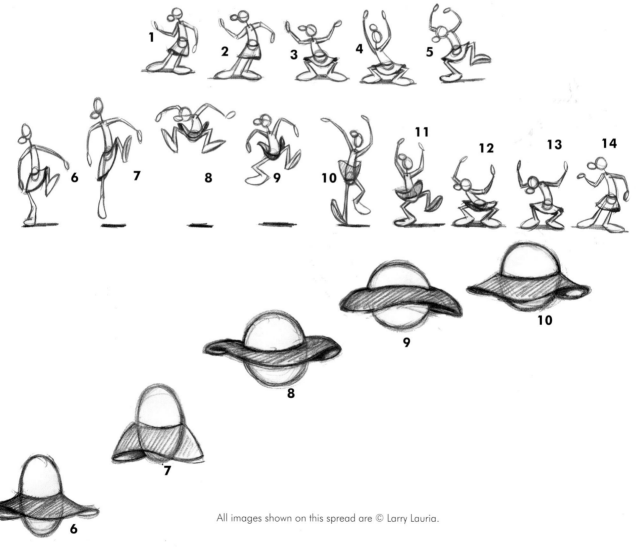

All images shown on this spread are © Larry Lauria.

Overshoot

Another aspect of starting and stopping is that objects will generally overshoot their mark before settling back into their final position. This is an effect that you'll generally use for most objects in motion. This overshoot is likely to be the default for 3D software animation but you'll need to override it for mechanical objects or where you don't want your ball, say, to bounce right through the floor.

Follow through

If you've ever had tennis or golf coaching, you'll remember your coach telling you to 'follow through' after you've hit the ball. By this, the coach meant 'don't try to stop the arm movement once racquet or golf club has made impact; allow natural carry through of movement'.

When animating an action, bear in mind that few movements end abruptly at a given point and objects are usually made up of a number of connected parts of varying weight and type. For example, Superman has tight clothing that would remain attached to his body like a second skin. His cloak, however, although attached to his shoulders, will behave quite differently; it will billow in the wind and come to rest after Superman, himself, has alighted. How far the cloak carries on moving and how swiftly it comes to rest after Superman has landed will depend on the type of fabric (e.g. gossamer light, or heavy velvet) and friction, e.g. air resistance. The same principle applies to the animation of all secondary objects attached to the main object as explained under 'overlapping action', e.g. hair or floppy ears.

Squash and stretch

You're probably familiar with this animation concept from Disney characters. They have a rubbery, elastic quality when they move. Animation is the art of exaggerating movement for dramatic and comic effect. The principles are simple: when an object hits something, it squashes and when it rises, it stretches (figs 1.20–1.25). This is standard animation practice for 2D and much 3D. Just how much you exaggerate the effect will depend on the degree of realism you want to convey.

Fig. 1.23 Application of squash and stretch for this pencil by Larry Lauria.

All images shown on this spread © Larry Lauria.

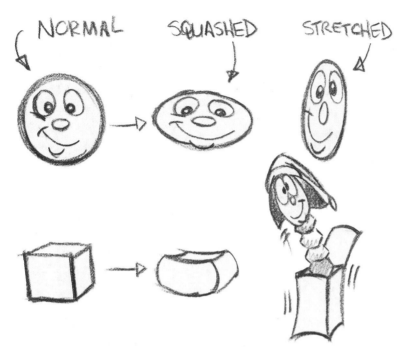

NORMAL SQUASHED STRETCHED

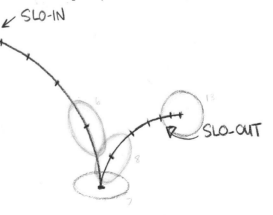

Slow-in and slow-out

Most moving objects don't begin and end the movement at full speed. They begin slowly, get up to speed and slow down before drawing to a stop. Think of a car starting, driving and stopping or perhaps something that you see constantly on TV station breaks and commercials: a flying logo. It takes off smoothly and slowly from a stationary position, gathers speed and spins or flies around before settling gently into its final position on screen. The bouncing ball demonstrates another type of slow-in/slow-out (fig.1.25).

Because this smooth, slow-in/slow-out type of movement is so common, your software is, again, likely to use it as the 'default', meaning that the software may give you this type of movement whenever you move an item from point A to point B, unless you instruct it otherwise. You might not want this type of movement when you need the movement to be sharper, for example when a lid falls shut from an open position. The lid would slow-out but, similarly to the ball hitting the ground, it speeds up as gravity pulls it downwards to its shut position. Indiscriminate use of 3D software's default slow-in/slow-out motion gives an unnatural, floating look, so use appropriately and with due care.

Fig. 1.24 Application of squash and stretch for Larry's Jack-in-the-box.

Fig. 1.25 This demonstrates slow-in/slow-out keyframes for Larry's bouncing ball (shown by the crosses on the curve). As the ball slows, the keyframes are closer together, i.e. there are more in-betweens, and vice versa when the ball speeds up. You can also see the principle of squash and stretch as applied to speed (as well as impact when the ball hits the ground).

SLO-IN

SLO-OUT

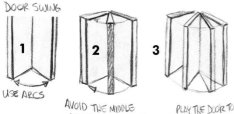

Fig. 1.26 Here, Larry demonstrates how a door swing moves in arcs.

Fig. 1.27 This simple head turn drawn by Larry follows the same principles.

Fig. 1.28 Larry's drawings of Joey jumping to reach the golden ring demonstrate a number of animation techniques discussed: moving in arcs, slow-in/slow-out, anticipation, squash and stretch and overlapping action.

In drawing 1 we see Joey in normal standing position. In drawing 2 he is anticipating his leap by bending his knees prior to takeoff, clenching his fists and looking toward his goal with a determined expression.

In drawing 3 he takes off and we see how his body is stretched as he rises. Note the overlapping action of his hair and clothing at different parts of the action. When Joey lands, his knees bend once again before he straightens back into his normal standing position.

Joey is vertically challenged. He must get the golden ring *at all costs!*

Moving in arcs

Objects thrown into the air will go up and come down following a parabolic curve. A ball bouncing demonstrates this curve (fig.1.25). Move your objects in arcs – however slight – rather than in straight lines wherever possible, for example when a character's head turns from one side to the other (fig.1.27) or, similarly, when a character's eyes move left to right and vice versa. Even a door opening and closing follows this principle (fig.1.26).

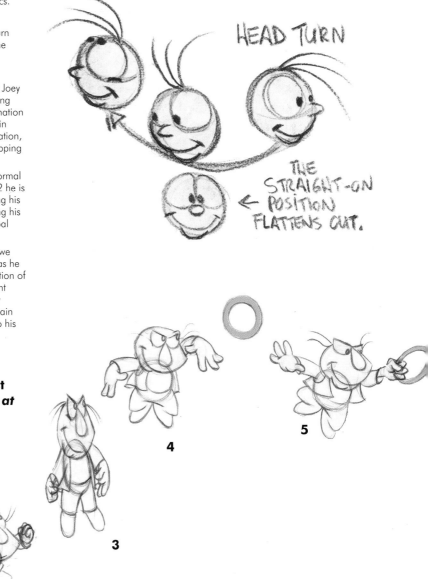

Anticipation

Character animation is all about timing and pacing. In order to maximize the drama or comic effect of any important action, it's important to signal to the audience that something is about to happen before it actually does happen. That way, we not only gain greatest impact from the scene but we also allow the audience time to register what's happening to a character on screen (things happen much faster in animation than in live action). We need to build in *anticipation* at all levels from a simple action such as jumping or reaching for a mug (figs 1.28 and 1.29) or doing a take or double take when something really shocks or excites a character.

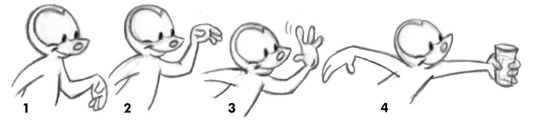

1 2 3 4

Takes and double takes

These are just exaggerated forms of anticipation, e.g. a character walks off a roof, a mountain ledge or whatever and continues to walk unconcernedly on thin air until some sixth sense tells him that his feet are no longer on terra firma, at which point he looks back or down and becomes aware of his plight. He shows us his reaction (the take) usually by a frozen expression of horror (a 'hold') – before falling very fast to an unhappy end. The double take is a variation when it takes two looks (the first look doesn't quite register the situation) before he fully realizes his predicament and falls.

Fig. 1.29 Grabbing the glass: anticipation is evident in how Larry has drawn the arm and hand movements. Notice how the arm bends before stretching out and how the hand opens (in drawing 3) in anticipation of closing around the glass in drawing 4. Also notice the balancing action of the other arm.

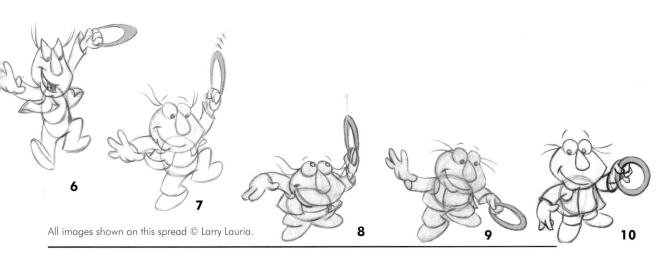

6 7 8 9 10

All images shown on this spread © Larry Lauria.

Holds

Holds are deliberate pauses in an action. But beware! In either 2D or 3D animation, just leaving a character in a static position, without even an eye blink, can be fatal – literally. Your character appears to die on screen and may look like part of the painted background. For this reason, your 'hold' should, more often than not, be a 'moving hold', i.e. your character pauses, but some small part still moves: it might just be an eye blink now and then or a slight shift in position.

How long should a hold last? This is an area where you should experiment, be very self critical and you will gain experience. There are many types of holds, not all for the purpose of dramatic effect. You may, for example, want to show your character looking at something off screen, before cutting to show what is being looked at. The hold on the character in this case should be for about 16 frames (if the running speed of your final video is at 25 f.p.s.) and for a few more frames if you are making a video at 30 f.p.s. Some holds are only a few frames long, e.g. the closed eye position for a blink (see Chapter 7). Normally a hold must be for a minimum of six frames to register that it is, in fact, still.

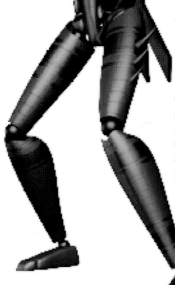

Fig. 1.30 Robots make excellent bodies for linking joints in either forward or inverse kinematics. These principles are outlined briefly under 'Force and drag' and explained further in Chapter 5. This robot is designed by Kenny Frankland. Image © Kenny Frankland 2001.

Force and drag

Many objects, most notably humans and animals, are made up of a series of flexible joints, all linked to each other (seen graphically in the body of the robot in fig 1.30). In 3D animation, this is a hierarchical structure, where each item can be termed the 'parent' of the children who are dependent upon it. Take the example of the leg. The knee is a child of the thigh (the thigh being the parent of the knee, but a child of the lower torso); the shin is a child of the knee; the foot is a child of the shin and the toes are children of the foot. When you move the 'parent' the children automatically follow but will lag a little behind the parent. Each successive child in the overall chain will trail a little behind its parent in slightly overlapping action. This type of linkage is known as 'forward kinematics' (or 'kinemation'). Another form of this hierarchy is 'inverse kinematics'. This is where the *child* initiates the movement and all the other links in the chain follow, bending or rotating according to their natural constraints which have been pre-set by the animator. Setting constraints for all the joints is often a lengthy process, but it saves much time in the long run if the character is, say, dancing or doing some other complicated action.

Cycles

Using cycles, i.e. repeats of the same set of drawings, is a great time-saving device, particularly in the case of traditional hand-drawn animation. If, say, you want your character to walk past a house, it takes a great many drawings to have him cross the screen, left to right with a static background. If, on the other hand, you continually cycle two steps of the character, making him 'walk on the spot' while the background is panned behind, you achieve the same effect, but a great deal of drawing time is saved. The same principles can be applied in computer animation: a repetitive action can be accomplished by copying a given set of frames (e.g. the eight-frame walk cycle of the little man walking in the top right-hand corner of this book) to another part of the timeline. One of the great benefits of computer animation over traditional techniques is that your character no longer has to 'walk on the spot' while the background moves: the computer will allow him to follow any path automatically, cycling the set of frames over the path, no matter how winding or complicated. To make a seamless cycle, there should be a smooth transition between first and last drawings in the cycle.

Keyframe animation

In understanding this term, we firstly need to be aware that time, in movies, is measured in frames. There are 24 frames per second in projected movie film in cinemas, 30 f.p.s. in American (NTSC) television and video, and 25 f.p.s. in European and Australasian (PAL) TV and video, and often 15 f.p.s. or even fewer for online animations or movies.

Keyframe gains its name from its traditional hand-drawn origins when the chief animator (being the best artist) drew the 'key poses' (or 'extremes' of position and movement) of a character at a particular frame number (a given point in time) to mark each major change in a character's position. The in-between artist then filled in all the intermediate (in-between) positions. Your computer is the in-between artist and you are the key animator. Keyframes can be thought of as poses if applied to a character, e.g. each of the numbered images of Joey in fig.1.28.

In 3D terms, each keyframe will set an object's position, degree of rotation and/or scaling in the X (horizontal), Y (vertical) or Z (depth) axis – at a particular frame number (fig. 1.31) in the timeline, which is measured in frames and seconds.

Fig. 1.31 3DS Max screen grab showing section of keyframe for an animation of a teapot lifting by itself, jiggling and pouring tea before reseating itself back on the table. The key spots on the timeline indicate the teapot's position and rotation changes. Image © Marcia Kuperberg 2001.

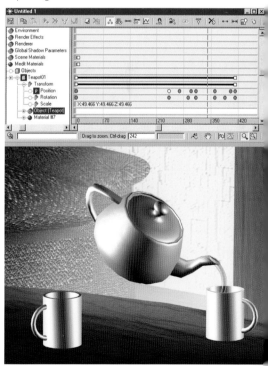

Staging and posing

It may seem obvious that your audience should notice and understand what your characters are doing on screen. Alas, very often, inexperienced animators spend much time working on a particular movement, only to find that its significance is totally lost on the audience.

You need to choreograph the characters' actions so that their meaning is immediately clear to the viewer. This is called 'staging' or 'posing'.

Larry Lauria comes from a traditional Disney-style, craft animation background. These are his guidelines:

1. Posing involves mainly the key poses.

2. Exaggerate the line of action.

3. Look for strong silhouettes which express emotion.

4. Really push your drawings.

5. Look for secondary body elements to assist your posing, e.g. hair, hands, clothing, feet.

Straight ahead animation

You may hear this expression, although it is generally considered to be a less effective way of working than pose to pose. It springs from traditional 2D hand-drawn animation when an artist may have had an action in mind and just kept on drawing until the action was complete, i.e. without first mapping out the key poses. Obviously, even with this spontaneous way of working you would certainly need to rely on your computer to do the in-betweening for 3D work and for much 2D work, which really brings you right back to the pose to pose way of working. To try to create each frame's movement, yourself, in the computer would be to negate this vital function of your animation program.

In computer animation it's a good idea to get used to thinking of movements as beginning and end changes to the status quo of a character (or object) and these 'changes' are, in effect, key poses at keyframes. The really important thing is to create meaningful poses. The stages of creating these are shown in fig.1.32. If you are working with 3D characters rather than 2D drawings, you may still find it helpful to sketch out the poses to help visualize the action.

All images shown on this spread are © Larry Lauria.

Fig. 1.32

A Sketch the key poses showing clear lines of action.

B Build the character, still following the lines of action.

C Check the silhouettes of these poses: they should clearly express action or emotion.

D Add the detail. These principles apply to hand-drawn or computer animation.

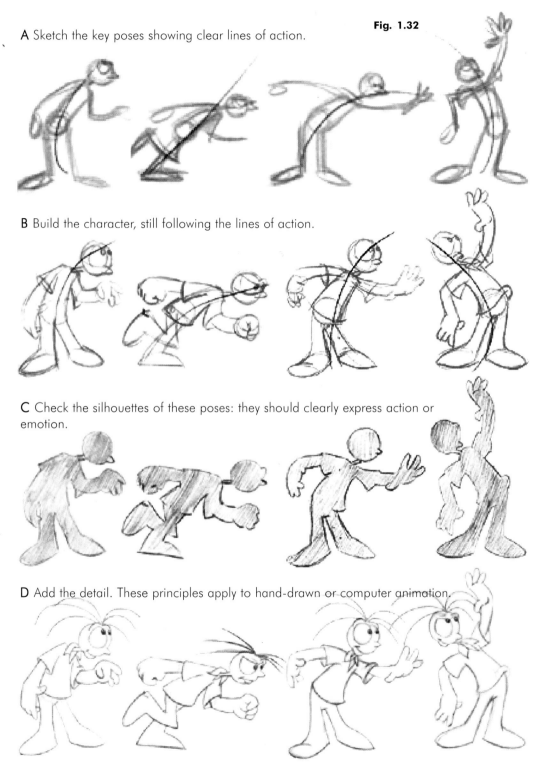

CONCLUSION

Ways of making still drawn images appear to move have been known about for centuries, but it is only in the last hundred years or so that our understanding of this phenomenon has developed sufficiently to make screen-based animation as we know it today. Many innovative thinkers and artists have contributed along the centuries to make this possible.

Computer technology has not only speeded up the animation production process but has enlarged the field of animation into a much broader range of media than movies for cinema, televison or video. New media includes CD-ROM, DVD, computer games and the Internet. These media themselves have produced new types of animation which are explored in other chapters, notably the chapters on Games and Multimedia.

Artists and creative agencies who once restricted their talents to one or another medium are now becoming more broad-based, due to digital convergence.

Effective animation techniques spring from traditional crafts of hand-created drawings which, in turn, come from an understanding of Newton's Laws of Motion.

Whether working in 2D or CGI (3D) you can improve your animation by experimenting with and exploring traditional techniques such as overlapping action, overshoot, follow through, squash and stretch, slow-in and slow-out, moving in arcs, anticipation, holds, cycles, staging and posing.

Fig. 1.33 Creating 3D lip synched animation (see Chapter 7).

Animation is a never-ending creative art. Enjoy it!

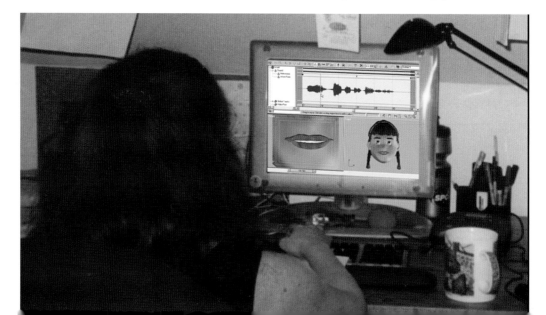

chapter 2

understanding the technical
constraints of creating for
different digital media

by Rob Manton

Chapter 2

by Rob Manton

Understanding the technical constraints of creating for different digital media

INTRODUCTION

Computer animation is an enormous and rapidly expanding field with many software products and techniques available. This chapter attempts to demystify the subject and to explain the reasoning that might help you to choose an appropriate animation package and file format for your animation project.

First, we look at some of the fundamental principles of computer graphics to help you understand the jargon and make sense of the options available in animation software packages.

Second, we look at the type of animation tools available. Many different packages implement tools based on the same general principles. This section will help you to identify the techniques that you need and help you find them in your chosen package.

Finally, we consider some of the issues that affect the playback of animation on various different delivery platforms. It is useful to understand the strengths and limitations of your chosen means of delivery before designing the animation.

When you have finished reading this chapter you will have a basic understanding of:

• The terminology used to describe computer graphics and computer animation.

• The types of animation package and their suitability for different applications.

• The standard animation techniques that are available in many animation packages.

• How to choose a file format suitable for your needs.

• How to prepare animation sequences for playback on your chosen delivery platform.

In the early days of commercial computer animation most sequences would be created on a physically large, expensive, dedicated machine and output onto video tape. Since then we have seen rapid developments in the capabilities of personal computers which have opened up many affordable new ways of creating animation on a general purpose computer, but also many new output possibilites for animation. These include multimedia delivered on CD-ROM, within web pages delivered over the Internet, on DVD and within fully interactive 3D games. Later in this chapter we consider the ways in which animation sequences can be prepared for delivery in these different media.

The early computer animations were linear. Video and television are inherently linear media. Many of the more recent developments including multimedia and the web have allowed user interaction to be combined with animation to create interactive non-linear media. The culmination of this process has been the development of 3D games where the user can navigate around and interact with a 3D environment. There is still a large demand for traditional linear sequences alongside the newer interactive applications, so we need to consider approaches to creating and delivering each kind of animation.

In computer graphics there are two fundamentally different approaches to storing still images. If I wanted you to see a design for a character I could either send you a photograph or sketch of it or I could describe it and you could draw it yourself based on my instructions. The former approach is akin to bitmap storage which is described shortly. The latter approach is akin to a vector representation.

If I want to show you a puppet show I can either film it with my video camera and send you the tape, or I can send a kit of parts including the puppets and some instructions about what to make the characters do and say. You can re-create the show yourself based on my instructions. The former approach is similar to the various digital video or video tape-based approaches. We can design the animation in any way we choose and send a digital video clip of the finished sequence. As long as the end user has a device capable of playing back the video file then we can be confident that it will play back properly. This approach is effectively the bitmap storage approach extended into the additional dimension of time.

Alternative approaches that delegate the generation of the images and movement to the user's hardware include interactive multimedia products like Director or Flash, web pages using DHTML, computer games and virtual reality. These approaches shift some of the computing effort to the user's equipment and can be thought of as an extension of the vector approach into the time dimension.

A few years ago the relatively slow nature of standard PCs made the former approach more viable. It was reasonably certain that most PCs would be able to play back a small sized video clip so the ubiquitous 'postage stamp' sized video or animation clip became the norm. Now that standard PCs and games consoles have much better multimedia and real time 3D capabilities, the latter approach is becoming more widespread. The file sizes of the 'kit of parts approach' can be much smaller than the 'video' approach. This has opened up some very exciting possibilities including virtual reality, games and 3D animation on the web.

SOME TECHNICAL ISSUES

Animation consists fundamentally of the creation and display of discreet still images. Still images in computer graphics come in many forms and in this section we attempt to describe some of the differences. Which type you need will depend on what you plan to do with it and this is discussed later in the chapter. Still images can be used in the creation of animation, as moving sprites in a 2D animation or as texture maps or backgrounds in a 3D animation for example. They can also be used as a storage medium for a completed animation, for recording to video tape or playing back on computer.

DISPLAY DEVICES

Animations are usually viewed on a television set, computer monitor or cinema screen. The television or computer image is structured as a 'raster', which is a set of horizontal image strips called scan lines. The image is transferred line by line onto the screen. This process, known as the refresh cycle, is repeated many times a second at the refresh frequency for the device.

In televisions the refresh cycle is broken into two intermeshing 'fields'. All odd numbered scan lines are displayed first then the intermediate, even numbered scan lines are drawn

second to 'fill in the gaps'. This doubles the rate at which new image information is drawn, helping to prevent image flicker. For PAL television this doubles the effective refresh rate from 25 Hz (cycles per second) to 50 Hz. For NTSC this increase is from nearly 30 Hz to nearly 60 Hz. This works well if adjacent scan lines contain similar content. If they don't and there is significant difference between one scan line and the next (as with an image that contains thin horizontal lines, like a newsreader with a checked shirt) then annoying screen flicker will occur.

Modern computer monitors refresh at a higher rate than televisions and are usually non-interlaced. If you have a PC you can examine the refresh frequency being used by looking in the display properties section in the Windows control panel. It is probably set to 75 Hz (cycles per second). Although the image on a computer screen is probably being refreshed (redrawn) 75 times a second, our animation doesn't need to be generated at this rate. It is likely that the animation will be created at a much lower frame rate as we will see shortly.

BITMAP IMAGES AND VECTORS

We stated in the introduction to this chapter that computer graphics images are stored in one of two fundamentally different ways. Bitmaps are conceptually similar to the raster described above. This structure lends itself directly to rapid output to the computer display. The alternative is to use a vector description which describes the image in terms of a series of primitives like curves, lines, rectangles and circles. In order to convert a vector image into the raster format and display it on screen it has to be rasterized or scan-converted. This is a process that is usually done by the computer display software. You may also encounter these ideas when trying to convert vector images to bitmap images using a graphics manipulation program.

Bitmap images can be created from a range of sources: by rendering 3D images from a modeling and animation package, by scanning artwork, by digitizing video stills, by shooting on a digital camera, by drawing in a paint program or by rasterizing a vector file. They can also be saved as the output of an animation package. They comprise of a matrix of elements called pixels (short for picture elements). The colour or brightness of each pixel is stored with a degree of

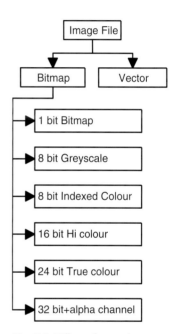

Fig. 2.1 Different formats for saving still images. Not all types are likely to be suitable for your requirements!

128	64	32	16	8	4	2	1
1	1	1	1	1	1	1	1

128+64+32+16+8+4+2+1=255

128	64	32	16	8	4	2	1
1	0	1	0	1	0	0	1

128 + 32 + 8 + 1 = 169

Fig. 2.2 A byte is a set of eight bits each with a different weighting. You can think of each bit as an on-off switch attached to a light-bulb of a differing brightness. By switching all of the lights on you get a total of 255 units worth of light. Switching them all off gives you nothing. Intermediate values are made up by switching different combinations.

Fig. 2.3 A bitmap image close up. The image is composed of scan lines, each of which is made up of pixels. Each pixel is drawn with a single colour. Enlarging a bitmap image makes the individual pixels visible.

accuracy, which varies depending on the application.

A word about bits and bytes

In computing the most basic and smallest storage quantity is called a bit. A single bit can either be set on or off to record a 1 or 0. Bits are arranged in units of eight called bytes. Each bit in a byte is allocated a different weighting so that by switching different bits on or off, the byte can be used to represent a value between 0 (all bits switched off) and 255 (all bits switched on). Bytes can be used to store many different types of data, for example a byte can represent a single text character or can be used to store part of a bitmap image as we describe below. As the numbers involved tend to be very large it is more convenient to measure file sizes in kilobytes (kb – thousands of bytes) or megabytes (Mb – millions)

Types of bitmap image

The colour depth or bit depth of a bitmap image refers to the amount of data used to record the value of each pixel. Typical values are 24 bit, 16 bit, 32 bit and 8 bit. The usefulness of each approach is described below.

The simplest approach to recording the value of a pixel is to record whether the image at that point is closest to black or white. A single bit (1 or 0) records the value of the pixel, hence the approach is called a true bitmap. It has a bit depth of 1 bit. The monochrome image has stark contrast and is unlikely to be useful for much animation. Since it takes up the smallest amount of disk space of any bitmap, 1-bit images are sometimes useful where file size is at a premium, in some web applications for example. 1-bit images are sometimes used as masks or mattes to control which parts of a second image are made visible.

A greyscale image records the brightness of the pixel using a single byte of data which gives a value in the range 0–255. Black would be recorded as 0, white as 255. This has a bit depth of 8 bits (1 byte). Greyscale images are not very useful for animation directly, but may be useful as masks or for texture maps in 3D graphics.

Colour images are stored by breaking down the colour of the pixel into Red, Green and Blue components.

The amount of each colour component is recorded with a degree of precision that depends on the memory allocated to

it. The most common type of colour image, called a true colour image uses a bit depth of 24 bits.

A single byte of data, giving a value in the range 0–255, is used to store each colour component. White is created with maximum settings for each component (255, 255, 255) and black with minimum values of each (0, 0, 0). As the term 'true colour' implies, they give a good approximation to the subtlety perceived by the human eye in a real scene. It is possible to store colour data at a higher resolution such as 48 bit, and this is sometimes used for high resolution print and film work.

For images displayed on screen or TV, 24 bit is usually considered adequate as the eye is unable to perceive any additional subtlety. True colour images are the most common type that you will use for your animations although for some applications where image size and download speed are critical you may need to compromise.

A common alternative format is 16 bits per pixel (5 bits red, 6 bits green, 5 bits blue) which gives a smaller file size but may not preserve all the subtlety of the image. You would be unlikely to accept a compromise for television or video output, but for multimedia work the saving in file size may be justified.

32-bit images contain a standard 24-bit true colour image, but with an extra component called an alpha channel. This is an additional 8-bit mono image that acts as a stencil and can be used to mask part of the main image when it is composited or placed within an animation sequence. This alpha channel can also come into play when the image is used as a texture map within a 3D modeling program. Unless you need the alpha channel then saving images as 32 bit may waste disk space without giving any benefit. You should save as 24 bit instead.

An alternative way of recording colour information is to use a colour palette. Here a separate 'colour look-up table' (CLUT) stores the actual colours used and each pixel of the image records a colour index rather than a colour directly. Typically a 256-colour palette is used. Indexed colour images have the advantage that they only require 1 byte or less per pixel. The disadvantage is that for images with a large colour range, the limitation of 256 different entries in the palette may cause undesirable artefacts in the image.

255	255	255	249	249	248	242	242
243	236	236	236	229	230	229	223
223	223	217	217	217	210	210	210
204	204	204	197	198	197	192	191
191	185	185	185	178	178	178	172
173	173	166	166	166	160	159	160
153	153	153	146	147	146	141	140
141	134	134	134	127	128	127	122
121	121	115	115	115	108	109	108
102	102	102	96	96	95	89	89
89	83	83	83	77	77	77	70
70	70	64	64	64	58	57	58
51	51	51	44	44	45	38	38
38	26	25	25	19	19	20	6
6	7	255	255	255	249	248	249

Fig. 2.4 The contents of a bitmap file. This is a 24-bit true colour file. Each value is a byte representing either the red, green or blue component of a pixel. Note how each value is between 0 and 255.

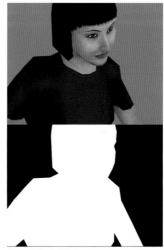

Fig. 2.5 A 32-bit image containing the 24-bit visible image and the 8-bit alpha channel. The alpha channel is used when compositing the image over another background as shown below.

Fig. 2.6 Character, produced by Dave Reading at West Herts College for the *Wayfarer* game.

These include colour banding where subtle regions of an image such as a gentle sunset become banded.

Indexed colour (8-bit) images are useful when the content contains limited numbers of different colours. Menus and buttons for interactive programs can be designed with these limitations in mind. 8-bit images with their reduced file size are sometimes used within CD-ROM programs or computer games where their smaller size helps to ensure smooth playback and limits the overall file size of the sequence. For high quality animation work intended for output to video or television you should save images in true colour 24 bit.

Vector images

Vector images record instructions that can be used to reconstruct the image later. Vector images can be created by drawing them in a drawing package or by the conversion of a bitmap image. They contain objects like spline curves, which are defined by a relatively small number of control points. To save the file only the position and parameters of each control point need to be stored. When viewed on a monitor, vector images are rasterized by the software. This process effectively converts the vector image to a bitmap image at viewing time. Vector images have a number of benefits over bitmap images. For many types of image they are much smaller than the equivalent bitmap. This makes vector images an attractive alternative for use on the Internet.

Secondly, vector images are resolution independent. This means that they can be viewed at different sizes without suffering any quality loss. Bitmap images are created at a fixed resolution as explained in the next section.

Vector images cannot be used to represent all types of image. They are typically used for storing computer-drawn artwork including curves and text. Scanned photographs and other images with large amounts of colour and image detail are difficult to convert usefully to vectors. Packages like Adobe Streamline and Macromedia Flash attempt this conversion but it is often necessary to compromise significantly on image quality in order to achieve a small sized vector image from a bitmap original. Images with photographic realism are not suitable for this process, but more simplified cartoon style images are. This accounts for the cartoon-like look of many images within Flash animations.

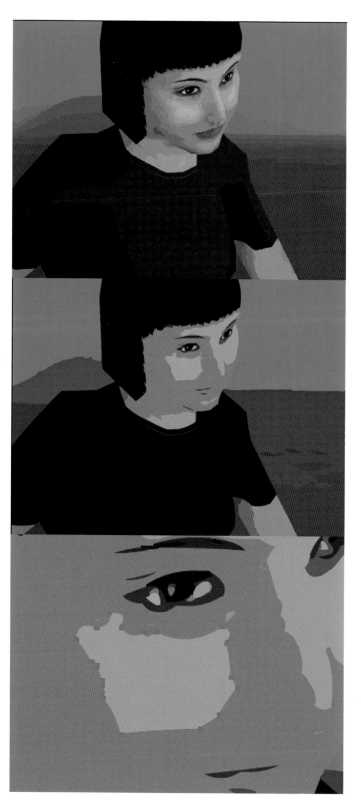

Fig. 2.7 A bitmap image converted to vector form in Flash. Note how each area of colour has been converted into a filled polygon. The high and low quality versions shown above take 39 kb and 7 kb of disk space respectively. The more detail recorded, the higher the number of polygons or curves stored and the larger the vector file size. Vector files are more effective for storing cartoon style line artwork. Photorealistic images do not usually lend themselves well to vector storage.

IMAGE SIZE AND RESOLUTION

The resolution of a bitmap image is defined as the number of pixels per unit distance. The term is also sometimes (sloppily) used to describe the number of pixels that make up the whole bitmap. Since we are unlikely to be outputting animation to paper we are more interested in the required image size for our animations. This influences both the quality of the image and its file size (the amount of data that will be required to store it). The image size needed for an animation varies depending on the output medium.

There are a bewildering number of sizes for television output. This variety is due to the different standards for PAL and NTSC but also due to variations in output hardware. Even though the number of scan lines is fixed for each television standard, different horizontal values are possible depending on the aspect ratio of image pixels used in particular hardware. For systems using square pixels such as the Miro DC30 video card, graphics for PAL output should be 768 by 576 pixels. Systems using non square pixels such as the professional AVID NLE system typically require either 704 by 576 pixels or 720 by 576. NTSC systems require either 720 × 486 or 640 by 480. High Definition (HD) Widescreen format is now becoming available which further adds to the confusion. This uses a much larger number of image scan lines, 1920 × 1080 or 1280 × 720. You should check the specific requirements of your hardware before preparing animation for output to television.

The amount of data required to store an image (without compression, which is discussed below) can be calculated as follows:

Data to store image (bytes) = width (pixels) × height (pixels) × number of bytes per pixel

For a typical 720 by 576 PAL video image this would be 720 × 576 × 3 (3 bytes per pixel for an RGB image)

= 1 244 160 bytes

= 1.244 Megabytes (Mb)

In contrast to vector images, which are resolution independent, bitmap images are created at a fixed resolution. If images were created at say 320 by 240 pixels and enlarged for output to video, then the individual pixels

would become visible, giving an undesirable blocky look. For television or video work the quality of the finished sequence is paramount and you should ensure that the images are created at the correct size.

For CD-ROM or web applications the size of the files are constrained by the speed of the CD-ROM drive or the Internet connection. For CD-ROM work 320 by 240 pixels is a common size for bitmap-based animation and video files. In the medium term the restrictions caused by computing hardware and the speed of the Internet will ease and full screen video will become the norm on all delivery platforms. Vector-based animation files like Macromedia Flash are not limited in the same way. Because they are resolution independent, Flash animations can be scaled to larger sizes without reduction in image quality.

FRAME RATE

As explained in the first chapter, there is no fixed frame rate that is applicable to all animation. Television works at 25 f.p.s. (PAL) or 30 f.p.s. (NTSC). Film runs at 24 f.p.s. Technical limitations may require animation sequences for delivery from computers to be created at lower frame rates. The vector-type animation files that require real time rendering on the user's machine can play significantly slower than the designed rate on older hardware. Most interactive products have a minimum hardware specification defined. During the development process the animation or interactive product is tested on computers of this minimum specification to identify and resolve these playback problems. If you are creating Flash, Director or other interactive content be sure to test your work regularly on the slowest specification of hardware that you intend to support. It is relatively easy to create amazing eye-catching content to work on high spec hardware. To create eye-catching content that works properly on low spec hardware is more of a challenge!

DATA RATES AND BANDWIDTH

The data rate of a media stream like a video, animation or audio clip refers to the amount of data per second that has to flow to play back that sequence. For an uncompressed bitmap animation sequence this is simply the size of a single image multiplied by the number of frames per second (the frame rate).

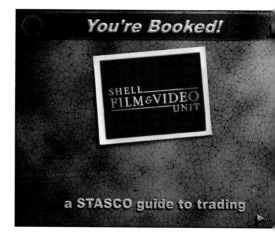

Fig. 2.8 The introduction sequence for the Shell Film & Video Unit CD-ROM *You're Booked!*. Note how the animation (the logo in the frame) is contained within a small screen area. This ensures smooth playback on relatively slow CD-ROM drives.

So for 720 by 576 uncompressed PAL video the data rate is 1.244 Mb per image \times 25 frames per second = 31.1 Mb/s.

For vector animation typified by Macromedia Flash, the data rate required is determined by the complexity of the images in the sequence rather than the size of the frame and is very difficult to estimate in advance.

Bandwidth refers to the ability of a system to deliver data. If the data rate of a data stream (like a digital video file) is higher than the bandwidth available to play it back then the data stream will not play properly.

As an example, the theoretical maximum bandwidth deliverable from a 16-speed CD-ROM drive is 2.5 Mb/s. (Note that the graphics card and system bus also contribute to providing bandwidth as well as the CD-ROM or hard disk. Poor quality components can slow down the overall performance of your system.)

In order to ensure smooth playback on such a system the data rate of the video sequence would need to be significantly reduced. This can be achieved by reducing the image size (typically to 320 by 240 for animation played back on CD-ROM), the frame rate (typically to 15 f.p.s. – below this level the effect is annoying and any lip synchronization is lost) and applying compression, which is discussed next.

The high end computers equipped for professional Non-Linear Video Editing typically have AV (audio-visual) spec hard disks with a bandwidth of 25–35 Mb/s. These are capable of playing back non-compressed video files. Amateur or semi-professional hardware may only be capable of 2–10 Mb/s. If you have a video editing card installed in your system there should be a software utility that will help to measure the maximum bandwidth for reading or writing to your hard disk.

At the other extreme of the bandwidth spectrum is the Internet. Home users connected to the net via a standard modem may experience a bandwidth as low as 1 kb/s (0.001 Mb/s) on a bad day. In order to create your animation sequence so that it will play back properly, you need to take into consideration the bandwidth available to your end user.

COMPRESSION

Compression refers to the ways in which the amount of data needed to store an image or other file can be reduced. This can help to reduce the amount of storage space needed to store your animation files and also to reduce the bandwidth needed to play them back.

Compression can either be lossless or lossy. With lossless compression no image quality is lost. With lossy compression there is often a trade-off between the amount of compression achieved and the amount of image quality sacrificed. For television presentation you would probably not be prepared to suffer any quality loss, but for playback via the web you might sacrifice image quality in order to achieve improvements in playback performance. Compression ratio is defined as the ratio of original file size to the compressed file size. The higher the amount of lossy compression applied, the poorer the image quality that results.

Spatial compression

Spatial compression refers to techniques that operate on a single still image. Lossless spatial compression techniques include LZW (used in the .GIF format) and Run Length Encoding. This latter approach identifies runs of pixels that share the same colour and records the colour and number of pixels in the 'run'. This technique is only beneficial in images that have large regions of identical colour – typically computer generated images with flat colour backgrounds.

Lossy spatial techniques include JPEG compression, which achieves its effect by sacrificing the high frequencies (fine detail) in the image. As a result artefacts (unwanted side effects) like pixellation and blurring of fine detail can occur.

Digital video files can be stored in MJPEG format, which uses these techniques and can achieve compression ratios in the range 2:1 to 50:1. This format is used for storing sequences that are subsequently to be edited or post-processed. Playback of MJPEG files is usually only possible on PCs fitted with special video capture and playback hardware and fast AV hard disk drives. It is ideal for storage and playback from these machines as it gives the optimum image quality, however, it is unsuitable for general distribution as standard PCs are unable to play this format.

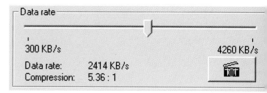

Fig. 2.9 Setting the compression ratio when capturing video on the Miro DC30 video card. Saving your sequences with low compression settings will maintain picture quality but create huge files that don't play back smoothly. Applying too much compression may spoil your picture quality.

Fig. 2.10 The main timeline in Macromedia Director. Image layers are on the vertical axis and frames on the horizontal axis.

The choice of an appropriate compression method may have a significant impact on the visual quality and playback performance of a multimedia, web or game animation. For television or video work a poor choice of compression method may impair your final image quality.

Temporal compression

Temporal compression refers to techniques that consider how images in a video or animation sequence change over time. An animation or video sequence may comprise of a relatively small changing area and a static background. Consider the ubiquitous flying logo sequence. If the logo moves against a static background then the only parts of the image that change from frame-to-frame are the ones visited by the moving logo. Temporal compression aims to save on space by recording only the areas of the image that have changed. For a small object moving against a static background it would be possible to store the entire image in the first frame then subsequently just record the differences from the previous frame. Frames that record only those pixels that have changed since the previous frame are called Delta frames.

In practice it is often necessary to periodically store complete frames. These complete frames are called keyframes and their regularity can often be specified when outputting in this format.

The regular keyframes have two important benefits. If the entire scene changes, for example when there is a cut in the animation or if the camera moves in a 3D sequence, then the keyframe ensures that the complete image is refreshed which contributes to ensuring good image quality. Secondly, the regular keyframes ensure that it is possible to fast forward and rewind through the animation/video clip without an unacceptable delay. This may be important if your animation sequence is to be embedded in a multimedia product and pause and fast forward functionality is required.

The degree of compression achieved depends on the area of the image which remains static from frame to frame and also on the regularity of keyframes. Because keyframes occupy more file space than delta frames, excessive use of keyframes will restrict the potential compression achieved. Where no fast forward or rewind functionality is required and where the sequence has a completely static background throughout and a relatively small screen area occupied by the moving parts, it may be beneficial to restrict the number of keyframes to just 1.

Fig. 2.11 A sequence of frames created for the title sequence to the Shell Film & Video Unit CD-ROM *Fuel Matters!*. Each frame has been subjected to different amounts of blurring in Photoshop and the whole sequence is assembled in Director. The effect is for the title to snap into focus.

Note that with some kinds of animation there is no saving to be achieved by temporal compression. If all pixels in an image change every frame, for example when the camera is moving in a 3D animation, then temporal compression will be unable to achieve any reduction in file size. The only option will be to rely on more lossy spatial compression.

Temporal compression is implemented by codecs like Cinepak and Sorenson. It is often a matter of trial and error to achieve the optimum settings for keyframe interval for a particular animation or video sequence. Temporal compression is appropriate for the storage of final animation or video sequences where maximum compression is necessary to achieve smooth playback from a limited bandwidth device. Where rapid motion exists in the sequence temporal compression can introduce undesirable artefacts like image tearing. As further editing would exaggerate and amplify these artefacts, this format is unsuitable for subsequent editing and post-processing.

TYPES OF SOFTWARE USED IN ANIMATION

Having discussed some of the main ideas involved in storing images and animation and video sequences we are now in a position to consider some of the main types of software package that you are likely to use when creating your animations. Although many different packages are available, they mostly fall into one of the categories described in this section. There are a finite number of animation techniques available and each individual software package will implement only some of them. Many packages are designed to be extended with third party plug-ins (additional software components that can be added to the main software), so even if your chosen package doesn't implement one of the techniques described, it is possible that the functionality will be available via a plug-in from a third party supplier.

2D sprite animation packages

The term 'sprite' was originally applied to the moving images in the early arcade games. Today it can be used to mean any image element that is being manipulated in a 2D animation package. Most 2D animation tools allow scenes to be built up from individual image elements, which are either drawn within the package or imported from an external file. Some work primarily with bitmap images and others with vector images or a combination of the two. Macromedia Director

Fig. 2.12 The frames imported into Director and added to the timeline. Note how the changing area of the image is tightly cropped. The background remains constant. It would waste disk space and slow down playback performance if each image had to be loaded in full. This is a kind of manual temporal compression.

was originally designed to work with bitmaps but more recently vector image support has been added. Macromedia Flash started as a vector animation tool but has support for bitmap images built in.

A typical 2D animation tool provides a timeline-based interface showing image layers on the vertical axis and frames on the horizontal axis.

Sprites are individual image elements that are composited (combined) over a background while a program runs. Different combination styles may be available such as varying the opacity or colour of the sprite.

Each sprite can be modified by adjusting parameters such as its position, scale and rotation. The position of the sprite is usually specified in pixel co-ordinates from the top left corner of the screen.

For reasons of efficiency many packages treat images and other elements as templates which are often collected together in some kind of library. In Macromedia Director the images are termed 'cast members' and the library is called a 'cast'. In Macromedia Flash the images are called symbols and the library is indeed called the library.

To assemble frames of the animation, the designer allocates the image templates stored in the library to the appropriate frame on the timeline. Although the terminology varies from package to package, the principle is the same. In Director, each time a cast member is placed on the timeline it is referred to as a sprite. In Flash, each use of a library symbol item in the timeline is called an instance.

When the animation file is stored, only the original image 'template' needs to be stored along with references to where and when each one appears in the animation timeline. This means that an image can be used multiple times without adding significantly to the file size. A Flash file of a single tree would probably take nearly the same amount of download time as a forest made up of many instances of the same tree template. The size, position and rotation of each instance can be adjusted individually.

Creating animation with 2D sprite animation packages

In this section we look at some of the techniques available for creating animation with a 2D package.

Fig. 2.13 Some of the sprite properties available in Director. In a 2D animation package, sprites (individual image elements) are usually positioned in pixels relative to the top left corner of the visible screen area. Here the X and Y values give the position of the object and the W and H values give its width and height.

HAND-DRAWN ANIMATION

The simplest technique is to manually create each frame of the animation sequence. Each frame could be drawn using a paint or drawing program or drawn on paper and then scanned in. The software is used to play back the frames at the correct frame rate – a digital version of the traditional 'flick book'.

An equivalent approach is to manually position image sprites in each frame of a sequence. This is akin to the way traditional stop-frame animators work.

Onion skinning is a feature available on many of these programs. This allows the user to create a sequence of images using drawing tools while seeing a faint view of the previous image or images in the sequence. This is helpful in registering the images.

Rotoscoping is a process involving the digitizing of a sequence of still images from a video original. These still images can then be modified in some way using paint or other software and then used within an animation or video sequence. Adobe Premiere allows digital video files to be exported in a film strip format which can be loaded in an image editing program like Adobe Photoshop for retouching.

SPLINE-BASED KEYFRAME ANIMATION

The technique of manually positioning different elements in consecutive frames is labour intensive and requires considerable skill to achieve smooth results. As described in the first chapter, most computer animation tools provide a way of animating using keyframes. These are points in time where transform (the position, rotation, scale) or any other parameter of an element is defined by the animator.

The great efficiency benefits over the manual animation approach are provided by inbetweening (also known as tweening). This is the mechanism that interpolates the values defined at the keyframes and smoothly varies them for the intermediate frames. In this way a simple straight-line movement can be created by defining keyframes at the start and end points.

Keyframes have to be added by the user using the appropriate menu selection or keyboard shortcut.

They can usually be adjusted either by interactively

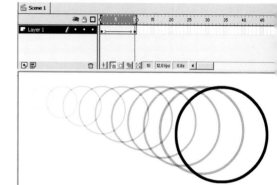

Fig. 2.14 Simple keyframe sequence in Flash. The position and size of the object has been defined at two separate keyframes and is being tweened. Onion skinning is used to display all the frames. The equal spacing of the object's positions creates a movement that occurs at constant speed then comes to an abrupt and unnatural stop.

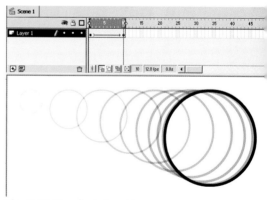

Fig. 2.15 The effect of applying ease out on a tweened animation in Flash. Note how the positions of the object are more bunched up towards the end of the movement on the right-hand side. This gives the effect of a natural slowing down.

positioning an element or by typing in values. In Director sprites can be dragged or nudged using the keyboard or can be typed in via the sprite inspector palette.

Two keyframes are adequate to define a straight-line movement. With three or more, complex curved motion is possible.

As described in the first chapter, the physics of the real world causes objects to accelerate and decelerate at different times. Objects dropped from rest, for example, start slowly and accelerate due to gravity. Cars start slowly, accelerate, decelerate and gradually come to a halt. These kind of dynamics can be approximated by using the ease-in and ease-out features provided by some software. Ease-in causes the object to start slowly and then accelerate. Ease-out does the opposite, gradually slowing down the motion.

Not only can the position, rotation and scale of each element be animated, but other settings that modify how the elements look. It may be possible to animate the opacity (visibility) of elements by setting different opacity values at keyframes.

Fig. 2.16 The sequence of frames created for an animated button in the Shell Film & Video Unit CD-ROM *PDO Reflections and Horizons*. The series of morph images are created in Flash using the shape tweening feature. Some elements that are not part of the shape tween simply fade up.

2D MORPHING

Morphing is the process that smoothly interpolates between two shapes or objects. There are a number of different types of morphing that can apply to images or 2D shapes or a combination of the two. With a 2D animation program like Macromedia Flash you can morph between two 2D shapes made up of spline curves. This process is termed shape tweening. In order to help define which parts of the first shape map to which parts of the second shape, shape hints can be manually defined.

USING READY-MADE ANIMATIONS

You will be able to import and use various kinds of ready-made animation file. Digital video files, Flash movies, animated GIFs and various other kinds of animation or interactive content can often be imported and reused.

OUTPUT OPTIONS

Most 2D animation tools provide an output option to a digital video format like AVI or Quicktime or a sequence of still images. For output to video or television this will be

appropriate, however, for playback from computer there are two reasons why this may not be your first choice. The first reason is to do with efficiency. The original 2D animation file is likely to be much more compact than a rendered digital video output. For playback of Flash animation on the Internet for example, this reduced file size is a significant selling point. The second reason is to do with interactivity. Pre-rendering the animation forces it to be linear. Leaving the generation of playback images to runtime allows for user interaction to influence and vary what happens in the animation. Examples of file formats that work in this way include the Flash .swf format and the Director projector (.exe).

3D MODELING AND ANIMATION

As in the real world, what you see of a 3D scene depends on the viewpoint that you are looking from. In a 3D modeling package you create a 3D world and then define a camera to view it with. A typical interface for a 3D modeling and animation package uses multiple viewports that display different views of the 3D world being created. These can include a combination of orthogonal (square-on, non-perspective) views like top, front, right which help you to assess the relative sizes and positions of the elements in your scene, and perspective views which help you to visualize them in 3D. The designer is able to refer to multiple views to fully understand the relationship of the objects and other elements in the virtual world.

Viewing the 3D scene

The objects in the 3D world can be built with a variety of techniques, which are described later, but in order to display the view that can be seen from the given viewpoint, all objects are converted to triangles. Each triangle is comprised of edges which each connect two vertices.

The positions of each vertex are defined in 3D co-ordinates. To view the scene, a viewing frustrum (a prism that defines the visible areas of the 3D world as seen from the viewing position) is first used to identify and discard those triangles that fall outside the visible area. This process, known as clipping, reduces the amount of processing done at the latter stages. Further processing is applied to achieve hidden surface removal, so that polygons completely occluded by

Fig. 2.17 The user interface of 3DS Max, a typical 3D modeling and animation package. Note how the different viewports give different information about the 3D object. Character produced by Dave Reading for the *Wayfarer* game at West Herts College.

Fig. 2.18 A 3D sphere. Most 3D objects are built from triangles which are comprised of three edges connecting three vertices. The location of each vertex in 3D space is given by an x, y, z co-ordinate.

Fig. 2.19 A 24-bit true colour image for use as a texture map and a 3D object with the texture map applied.

others (covered up) are not processed. The locations of each vertex are mapped onto a flat viewing plane to give the flat projected view that is shown on screen.

This is sufficient to see the shape of the geometry (3D objects) that you have created as a wireframe however, it is more useful to display the 3D objects as solids. This process of calculating what the solid view looks like is called rendering. The most common type is photorealistic rendering which seeks to mimic the real world as closely as possible. Other types of non-photorealistic rendering include cartoon style ('toon' rendering) and various other special effects.

Rendering the 3D scene

Rendering requires light sources to be created and surface properties to be defined for the geometry. The rendering process generates an image of the scene (usually a bitmap), taking into account the light falling on each visible polygon in the scene and the material defined for it. The way that this calculation is done varies according to the shader that you choose. These are algorithms developed by and named according to researchers in the computer graphics field like Phong and Blinn. Some shaders are more computationally expensive (slower to process) than others and some are more realistic. Photorealistic shaders provide approximations to the way things appear in the real world. Non-photorealistic shaders create different stylistic effects.

Part of the job of the designer and animator is to choose material properties for the objects in the 3D scene. Materials can be selected from a library of ready-made ones or created from scratch. Material properties usually include the colour values that are used in the lighting calculations. It is also common to define texture maps to vary material properties across the surface of the object. These textures can make use of bitmap images or procedural textures which use mathematical formulae to generate colour values. Procedural maps are useful for generating realistic natural looking surfaces.

Rendering time

Factors that influence the time taken to render a scene include the processor speed of the computer and the amount of RAM memory, the number of polygons in the scene, the number of light sources, the number and size of texture

maps, whether shadows are required and the size of the requested bitmap rendering. Complex scenes can take minutes or even hours to render. Final rendering of completed sequences is sometimes carried out by collections of networked computers known as 'rendering farms'. It is important as you create animations to perform frequent low resolution test renders to check different aspects of your work. You might render a few still images at full quality to check the look of the finished sequence and then do a low resolution rendering of the whole sequence perhaps with shadows and texturing switched off to check the movement. It is a common mistake by novice animators to waste lots of time waiting for unnecessary rendering to take place.

For applications that render 3D scenes in real time the number of polygons is the crucial factor. Computer games' platforms are rated in terms of the number of polygons that they can render per second. The combined memory taken up by all the texture maps is also significant – if they all fit within the fast texture memory of the available graphics hardware then rendering will be rapid, if they don't then slower memory will be used, slowing down the effective frame rate. As a result, games designers use small texture maps, sometimes reduced to 8 bit to save texture memory.

MODELING TECHNIQUES

Primitives and parametric objects

Most 3D modeling tools offer a comprehensive range of 3D primitive objects that can be selected from a menu and created with mouse clicks or keyboard entry. These range from simple boxes and spheres to special purpose objects like terrains and trees. The term parametric refers to the set of parameters that can be varied to adjust a primitive object during and after creation. For a sphere the parameters might include the radius and number of segments. This latter setting defines how many polygons are used to form the surface of the object, which only approximates a true sphere. This might be adjusted retrospectively to increase surface detail for objects close to the camera, or to reduce detail for objects far away.

Standard modeling techniques

The standard primitives available are useful up to a point, but for more complex work modeling can involve the creation

Fig. 2.20 The Geometry creation menu in 3DS Max. These primitive shapes are parametric which means that you can alter parameters such as the length, width and height of the box as shown.

Fig. 2.21 Different approaches to modeling 3D objects. A 3D logo is created by extruding a 2D type object.

Fig. 2.22 A 2D shape is lathed to create a complete 3D bottle. Mathematically this is known as a surface of revolution. A complex shape like a saxophone can be created by lofting – placing different cross-sectional *ribs* along a curved *spine* shape.

Fig. 2.23 Polygon modeling: a group of vertices on the surface of a sphere have been selected and are being pulled out from the rest of the object. This technique allows skilled modelers to create free form geometry with minimal numbers of polygons, which is important for performance in real time games.

of a 2D shape using spline curves or 2D primitives like rectangles and circles. The 2D shape is then converted to 3D in one of several ways.

The simplest approach is extrusion. A closed 2D polygon is swept along a line at right angles to its surface to create a block with a fixed cross-sectional shape.

Lathing is a technique that takes a 2D polygon and revolves it to sweep out a surface of revolution. This approach is useful for objects with axial symmetry like bottles and glasses.

Lofting is an extension of extrusion that takes an arbitrary 2D shape as a path (rather than the straight line at right angles to the surface) and places cross-sectional shapes along the path. The cross-sectional shapes which act as ribs along the spine created by the path can be different shapes and sizes. Lofting is useful for complex shapes like pipes and aircraft fuselages.

3D digitizing

Just as 2D images can be acquired by scanning 2D artwork, 3D mesh objects can be created by digitizing physical objects. 3D scanners come in various types, some based on physical contact with the object and some based on laser scanning. The resulting mesh objects can be animated using the skin and bones approach described below. Characters for games and animated motion pictures are often digitized from physical models. Ready digitized or modeled 3D geometry can also be purchased allowing you to concentrate on the animation.

Modifiers

Modifiers are adjustments that can be added to a 3D object. Modifiers include geometric distortions like twists and bends which change the shape of the object to which they are applied. The individual nature of each modifier is retained so their parameters can be adjusted or the modifier removed retrospectively.

Polygonal models and meshes

For more flexible sculpting of 3D objects it is sometimes useful to convert objects created with primitives and modifiers into polygonal meshes. Consider a 3D sculpture made out of chickenwire and imagine that it was made out of elastic wire that could be stretched. Polygonal mesh-based objects can be sculpted by selecting vertices or groups of vertices and manipulating them by moving, scaling and adding modifiers. The disadvantage of the mesh-based approach is that the designer doesn't have access to any of the original creation parameters of the shape. Polygonal mesh-based modeling is an artform that is particularly important for 3D game design where low polygon counts have to be used to achieve good performance.

NURBS

NURBS (Non-Uniform Rational B-Spline) curves can be used to create complex 3D surfaces that are stored as mathematical definitions rather than as polygons. They are the 3D equivalent of spline curves and are defined by a small number of control points. Not only do they make it possible to store objects with complex surfaces efficiently (with very small file size) but they also allow the renderer to draw the surface smoothly at any distance. The renderer tesselates (subdivides it into a polygonal mesh) the surface dynamically so that the number of polygons used to render it at any distance is sufficient for the curve to look good and run efficiently. NURBS are good for modeling complex 3D objects with blending curved surfaces such as car bodies. Think of NURBS' surfaces as a kind of 3D vector format that is resolution independent. Contrast this to the polygonal mesh which is more like a bitmap form of storage in that it is stored at a fixed resolution. If you zoom into a NURBS' surface it still looks smooth. If you zoom into a polygonal mesh you see that it is made up of flat polygons.

Metaballs

Metaballs are spheres that are considered to have a 'force' function which tails off with distance. A collection of metaballs is arranged in 3D and converted to a polygonal mesh by the calculation of the surface where the sum total effect of the 'force function' of each metaball gives a constant value. They are useful for modeling organic shapes. The effect is similar to modeling a physical object by sticking

Fig. 2.24 Dave Reading's Rachel character with a twist modifier attached. Modifiers can be used to adjust the shape of other objects, giving you great freedom to create unusual objects.

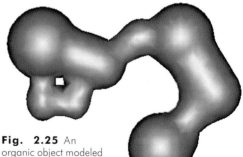

Fig. 2.25 An organic object modeled with metaballs. This modeling tool is akin to combining lumps of clay together.

lumps of clay together. Metaball modeling may be available as a plug-in for your 3D modeling package.

ANIMATING 3D WORLDS

The core set of animation techniques available to 2D animation packages is still available to 3D ones. As described earlier, the equivalent of the 'stop frame' approach is to manually position objects at each frame of an animation. Computer animation novices sometimes use this approach simply because they are unaware of the more efficient keyframe technique. This technique effectively creates a keyframe at every frame of the sequence.

Keyframe animation

Keyframe animation is the staple method for animating 3D objects. The transform (combination of position, scale and rotation) applied to each visible object in the scene (a combination of translation, rotation and scaling) can be animated by applying different values at different times. The software interpolates these values to smoothly vary them in the intermediate frames. This technique is useful for animating individual rigid bodies like our friend the flying logo but also for moving lights and cameras around the scene. Other properties of the 3D scene such as material properties like the opacity of a surface or modifier parameters like the amount of distortion applied may also be animated with keyframes. There is typically a visual keyframe editor to show how the value being animated varies with time and a keyboard entry approach for adjusting keyframes.

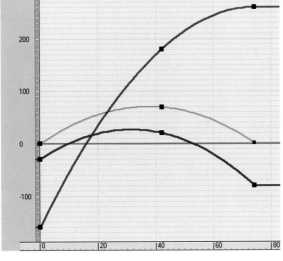

Fig. 2.26 The track view window in 3DS Max. The curves show how the x, y and z positions of an object are interpolated between the keyframes which are shown as black squares. Note that a smooth spline curve is used to interpolate each parameter in this case.

LINKED HIERARCHIES

For more complex work it is frequently necessary to link objects together. Consider the robot shown in fig. 1.30. A 'child object' such as a foot might be linked to a 'parent object' like the lower leg. The child object inherits the transformation from its parent, so if the robot was moved the legs and arms would stay connected and move with it. The foot has its own local transformation which means that it is able to rotate relative to the rest of the leg. Each object has a pivot point which acts at the centre for movement, rotation and scaling. In order for the foot to pivot correctly its pivot point must be moved into a suitable position (in this case the ankle).

Forward kinematics

Forward kinematics refers to the traditional way of posing a linked hierarchy such as a figure. The process frequently requires multiple adjustments: the upper arm is rotated relative to the torso, then the lower arm is rotated relative to the upper arm, then the hand is rotated relative to the lower arm. Forward kinematics is a 'top down' approach that is simple but tedious. The figure or mechanism is 'posed' at a series of keyframes – the tweening generates the animation.

Inverse kinematics

Inverse kinematics allows the animator to concentrate on the position of the object at the end of each linked chain. This end object is called the end effector of the chain. It might be at the tip of the toe or the fingers. IK software attempts to adjust the rotations of the intermediate joints in the chain to allow the animator to place the end effector interactively. The success of IK depends on the effort put in to defining legal rotation values for the intermediate joints. For example, an elbow or knee joint should not be allowed to bend backwards. Minimum and maximum rotations as well as legal and illegal rotation axes can be specified.

Skin and bones animation

A linked hierarchy can be used to build a character which is then animated with forward or inverse kinematics. Because the figure is composed of rigid objects linked together the

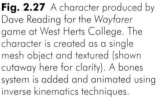

technique is more appropriate for robots and machinery rather than natural organisms and realistic characters. These can be created more realistically by bending and posing a single continuous character mesh.

A bones system is a set of non-rendering objects arranged in a hierarchy which reflects the limbs and joints found in a matching character. The bones system can be attached to a mesh object so when the bones are adjusted the mesh is distorted to reflect this. More sophisticated systems allow for realistic flexing of muscles as arms or legs are flexed. This is particularly useful for

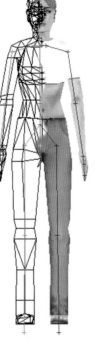

Fig. 2.27 A character produced by Dave Reading for the *Wayfarer* game at West Herts College. The character is created as a single mesh object and textured (shown cutaway here for clarity). A bones system is added and animated using inverse kinematics techniques.

Fig. 2.28 The animation of the bones is transferred to the skin object.

character animation where the character model may have been created by digitizing a solid 3D object. Bones systems can be used with motion capture data to provide very realistic character movement.

3D MORPHING

With a 3D modeling and animation tool you can arrange for one 3D object to morph into another (called the morph target). There may be a requirement that the original object and morph target have the same number of vertices. The process of morphing causes the vertices of the original shape to move to the positions of matching vertices on the morph target object. The output of this process is a series of in-between 3D objects which can then be viewed in sequence to give the effect of the smooth transition from one shape to the other. Morphing is often used to achieve mouth movement of 3D characters.

PROCEDURAL ANIMATION

Naturally occurring phenomena like smoke and rain are too complex to model manually. Mathematical formulae (also known as procedures) can be used to generate and control many small particles which together give the desired natural effect. Procedural techniques can be used for other complex situations, like the duplication of single characters to create crowds of people or herds of animals that appear to behave in realistic ways.

OUTPUT OPTIONS

The most common type of output format for 3D animation is either as a digital video file or a sequence of bitmap images. The image size can be adjusted depending on whether the sequence is intended for playback on video or television, on film, off computer or via the web.

3D models and animations can also be exported in formats designed for interactive 3D via an appropriate plug-in. These include formats for 3D game engines like Renderware, and formats for web-based interactive 3D like VRML and Macromedia's Shockwave 3D. There are also plug-ins to convert rendered 3D output into 2D Flash sequences using a cartoon style shader.

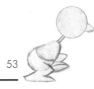

VIDEO EDITING AND COMPOSITING TOOLS

There are many occasions when you will need to post-process your animations. You may need to combine your animation with one or more video sequences for some creative multi-layering effect. You might simply need to join parts of a rendered sequence together into a single file. You might need to compress a rendered sequence so that is has a controlled data rate for smooth playback from CD. If you render your animation sequence as a digital video file then it can be treated as any other video sequence in an NLE (Non-linear editing) tool. You may need to retain an alpha channel in your sequence in order to composite your moving logo over a video background. In this case you might render your animation as a sequence of still images using a file format that supports alpha channels like TGA or PNG. The still image sequence can then be imported into the video editing package and the alpha channel used to composite the 3D animation with other video layers.

DELIVERING ANIMATION

Phew! Now that we have looked at some of the concepts and file formats involved we can start to identify which ones are appropriate for different applications. Linear animation sequences are the staple of video, film and television applications. Much computer delivered animation is linear. Interactive media like multimedia, web pages and computer games may also contain non-linear animation.

Output for video/television

For output to video or television a digital video file or sequence of rendered still images is played back on a video-enabled computer or NLE system and recorded on a video recorder. File formats supported by typical video editing hardware include AVI or Quicktime with the MJPEG codec, which uses lossy spatial compression to achieve any bandwidth reduction. Professional NLE equipment can cope with uncompressed sequences to maximize image quality, amateur equipment may offer a reduced bandwidth and require more compression with a matching reduction in image quality.

Animation sequences featuring rapid movement rendered at 25 f.p.s. (PAL) or 30 f.p.s. (NTSC) and output to video can

Fig. 2.29 A sequence of rendered images with alpha channels is composited over a video sequence in Adobe Premiere.

appear 'jerky'. This problem can be solved by a technique called field rendering, which takes advantage of the interlaced nature of TV displays. The animation is effectively rendered at 50 f.p.s. (PAL) or 60 f.p.s. (NTSC) and each set of two resulting images are spliced together or interlaced. The subsequent animation appears smoother. Another implication of the interlaced TV display is that you need to avoid thin horizontal lines (1 or 3 pixels high) in your images as these will flicker. For computer display this is not an issue.

Output for film

For film output the frames need to be rendered at a much higher resolution, typically 3000 × 2000 pixels, and output to film via a film recorder. As a result file sizes are much increased.

Playback from computer

Digital video files in AVI, Quicktime (.MOV) or MPG format can be viewed directly on a personal computer. Either you can rely on one of the standard player programs such as Windows Media Player or Apple's Quicktime player, or else build your animation sequence into a multimedia program.

For playback directly from hard disk the data rate of the sequence needs to be low enough for smooth playback. Typically photorealistic animation files might be rendered at 640 by 480 pixels at 15 f.p.s. Larger image sizes can be tried but you need to test the smoothness of playback. For playback from CD-ROM your digital video sequence would need to have a lower data rate of perhaps 250 kb. This would probably require a smaller image size, possibly 320 by 240 pixels. AVI or Quicktime could be used with either the Cinepak, Indeo or Sorenson codec to achieve the data rate reduction using a mixture of spatial and temporal compression. Your choice of data rate and image size will be influenced strongly by the specification of hardware that you want your animations to play back on.

You might also consider MPEG 1 which delivers 352 by 288 pixels and can give rather fuzzy full screen playback at the very low data rate of 150 kb/s. Some animation packages will render to MPEG directly, others may need to render to an intermediate AVI or Quicktime file and use a stand alone MPEG encoder like the one from Xing software. Professional users might use a hardware MPEG encoding suite to achieve maximum image quality.

Multimedia development tools like Macromedia Director can be used to play back animation sequences stored as digital video files like MPEG, AVI or Quicktime. Director can also be used to present a sequence of still images, or play back a compressed Flash movie.

Pre-rendered animation on the web

Web pages can incorporate pre-rendered animations using file formats including animated GIF, AVI, Quicktime, MPEG, DivX, ASF and Real. Due to the limited bandwidth available to most users of the Internet it is important to keep file size down to the absolute minimum for this purpose. Animated GIFs can be kept small by reducing the number of colours and limiting the number of frames. For the other formats, image sizes are often reduced down to a very small 176 by 144 and large amounts of compression are applied. The files can either be downloaded and played back off-line or streamed: the quality of the experience depends largely on the bandwidth provided by the user's Internet connection. This may be more satisfactory for users who access the Internet via a corporate network with a relatively high bandwidth. It is more common to use one of the vector animation formats like Flash or Shockwave that require the user's computer to rebuild the animation sequence from the 'kit of parts' that is downloaded.

Real time 3D rendering and computer games

Much 3D computer animation is rendered to image or video files and played back later. This non-real time approach is suitable for sequences that can be designed in advance. For virtual reality and 3D games applications, it is impractical to predict all the different images of a 3D environment that will be needed. Instead, the application must render the scene in real time while the user is interacting. This requires fast modern computer hardware plus real time 3D rendering software like Direct3D and OpenGL where available.

Computer games are usually developed using a programming language like C or C++ in conjunction with a real time 3D rendering API (Application programming interface) such as Direct3D, OpenGL or Renderware. A 3D environment is created in a 3D modeling program like Maya or 3D Max and exported in an appropriate format. The 3D environment is populated with characters and objects. As the user navigates around the 3D environment the rendering

engine renders the scene in real time. Animation comes in several forms. Pre-rendered full motion video (FMV) can be added to act as an introduction sequence. Characters or objects can be animated by producing sequences of morph targets. Alternatively, animated bones systems can be defined to distort the skin of a character model. With a fast PC or games console real time 3D engines can process tens of thousands of polygons per second, and although the visual quality of renderings cannot currently match that achieved by non-real time approaches, the gap is closing rapidly.

There are a number of systems offering real time 3D graphics on the web. These include VRML (virtual reality modeling language) which is a text file-based approach to 3D. VRML has been less successful than originally anticipated due to the lack of standard support within browsers. There are a number of proprietary solutions based on Java technology including the one by Cult3D. At the time of writing the approach which seems most likely to become commonplace is Macromedia's Shockwave3D format. This is a real time 3D rendering system that uses very small compressed files and importantly is supported by the widely installed base of Shockwave browser plug-ins. This technology can be used either simply to play back linear sequences but in a highly compact file format, or alternatively to provide fully interactive 3D applications. The widely used and supported Lingo programming language can be used to control object and camera movements and to detect user interaction with the 3D scene.

CONCLUSION

In this chapter we have looked at some of the jargon of computer graphics and computer animation. We have seen the ways in which animation can be created in 2D and 3D animation packages and looked at the differences between different delivery platforms. In the next chapter we get down to business and start creating a 3D scene.

chapter 3

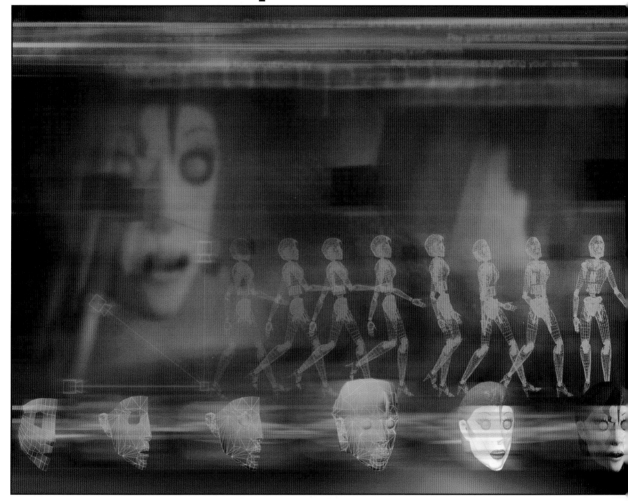

techniques and stages of creating 3D computer animation

by Marcia Kuperberg

Chapter 3
by Marcia Kuperberg
Techniques and stages of creating 3D computer animation

Fig. 3.1 First year students on a BA (Hons) Media Production course at West Herts College, Watford (near London) were given a brief to create a 3D room using three basic methods of polygonal model making. Using 3DS MAX release 3, they completed the exercise in about 30 hours, having had no prior experience of using 3D software. This is a bar scene created by Daniel Acharya and Jeetinder Mattu.

The use of strong colours, contrasting tones and volumetric lighting help create the atmosphere.
© West Herts College 2001.

INTRODUCTION

This chapter takes you stage by stage through practical 3D polygonal model making and camera animation. Included are tips on lighting your scene.

When you have finished reading this chapter and trying out the techniques demonstrated, you will have a basic understanding of:

• How to set about the task of creating a 3D room – working from a brief.

• How to think about everyday objects around you and translate them into 3D models using some basic methods of polygonal construction.

• How to make your models look realistic and interesting through the application of textures and materials.

• Types of lights commonly used in 3D computer animation, and how to use them effectively to light your scene.

• Using virtual cameras to create views from various angles and to move around your scene.

If you've read Chapter 1, you'll have a broad understanding of how – over the centuries – artists, photographers and inventors brought us to where we are today, sitting at our desks, contemplating creating animation with the aid of computer technology.

No matter how clever the technology is, the fact remains that you, the animator, are the creative force behind whatever your audience sees on screen. If you want that to be entertaining and worth viewing, you'll try to apply the animation principles that were outlined in the chapter.

Hopefully, you've also read part or all of Chapter 2 to help you bust through the techno speak – and now you're ready to have a go at tackling some 3D work.

BUT, before you grab your mouse and hunch forward in your swivel chair, here are some tips to help you tackle the job:

1. Follow the brief.

2. Schedule your work to deliver on time.

3. Do the necessary background research.

4. Check the proposed action and framing from your storyboard before creating the model.

5. Think about the quickest, most efficient way to make your models.

6. Pay great attention to materials.

7. Pay equal attention to lighting your scene.

8. Use your virtual camera effectively but unobtrusively.

Fig. 3.2 I created this traditional French-style living room using simple polygonal modeling techniques available in most 3D software. 3DS Max 3 was used here.

The process of making each item is explained in this chapter.

© Marcia Kuperberg 2001.

Let's look briefly at each of these points and then we'll examine a room model to see their application in practice.

FOLLOWING THE BRIEF

You are normally given a brief by a client. This should always be written not verbal, as you will constantly need to refer to it. If you are given a verbal brief, you should confirm the requirements in writing to avoid any misunderstandings. If any parts of the brief are unclear, then you should go back to the client (or tutor) for clarification. Any changes to the original brief should, again, be confirmed in writing.

If you are working for a client, and the client changes the brief, i.e. has a change of mind, part way through the job, the changes may well have an impact on your ability to deliver on time. It's as well to be 'up front' about this, as the client may have no idea of how much time can be involved in what may seem a minor change to the original requirement. It's not smart to agree to make the changes, only to discover that a) it will double the cost and b) it can no longer be delivered on time. Always ensure that the proposed production storyboard is approved by the client before beginning a job.

SCHEDULING YOUR WORK TO DELIVER ON TIME

This is always difficult, because if you're a beginner, you don't know how long things will take. Before long, you'll have an idea however, and you'll need to scale your ambitions in line with your likely productivity if you are to meet a given deadline. Make sure you plan in sufficient time for research, time for meetings if you're working in a team, rethinking/ doing after critical feedback, time for experimentation, time for rendering, and contingency time if anything goes wrong.

DOING YOUR RESEARCH

Suppose you were following the same 'construct a room' brief as given to the BA Media students here, you would firstly need to decide what type of room you planned to create. Students chose a wide variety of rooms including those shown here (figs 3.1, 3.3 and 3.4).

Let's say you have decided upon a living room. You need to ask further questions in order to progress with the necessary picture research.

Some of these questions might be:

Fig. 3.3 Hannibal Lecter style prison cell seen from above, by Stuart Birchall and Alex Dunn of West Herts College. Cross pattern of bars and shadows makes this simple model interesting.

© West Herts College 2001.

• What type and period is the house containing this room?

• Who will be living in the house? This is when you think about the type of people who would be likely to choose a particular style of decor for their living room – their age and rough income bracket, the type of work they would do, their family situation etc. This would have considerable bearing on the look of the room you aim to create and the objects likely to be in it.

Having made that decision, you should jot down ideas for the design, possible colour scheme, items in the room and then gather as much reference material as you can. This is likely to cover a number of areas:

• colour ideas for different colour schemes;

• textures and patterns and images for items within the room: think of curtains, carpets, cushions, rugs, floors, furniture, light fitments and similar fixtures, patterns on ornaments and crockery, photographs/paintings on the walls;

• room settings of the type of room you plan to create;

• pictures of individual items you plan to include in your room.

Remember, it is unlikely that you will attempt to duplicate any of these things accurately; they act as a springboard for your own ideas and also provide valuable modeling reference as to the shape and makeup of general items. You will need to adjust your ideas to your modeling capabilities. At an introductory level of expertise, you are restricting yourself to modeling that can be accomplished using some of the most basic techniques – even though you want the finished effect to look totally professional.

• Lighting and shadow effects. Here you should consider the time of day of your sequence, whether there are lights to be shown as switched on (aside from lights you will use to light the objects and the scene), and the atmosphere you want to create.

CHECKING THE PROPOSED ACTION FROM YOUR STORYBOARD BEFORE CREATING THE MODEL

The original purpose of the brief in this instance was to familiarize students in basic techniques of 3D polygonal modeling so there was little animation involved.

If you were to go to the trouble of creating the entire room

Fig. 3.4 This boardroom by Cerys Hill and Joanna Goodman gains its attraction by the use of a subtle colour scheme and the pattern made by the wall lights.
© West Herts College 2001.

Fig. 3.5 The profile of the bottle and the wine glass should be created in the front or side viewport and lathed (another term is 'swept') 360 degrees around the Y-axis, aligning at the minimum (leftmost) point.

Fig. 3.6 After lathing and rendering.

model and only then think about the action that is meant to take place within it, some of your modeling efforts could be wasted. There may be an item within your environment that is only ever seen in the distance and you should be aware of that fact before you create it in order to minimize the modeling effort spent. You don't want to spend ages working on model details that will never be seen. This is a general principle that you should apply to all your models, regardless of what it is you're creating, or how experienced you are.

THINKING ABOUT THE MOST EFFICIENT WAY TO MAKE YOUR MODELS

It is surprising how effective your models can appear, by using the simplest of modeling techniques – providing you make good use of materials, textures and lighting. At this introductory level, you are going to create your room model using the following basic techniques:

• **Utilizing ready-made 'primitives'.** Primitives are ready-made, standard 3D geometric objects, e.g. spheres, boxes, cylinders, pyramids etc. (fig. 3.7), and then modifying them to suit your purpose, e.g. squashing, tapering, curving or bending, or pulling out vertices or faces – before finally grouping them to form your object, e.g. a sofa (figs 3.8 and 3.9).

• **Creating a 2D shape and extruding it along a straight path** to give it depth.

• **Lathing (or 'sweeping') a profile of a 2D shape around a circular path** to create a symmetrical 3D object, e.g. a wine glass, a bottle, a cup or a saucer (figs 3.5 and 3.6).

By now you will have your pictorial and other reference in and it is time to begin to think about creating your models. You may not consider yourself to be an artist, but you should still sketch out your basic ideas for your room and indicate in note form any particular pictorial or other references.

Polygons, patches, NURBS, metaballs, polygons

If you've read Chapter 2, you'll know that there are a number of different sorts of modeling available to you – you can choose any one method, or a combination of them all depending upon your software, the requirements of your scene and your own capabilities.

Images on this double page spread © Marcia Kuperberg 2001.

If you're just setting out in the world of 3D modeling, working with polygons is the best place to start. You'll probably find it easier and you can create surprisingly sophisticated looking scenes – particularly if the scenes are composed of non-organic objects like furniture. You'll mainly use boxes and other primitives, which you tweak, manipulate and modify. The great thing about working with polygons and many of today's object oriented parametric software packages is that if you change your mind part way through, you don't have to start again from scratch. This type of software stores commands in the construction process. This means that usually you can go back to an earlier command and change it, without having to rebuild other aspects of your model.

CONSTRUCTING THE BASIC ROOM

• **Only build what you need to.** Just as in a film set, you only need build the parts that will be seen by the camera – in this case, two walls, the floor and the ceiling if the camera tilts up.

Fig. 3.7 Primitive geometric objects: your building blocks for some types of modeling.

Fig. 3.8 The sofa has been created from manipulated boxes.

• **Examine everyday objects around you.** In your mind's eye, try to simplify their basic construction into primitives that can be modified as required, then grouped to form objects.

• **Use the correct scale.** It's a good idea to create your room and the objects within it in the correct scale right from the start. This does not mean that you should be an architect, a builder or have a product engineering qualification! It

Fig. 3.9

just means that you should firstly consider the likely general dimensions of the walls, windows and floors. A good idea is to measure items around you if unsure. You should then create the furniture and other items in scale to those larger parts of the scene as well as to each other. It doesn't matter whether you're working to a metric or imperial scale, as long as you roughly match the scale from graph paper where you choose to draw your sketches to the computer where you do your modeling.

Before starting your project, set up your software 'Preferences' to the scale of your choice (fig. 3.10) and have a supply of matching graph paper to hand. Again, I don't suggest that you sketch every little detail of each and every item on paper before creating it – just the general size, scale and shape of the various objects.

Fig. 3.10 3DS Max Preferences, in this case set to cm but you can decide on any unit of measurement.

This may first seem to be a waste of time. After all, you can start creating straight away – directly into the computer – item by item, at different times on different computers if on a network, and then merge each of these items into the final scene, scaling each item up or down to fit in with the size of other items within the scene.

However, if you adopt this approach, you may strike difficulties further down the line. Suppose you are creating a coffee cup and saucer that will be on a coffee table. If you are sharing the modeling tasks of your scene with others, it would be easy to spend quite some time creating a beautifully decorated fluted edge to your cup. You would see all your careful detail in its full glory. However, when the entire animation is finished, and you realize that your beautiful coffee cup is only seen in a shadowed long shot, you might well feel that all your effort was wasted.

Fig. 3.11 The family images in the centre of the frame in this and fig. 3.12 are scanned photos manipulated in Photoshop to add the textured 'canvas' look and the cutout oval in fig. 3.12.

The other benefit of working to the correct scale from the beginning is that others can work on individual items (having first checked the storyboard) and these can then be merged as they are, into the final scene with no further scaling. If modeling tasks are being shared, nominate someone to keep the master room file, so when individual items are created, only one person sends the update to all. Everyone should have copies of concept drawings and model sheets done to the scale used in the computers as well as storyboards.

The floor and the left wall. These are primitives: boxes, snapped into place at right angles to each other.

The wall with the windows. The back wall began life as three rectangles (shapes) – first the large one (the wall), and then the two inner ones (one for each window). All – as one complete set of shapes – were then extruded to the thickness of an outer wall. In order to be able to extrude all the rectangles together, as a single shape (so that the inner rectangles became holes for the windows), it was necessary to 'tell' the software not to 'start a new shape' when creating each of the secondary rectangles. An alternative is to edit the spline and attach all shapes to make one overall shape before extruding.

The left windowpanes were made by creating four intersecting long thin rectangles inside the window hole – two vertically and two horizontally (snapping to the grid). These were then cloned to make the right windowpanes. Then all were extruded – this time to a much lesser depth – and moved nearer the front of the window holes.

The pictures on the walls. The pictures inside the frames are 2D planes (figs 3.11 and 3.12). These are, in effect, renderable shapes as thin as paper. The pictures are scanned images of family photos that were manipulated in Photoshop to add – in one case – a canvas-like texture and in the other a slightly textured background behind a cutout oval. These images were then mapped as materials (planar projections) onto the planes.

The picture frames were created as 2D shape profiles (fig. 3.14) that were lathed around 360 degrees. Usually, when lathing a 2D profile, say, for creating an object such as the lamp base or a bottle, it will be lathed around the minimum axis so that there is no hole in the middle of the final object. Also, in order for the end object to appear rounded, it will have a minimum of ten segments when rotated around the axis.

In the case of the picture frames, there are only four segments – one for each side – and the axis of rotation (a 'sub-object' of the lathe modification) has been moved in the X direction to give a hole in the frame's centre (fig. 3.13).

The skirting board. This is a thin side section which has been extruded to the width of one wall, then copied and placed into position for the other walls. It was also used for each of the windowsills – manipulating the original shape

Images © Marcia Kuperberg 2001.

Fig. 3.12

Fig. 3.13 Max screen grab showing access to the Sub-Object, Axis and only four segments for rotation. **Fig. 3.14** Picture frame profile (stage prior to 'lathing').

Fig. 3.15 Top: curves created in the top viewport and then extruded to make the curtains.

Fig. 3.16 In 3DS Max, soft selection of vertices allows you to pull out vertices in a graduated way.

slightly, again copied but made shorter to fit across the bottom of the windowpanes (a builder might not approve!). Firstly the side section was made as a linear (straight lined) shape, snapped to the grid on one side, the side to be placed directly against the wall. Then the sub-object (vertices) was turned on and a vertex was selected, made into a bezier curve and manipulated via its handles into the curve required.

The curtains. There are a number of ways you can make these. A simple way is to make the curved edges in the top viewport and extrude them to the length desired (fig. 3.15).

The sofa is just a group of eleven primitive boxes manipulated in various ways, including mesh 'smoothing' (fig. 3.17). It is advisable to map textures (this topic is covered later in this chapter) at this early stage rather than after further modification to avoid texture distortion.

Your software may give you a variety of mesh smoothing techniques. Experiment to choose the method that gives you

Fig. 3.17

Fig. 3.18 **Fig. 3.19**

Smoothing the mesh increases the number of polygons and gives rounded corners to the sofa cushions shown here in figs 3.18 and 3.19. In fig. 3.18 the colour of the vertices gives an indication of the degree of fall off when pulled out as per settings in fig. 3.16 using 3DS Max release 3.

the end shape you prefer whilst trying to keep your polygon count as low as possible. The more you smooth, the 'tighter' but smoother the rounded parts will appear and the greater number of polygons you make (fig. 3.18), but – although you want to make the perfect object, bear in mind:

• the distance of your smoothed object from camera (will anyone actually notice those beautifully smoothed edges?)

• if you have too many unnecessary additional polygons in your model, your scene will take much longer to render – maybe not so noticeable when you just do a trial single image, but very noticeable when you need to render thousands of images for an extended animation. Keeping a low polygon count is even more crucial if creating models for use in computer games. For more on this, read Chapter 5.

The sofa's squashy back and side cushions. First create the box primitives – allow yourself a few more segments as you'll need to pull out a few vertices. Make one box and make copies for the other cushions from this. **Instances or copies?** Your software will probably allow you to choose whether to make 'instances' from your original or independent copies. Making an 'instance' means that when you change the original, all the instances automatically change too. This can be useful and a great timesaver – say you're creating a group of same-design chairs (as indeed you may well do if you decide to create a room like this). You might decide to change the basic shape of one chair leg and hey presto – all the other (instanced) legs change, too. Your sofa's back and side cushions, however, require slight variations to each, so in this case, you make copies from your original cushion, not instances. Smooth your mesh (fig. 3.17) to give rounded edges to otherwise box-like objects.

Soft selection. Select the vertex or vertices you want to pull out to further soften the basic rounded box shape. If your software has a 'soft selection' facility, this will be of great help. Soft selection allows you to select one or more vertices and the vertices in the surrounding area that you designate as your 'fall off' will also be pulled out – gradually falling away to the surrounding surface (fig. 3.18). In Max, you can set parameters to change the shape of the pulled out 'bubble' as well as the steepness of the surrounding fall off (fig. 3.16).

The footstool next to the sofa. This is a box with its

Fig. 3.20
The glass topped coffee table
The tabletop is a primitive box with its mesh smoothed to round off the corners and edges, giving it a slightly bevelled effect. It has a glass material applied. The table legs are copies of the chair legs with the same rosewood material. One chair leg was copied and instances made of the others. The legs were positioned in the top and front viewports in wire frame.

The magazine on top of the table is a thin box primitive with a scanned image of a magazine cover. You can't see it too clearly here but the 3D scene constructed in this chapter is based on the scene depicted on the cover. You can see this more clearly in fig. 3.47.

The bottle and glass on the table are made from lathed shapes (figs 3.5 and 3.6).

Fig. 3.21 Footstool
Images © Marcia Kuperberg 2001.

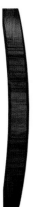

mesh smoothed to round off the edges. The corner shape will change according to its number of segments (fig. 3.21).

The antique chairs

The chair backrest. Firstly, create an ellipse shape and turn off any 'start new shape' option so that when you create a second ellipse inside the first one (fig. 3.22), they can be extruded as a single shape. Your software will probably allow you to do this by an 'outline' function or you can simply create a smaller oval inside the first one. Extrude

Fig. 3.22 Oval shapes are extruded to make the backrest frame.

Fig. 3.23 Side view of oval backrest bent 30 degrees on the X-axis.

Fig. 3.24 Antique chair.

Fig. 3.26 Soft selection on back.

Fig. 3.25 Top view of the chair backrest showing the vertices pulled out using soft selection.

the combined shapes having edited the spline to attach them. Bend the oval frame as shown in fig. 3.23.

The backrest cushion. Create another ellipse shape from the centre of your chair back frame, sized a little larger than the inner ellipse. Extrude the shape. Soft selection of vertices has been used in the same way as on the cushion of the sofa (figs 3.25 and 3.26).

The chair seat cushion. As with the seat cushions of the

sofa, this is a box primitive with the mesh smoothed to curve the edges. Using the top viewport, taper the cushion to make the back shorter than the front and after making the base underneath, check that the bottom of the cushion is firmly placed on the base.

The base under the seat cushion is a copy of the cushion (not an instance, as its size will be changed and the thickness lessened and scaled to be ever so slightly larger than the cushion). It will also end up with a wooden material to match the back frame, armrests and chair legs.

The armrests. Start off with a side profile shape using straight lines snapped to the grid using the rest of the chair as a guide for size. Turn off the snap-to-grid function and change some of the vertices into bezier ones with handles that you can manipulate to create the curves in your shape (fig. 3.27). Extrude the shape to the desired thickness. Using the top and front viewports, rotate the armrest so that one side touches the oval backrest and the other is at the front corner of the seat. Mirror and copy this (as an 'instance') to make the other armrest.

Fig. 3.27 Chair armrest profile created in side view.

The little padded parts on top of the armrests began as boxes originally with three segments, later smoothed (creating the box with extra segments allows the box to be bent later), then bent 200 degrees on the X-axis in the front viewport, tapered and then rotated and placed into position on top of the armrests (figs 3.24 and 3.28).

The chair legs. Here the profile was created and then *lathed* (another term is 'swept') around 360 degrees, aligning the shape on the minimum point – the centre of the 360-degree circle (fig. 3.29). Having made one chair leg, make instances of the other three and position them at each corner of the chair, ensuring their alignment with the bottom edges of the armrests.

Once you've completed one chair, and laid your chosen materials on it, you can group all the components of the chair and make instances of it for the other chairs. The chair here has a rosewood material for the wooden parts and the same bumpy beige fabric used for the sofa was used for the other parts (fig. 3.24). In the full room scene (fig. 3.2) the chairs have a lighter beechwood material.

Fig. 3.28 Stages of making the armrest pads: 1) a box, 2) the box smoothed to round off the corners, 3) the box bent and 4) the box tapered.

Fig. 3.29 Chair leg profile.

Images © Marcia Kuperberg 2001.

Fig. 3.30 The lamp profile.

The fireplace. Like much of the room, this consists of a number of boxes or extruded shapes. The carved, curly pieces beneath the mantelpiece were begun as a single curved shape created in the side viewport, which was then extruded and copied (as an instance) to the other side. The stepped panelling on the sides was done similarly – original shape created in the top viewport, extruded to the floor – then mirrored and copied (as an instance) to the other side.

The vase and the flowers. The vase is a primitive tube, tapered, curved and given a transparent glass material. The flowers are instances of an extruded shape, rotated and placed onto the bent stalks (long boxes with sufficient segments to allow them to be bent).

The lampshade is a tapered tube.

Fig. 3.31 Complete lamp on beechwood coffee table.

As the lamp profile will be lathed around 360 degrees, it is important that the left-hand line is straight (it will be the centre) and that the base is also straight. Weld the vertices created by lathing to get rid of any unnecessary ones in the centre of your object. When you begin to create your shape, use the 'snap-to-grid' function to get the basic shape quickly. Then go to the 'sub-object' level to access the vertices, 'refine' if you want to add some more, and make some of them into bezier curves to manipulate the shape.

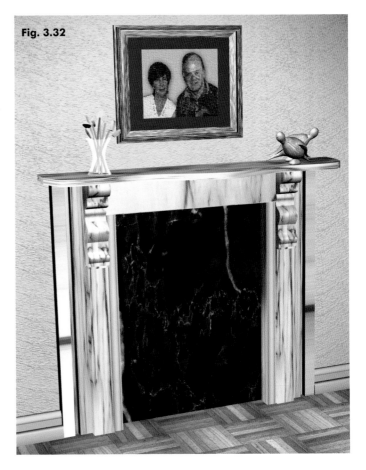

Fig. 3.32

The ornamental doves. The dove is made up from a number of objects: the pedestal base, the body and head, wings, eyes and beak.

The pedestal base is just a primitive box with few segments, smoothed and tapered, the **eyes** are two primitive hemispheres and the **beak** a cone.

The dove head and body is a lathed shape that was then further modified by using a lattice, a very useful modeling device. It can be applied to the whole object or just a part of it by first selecting a group of vertices, then selecting the lattice option (which then automatically surrounds the selected vertices: fig. 3.35). You then go to the lattice's sub-object level to select control points which you can move, scale or rotate to affect the shape of the enclosed object. Using the lattice's control points, the head was made smaller and rotated to tilt upwards.

The wing was originally created in the top view as a primitive plane with six length and eight width segments. An edit mesh modifier was applied in order to get to the sub-object vertex level where the vertices were scaled and moved to create a basic boat-like shape. To make the wing curve around the bird body, the plane was bent in the front viewport by first moving the (sub-object) centre along the X-axis (inset fig. 3.36) and then bending 45 degrees on X using Max's sub-object 'gizmo'. It was bent again, this time in the right view, 45 degrees on the Y-axis, with a minus 45 degree direction. Then various lattice modifiers were applied to give the final wing shape. The wing was then rotated into its position on the bird body and then mirror copied as an instance to form the second wing (fig. 3.36).

Fig. 3.33 Rendered bird.

Fig. 3.34 Profile of bird (side view).

Fig. 3.35 Use of lattice to angle and reshape a selected area.

Fig. 3.36 Curving the wings around the bird's body. After one wing is curved and placed on top and further manipulated as required, a second wing is made as a mirrored instance and placed into position.

Images © Marcia Kuperberg 2001.

The chandelier and the metallic chain

Fig. 3.37 The 'torus knot' is an extended primitive in Max that can be manipulated as shown to form links. For non-Max users, make a torus and in vertex mode, select the vertices of the bottom half of the torus and drag downwards. The links were rotated and moved into position and instanced to form the chain. A yellow ochre material was applied with shine added.

Fig. 3.38 Circular array, part 4 of the chandelier after bending.

Fig. 3.39

1 small cylinder
2 small sphere with eight segments
3 lathed shape
4 circular array of cylinders curving inwards (fig. 3.38)
5 brass ring
6 circular array of cylinders in a bulb shape
7 ring
8 lathed shape
9 faceted sphere

A lightbulb to be placed inside is just a smoothed sphere (also see fig. 3.68).

The chandelier is made up of a number of parts as shown in fig. 3.39. The beaded 'cut glass' effect is achieved by creating faceted rather than smoothed cylinders and spheres, with the cylinders manipulated as shown in fig. 3.40. Parts 4 and 6 of the chandelier have been made with 'circular arrays'.

Fig. 3.40 Cylinder, manipulated at sub-object vertex level.

To create the top circular array (no. 4, Fig. 3.39), first create a single faceted cylinder (or an ordinary cylinder on which you remove the smoothing groups). The circular array will require a common centre for all the cylinders arrayed around it. This can be a moved pivot point of the object itself, the world centre or the centre of the grid (in Max you can select 'Use transform centre' so that the centre of the **grid** becomes the array centre). Position the cylinder a distance from it (this will be the radius of the array).

The count value is the number of objects in the array. Entering 360 in the 'totals rotate Z field' gives a complete circle, fewer degrees will give a partial circle. Instances rather than copies of the cylinder were designated to make the array so when one cylinder was bent (80 degrees on the Z-axis – fig. 3.38), the other cylinders also bent. A lattice was then applied to the entire array to taper and reshape it.

For the second array (the 'bulb' shape), a single cylinder was bent 145 degrees on Z with a direction of 15 degrees to give it a twist, then the group was squashed.

PAYING ATTENTION TO MATERIALS

Many of today's 3D programs offer an amazing number of ways to create interesting materials. These materials are usually built up through a number of layers, masks and levels and creating them can become quite complex. If you are a beginner, it might be advisable in the early stages to content yourself with being able to change the shininess, colour and opacity of materials, add textures, create bump maps, and be able to use alpha and/or opacity maps to make parts of your textures transparent to allow other parts of the material to show through.

A bump map used in conjunction with either a plain colour material or a texture gives the material the effect of a raised or indented surface. A simple way to achieve the bumpy effect in Max is to copy the colour textured image into the bump map slot. The darkest parts of the texture will appear recessed and the lightest parts will appear to be raised (lampshade in fig. 3.45).

The table lamp: using alpha channels to create 'cutout' images on objects. The lamp base has a cutout image of flowers placed like a transfer onto its shiny green surface. The surface is a mid-green diffuse colour with the shininess and glossiness values increased to give it the effect of glazed ceramic. The flower pattern (fig. 3.43) is a map that has an alpha channel within the image (fig. 3.44) so that the blue background of the original

Fig. 3.41 Above: cream colour used for lampshade (fig. 3.45).

Fig. 3.42 Map for bumpy effect.

Fig. 3.45

Lamp. © Marcia Kuperberg 2001.

Fig. 3.43 Original flower map.

Fig. 3.44 Alpha channel of flower map.

Fig. 3.46 Alpha setting turned on in 3DS Max Materials Editor.

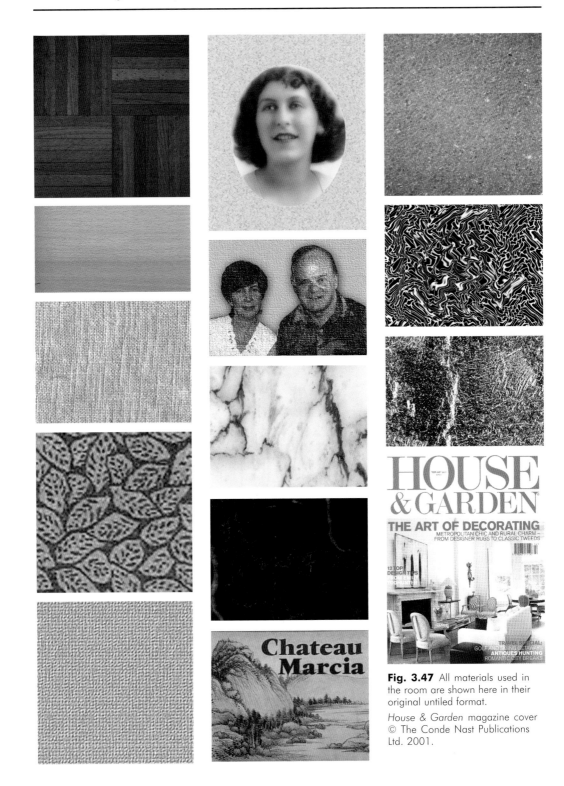

Fig. 3.47 All materials used in the room are shown here in their original untiled format.

House & Garden magazine cover © The Conde Nast Publications Ltd. 2001.

image has been made completely transparent, allowing the underlying material of the lamp base, a shiny dark green, to appear under the cutout flowers. Notice that the flowers have been tiled (fig. 3.45).

How do you get an 'alpha channel'? Once you have chosen your image, you must create an alpha channel for that image in an image editing program such as Photoshop (save a selection as a new channel and ensure that you save the image as a 32-bit image in a format that your 3D program can read). Only a few image formats will allow you to carry this extra channel, e.g. tif and tga. When making your alpha channel, all you need remember is that the part of the image that you don't want to see – i.e. the part that will become transparent to allow an underlying object or material to show through – must be made solid black. The part of the image that you do want to see – i.e. in this case, the flowers – must be made white; your alpha image will consist of just solid blacks and whites (fig. 3.44), unless you want some of the image to be partly transparent – in which case you will use varying levels of grey, depending upon how visible you want these parts to be.

When you turn on 'Alpha' in your 3D program materials editor, it will read the white part of the alpha as opaque and won't therefore interfere with the flower part of the image at all, i.e. the flowers will be seen on top of the green base material.

• **Techniques to minimize modeling.** It is useful to take the time to experiment and practise how to use alpha and opaque masking in your 3D software, as it can be very useful not just in creating an effect like the one shown on the lamp base, but also in other ways, for example, **the carpet fringe** (fig. 3.2). For this, a mask was created (fig. 3.51) to be used together with the carpet texture (fig. 3.50). **The label on the bottle** (fig. 3.6) was an image scaled down (with a UVW modifier at sub-object level) which overlaid the diffuse dark red colour of the wine bottle. The dark red was given a high shininess value and a sharp specular reflection to create a glass look. To create the effect of the label and rug fringe through modeling would be time consuming and unnecessary.

Besides choosing an appropriate material that enhances your model, the trick to making your material look good is to:

Fig. 3.48 This shows a hierarchy of levels used to create the material for the bird wings. A double sided material was used as the 2D plane would otherwise have been visible from only one side.

Fig. 3.49 Tiling and positioning of alpha flowers on the lamp base. Max's shrink wrap UVW mapping co-ordinates were used.

Fig. 3.50 The carpet texture.

Fig. 3.51 The carpet fringe (fig. 3.24) was created using the opacity map shown here to mask out parts of the carpet.

Fig. 3.52 Materials Editor of 3DS Max showing the use of a bump map to make the wallpaper effect.

Fig. 3.53 This greyscale image was placed in the bump map slot in the materials editor above. It is shown in its original untiled format. The effect of tiling can be seen in the wallpaper in fig. 3.54.

Fig. 3.54 The wallpaper texture after tiling.

• **Place (project) the bitmap onto the model in the best way** to avoid streaking or other unwanted artefacts. If your model part is a primitive sphere or a cylinder, your software will probably automatically apply the correct mapping co-ordinates – spherical or cylindrical. Planar mapping is usually the default and would be the most appropriate to use on flat objects such as the floor and ceiling. The lamp base is basically spherical but you will need to experiment with mapping co-ordinates to see which look best (fig. 3.45).

Very often, even though you are using the same material (say, a bumpy fabric) you need to apply the mapping co-ordinates manually and separately to each of the different parts of your model. This is almost certain to be the case if the material needs to be tiled and parts of the model vary considerably from each other in shape or size. Otherwise, the texture or pattern will appear the correct size and position on some parts but may be streaked, distorted or wrongly sized on other parts. Generally, it's best to apply your mapping co-ordinates before deforming your model.

As you know from Chapter 2, 'co-ordinates' (local or world) describe the placement of geometric objects in 3D space in the directions (axis) x, y, z. The corresponding terminology to describe placement of bitmaps onto models (and to differentiate these from co-ordinates used for geometry) is UVW. In the case of the sofa, UVW box mapping was applied to each part of the model separately before grouping the parts, with differing tiling on some of the pieces so that it looked as if the same fabric was used overall (fig. 3.9).

• **Tile the material** so that the pattern appears in the size and shape you want it – neither too big nor too small – (you can vary the tiling amount in both vertical and horizontal directions). The amount of tiling required (if any) will vary according to the size of the material map being applied and the size of each part of the model where the map is being applied. You'll find the tiling parameters in the materials section of your software, and possibly also within the modeling modification section – the place where you indicate whether you will be applying UVW mapping co-ordinates to your model. Experiment and render a small image to check the effect of different amounts of tiling. Sometimes you may need to scale the bitmap, change its angle or its position on the model.

• **Experiment with different types of surface properties.** Today's 3D software is becoming more and more sophisticated. Even basic software will offer you a choice of rendering methods to render your materials, e.g. Blinn, Phong, Metal. Each will give a different effect to each of your materials. Max added Oren-Nayer-Blinn to its list of rendering types within the Materials Editor in release 3. Invented originally for a matt terracotta look, this gives a soft highlight sheen. It tends to make a material slightly deeper in colour when rendered but shows off fabric textures rather better than other types of rendering (figs 3.55 and 3.56). You may have to invest in third party rendering plug-ins such as Renderman, sometimes an expensive option.

PAYING ATTENTION TO LIGHTING YOUR SCENE

You'll find it no surprise that lighting in computer animation is considered a real art, and is often a specialist field, much like modeling, texturing or character animation. In this respect, your 3D model is no different to a filmset where the lighting cameraman (the cinematographer) makes a huge contribution to the overall 'look' and atmosphere of the film – similarly the lighting designer in a theatrical production.

After all, what's the good of selecting the perfect colour scheme for your room – pattern, texture, colour and contrast – if your lights bleach it all out or the shadowed areas are so dark, you can't even discern that there is a pattern? When lighting your 3D scene, you are literally, painting with light. Described here are some of the different types of lights available in your software. Later in this chapter there are tips on lighting setups for your scene.

Types of lights

There are a number of different types of lights available to you depending on your software, and how much you can tweak them to give you very specific effects will vary with each program. Most programs will allow you the facility to exclude the chosen light's effect from selected items in your scene, an extremely useful function. You can usually also click on a given object's properties to exclude it from receiving shadows if you are using a shadow casting light. Too many shadows confuse the scene and increase rendering time. The most common types of computer lighting available are:

• **Ambient lighting.** This is the basic level of lighting

Fig. 3.55 Rendering with Max's Oren-Nayer-Blinn shader.

Fig. 3.56 The same scene with the same lighting but rendered with Phong shader. Notice the difference in the fabric highlights.

Images on this page © Marcia Kuperberg 2001.

Fig. 3.57 Single omni light placed at a distance, lights the wall evenly.

Fig. 3.58 The omni light placed at an angle to the wall gives gradated lighting.

Images on this double page spread © Marcia Kuperberg 2001.

available before you begin to add the types of lights listed below into your scene. In other words, it is the available light before you begin to 'paint your scene with light' from artificial light sources. It's best generally to leave this at the default setting, probably black – as changing it can give you problems in adjusting other lighting later. If you wish to add atmosphere, say by making deep purple shadows for a stark moonlit night scene, adjust the shadow colour separately.

• **Omni lights** – sometimes called 'point' or 'area' lights. These throw light in all directions like the sun. Unlike the sun and also unlike spotlights, omnis will usually shine right through walls and other objects. In some packages, omnis can also throw shadows, in which case their light is blocked by objects in their path. Check your own package to see what is available to you using omnis, e.g. the shadow casting properties, attenuation and decay.

• **Spotlights** – targeted. You'll be able to place the light itself within your scene and drag your mouse to place its target, i.e. where you wish it to point towards (the target is an indication of direction only – it doesn't affect the light if you place it near your target, in it, or beyond it).

You have the option of whether or not to show a targeted spot's directional cone with, perhaps, the option of a round or rectangular cast light. The latter is useful, if say, you want to light up a rectangular object such as a painting on a wall. Another useful option is one that lets you make one of your viewports into a spotlight view, i.e. as 'seen by the spotlight' (similar in principle to your camera viewport).

Spots have a 'hotspot': the centre and brightest part of the light that shows on the objects that are lit, and a 'fall off' – the area between the end of the hotspot where the light gradually reduces its brightness until it fades to nothing. The type of spot that lights up a performer on stage is normally a bright round circle with very little fall off (fig. 3.60). If you want a much softer effect, you will adjust your spot so that there is considerable difference in diameter between the hotspot and the fall off (fig. 3.61).

Spots can cast shadows and need to be placed at an acute angle in order to cast a longer shadow. A spot placed directly above an object will, like the sun, give a very small shadow around the base of the object.

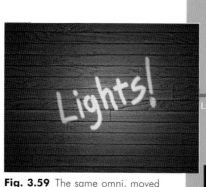

Fig. 3.59 The same omni, moved close to the wall, does not light evenly.

Fig. 3.60 Spotlight with bright hotspot and little fall off. No light falls outside the larger fall off ring.

Fig. 3.61 Spotlight with small hotspot and large fall off gives a much softer effect. No light falls outside the larger fall off ring which is slightly larger than the wall shown.

• **A free spot** is similar to a targeted spot, but you angle the light itself to point toward an object, rather than placing its target near the object. This means it is harder to make it to point where you want, but a light like this has its uses, because you only have the light, itself, to adjust, rather than both light and target. This is useful in cases where the light is linked, say – to a camera that is moving along a path.

Fig. 3.62 Night scene of room shown in fig. 3.2. Lights have been given various blue tones as shown on following pages. See fig. 3.63 for basic lighting setup used here.

Another example might be headlights attached to a car. The linked lights would be casting associated moving spotlights according to where the car is heading.

• **Directional light** is similar to a spotlight but casts a light

Images on this double page spread © Marcia Kuperberg 2001.

in one direction only rather than in a cone from a point. It is useful placed at an angle, given a volumetric setting to simulate shafts of light through windows.

• **Projector lights.** These lights have the property of being able to project a bitmap or an animation. You could use the latter effect, for example, if you wanted to show moving images on a TV screen.

• **Coloured lights.** You can see from the evening scene that some lights have been given a blue tint to simulate dusk and to reflect the scene outside the windows. You can adjust any light to be coloured and cast its colour into your scene.

Five lights have been used:

1. Omni Side Light (the main key light)

2. General Omni

3. General Fill Omni

4. Omni for floor

5. Floor stool n carpet spot

Fig. 3.63 Lighting setup for the scene in fig. 3.62.

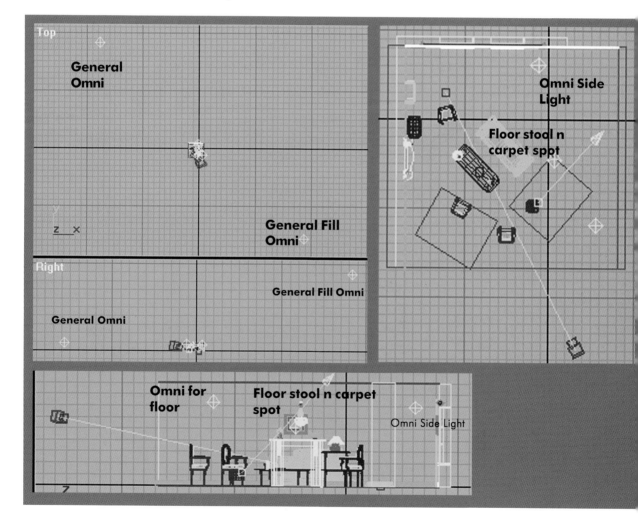

Fig. 3.64 Omni side light, the main key light for the scene. A number of objects have been excluded from its effects. It is a pale blue colour (see RGB settings), casts shadows, and is bright (with a multiplier of 1.5).

Fig. 3.65 Floor, stool and carpet spot. The purpose of this light is to throw a pool of light onto the carpet and enable the footstool to cast a long shadow.

Fig. 3.66 Omni for floor, and Omni general fill lights. These two omnis serve the purpose of providing low level fill lighting for different areas. They do not cast shadows or carry a list of objects excluded from their effects. The omni general fill light is coloured blue.

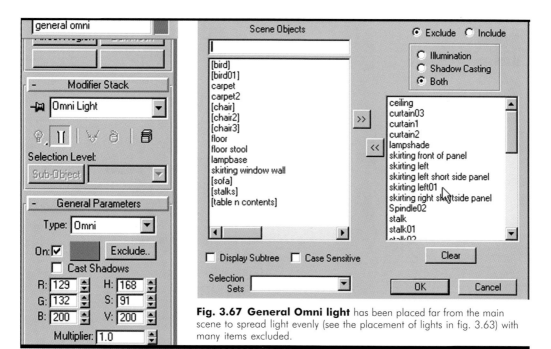

Fig. 3.67 General Omni light has been placed far from the main scene to spread light evenly (see the placement of lights in fig. 3.63) with many items excluded.

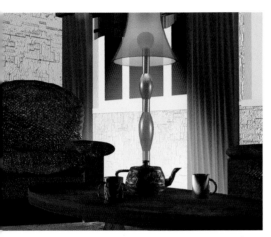

Fig. 3.68 The lamp has a self-illuminating sphere (the lightbulb) inside the semi-transparent shade and a volumetric beam to simulate the light cast by the lamp. A tiny omni has also been placed inside the sphere with its effect attenuated to cover a very small area inside the lampshade to give a brighter light to surround the lightbulb.

© Marcia Kuperberg 2001.

• **Volumetric lights.** When you sit in a cinema and you look back at the projection window, you'll notice the beam of light from the projector towards the screen. Volumetric lights allow you to create a lightbeam, not just the end effect of the light on the surface of your objects. If your software gives you the facility to create this type of lighting, it will allow you to adjust the size/shape of the beam (along the shape of the target spot shown as a cone or a directional light's parallel lines in your viewports), the opacity of the beam, its colour and, in some cases, even the swirl of the particles of dust within it (using animated 'noise' effects). Like raytracing and other special effects, the use of volumetric lights slows down rendering.

FINE-TUNING THE EFFECTS OF LIGHTS USED IN YOUR SCENE

Attenuation and decay. These are important features as they give you even greater control over the lights in your scene. Attenuation and decay settings control the fading out of lights over given distances.

When you are placing a number of lights into an interior, it becomes very easy for the scene to become over bright and 'washed out' unless you adjust the light's multiplier (explained below), and reduce it to, say, 0.5, or attenuate the light to tone down its effect over chosen areas. Often you'll also want to exclude certain objects from receiving light (fig. 3.67). In real life, we take the physical property of lights fading out over distance for granted. Your software will give you various settings to adjust this fade out; it is not automatic. The 'start' setting is the point where you want the fading out effect to begin. The light intensity will begin to fall off at the end of the far setting until the 'end' when there is no more light.

Your software will probably also allow you to utilize one of your viewports to view the scene from a given light's point of view. This can be very helpful when deciding how much of the scene you want the light to affect.

Multiplier effects. Multipliers multiply an entered value in the RGB settings: the colour of the light appears to change together with its brightness. A value greater than zero increases the level of the light, while a negative value decreases it. **Tip**: if a corner of your room or scene is too bright, and nothing else works, you could add a light to decrease the light, by using a negative multiplier in the light's parameters. Try it out: it can be a life saver!

Shadows. In some programs, all lights can cast shadows; in some, only spots cast shadows. You must be judicious when deciding which lights should cast shadows, not only because shadows increase rendering time, take up memory (RAM) but also because too many shadows crossing each other in different directions will cause visual confusion in your scene. No use of shadows at all, on the other hand, will make your scene appear artificial; your objects may look as if they are not properly anchored onto their surfaces.

Your software will give you considerable flexibility both in the types of shadows your lights can cast and in the ability to exclude chosen objects from casting or receiving shadows. You thought shadow casting was just a matter of clicking on/off a radio button (of a selected light) that says 'shadows'? Wait till you delve a little more into your software manual and find out just how many types of shadows there are, and how you can tweak and adjust their parameters for artistic effect – bet you never realized that shadows could vary so much!

Raycast shadows can give you the type of hard-edged shadows cast by the sun on a bright day (fig. 3.70). They are very accurate in terms of the physics of the scene, but take a long time to render relative to non-raycast shadows.

If you have a light shining through a glass object, and you want the shadows cast by the object to look realistically translucent you will require raycast shadows to achieve this effect. Similarly, an opacity map, or a map with alpha to create holes in your model will also require raycast shadows, or will give the game away with solid 'no hole' shadows.

Many programs also allow you control over the colour, density and texture mapping of shadows. Very sophisticated programs can even give you 'caustics' – the sort of effect you get with dappled sunlight at the bottom of a swimming pool. But if your program doesn't have caustics, you can fake the effect by using a projector light with animated noise (look up how to do this in your manual or online help). See Chapter 8 for more.

LIGHTING SETUPS

You've experimented with different types of lights. The example of the starkly lit evening scene of our room is demonstrated here but of course there are many approaches to lighting a scene. You could try using the time honoured way of professional lighting cameramen on filmsets: the three-point system. This consists of a key light which is the main light in

Fig. 3.69 Shadow parameters (3DS Max) used for the floor, stool and carpet spotlight (fig. 3.65). This light's main purpose was to cause the footstool to throw an oblique shadow and to light the carpet nearby. Initially the shadow was too harsh and prominent, so the density was lowered by half to 0.5 and the effect further softened by colouring the shadow blue.

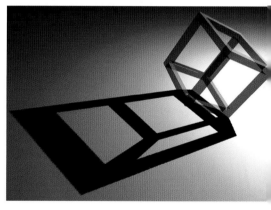

Fig. 3.70 Sharp hard-edged shadow. Image courtesy of Advanced Rendering Technology Ltd.

Other images on this double page spread © Marcia Kuperberg 2001.

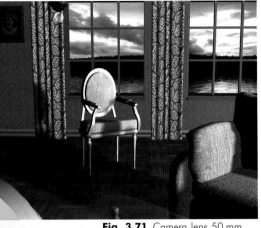

Fig. 3.71 Camera lens 50 mm.

Fig. 3.72 Telephoto lens 85 mm.

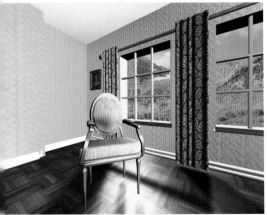

Fig. 3.73 15 mm lens, FOV: 100.

the scene and usually the one given shadow casting properties. This could be placed behind the camera, elevated to look down on the subject but to one side of it so that the lighting is not flat but shows the three-dimensional character of your model. On the opposite side, place a 'fill' light at a much lower level than the key light, so that this area of the model is not in total shadow. Then, behind the model, place a backlight to differentiate the main parts of the scene from the background. Try using a lower multiplier with larger attenuation so your lights don't spread further than you want. You may also need to exclude certain objects from receiving the light and/or the light's shadows (fig. 3.67).

You can apply this method to your whole scene, or just an area within it – lighting another zone elsewhere in a similar way. You can turn lights off and on, once you've created them to check each effect by rendering the scene from your camera viewport, so don't tweak everything all at once. Don't use an approximated rendering as it may not be accurate. **Tip:** to speed up rendering to check lighting, turn off antialiasing and render a smaller image size. Don't forget to turn the correct settings back on for the final render!

You could simply light your scene with a large number of omnis, grouped in threes with attenuation set so that the lights only affect small chosen groups or even single objects. Alternatively, you could use a combination of lights: omnis to give the overall basic light to a scene, plus spots carefully placed close to selected objects to give the lighting and shadows required. You can also get very dramatic and unusual effects by lighting from below or with the key light for backlighting and gentle fill lights placed front and side.

Lighting is an art. Experiment!

USING YOUR CAMERA EFFECTIVELY

Types of camera. It is likely that your software will give you the choice of using a free camera or a target camera. This is similar in many ways to using free spotlights or target spotlights. You'll mostly use a target camera as it is the easiest way to angle the camera to view the scene as you want. The free camera has to be angled without the aid of the target to point at the object, but it comes into its own when it has to follow a path and it can 'bank', i.e. rotate to balance itself as it enters and turns around the curves of its set path.

CAMERA LENSES

As with real cine or video cameras, you can move your virtual animation camera in many ways and in addition your software will offer you a range of virtual lenses that mimic real life ones, plus an infinite number of other focal lengths. Lenses, like those in real cameras, are measured in mm.

A 50 mm lens corresponds most closely to human vision (fig. 3.71); lenses shorter than 50 mm are referred to as wide-angle lenses and those longer than 50 mm are called telephoto lenses. The same scene with the camera placed in the same position but using a telephoto lens of say, 85 mm shows the scene in close-up, giving a foreshortened 'flattened' effect (fig. 3.72). If you want to exaggerate the perspective, use a wide-angle lens and adjust the field of view (FOV) to give you the desired effect (fig. 3.73). In general, wide-angle lenses are used for 'establishing' shots – to set the scene and familiarize the audience with the location – and close-ups are used to centre the audience's attention on some aspect of the scene or action.

Simulating photographic effects. Many animators like to do this by applying filters or rendering techniques to give out-of-focus or motion blur effects (figs 3.76 and 3.77). Also see examples in Chapter 7 (e.g. fig. 7.16). There are a number of ways to do this, depending on your hardware and software. You can also use compositing techniques in software such as Adobe After Effects. See Chapter 6 for examples of this (figs 6.65–6.70) and Chapter 8 for further resources.

Camera framing and movement are among the important tools that the filmmaker uses to convey drama and narrative. Read Chapter 7 for using your camera creatively in a narrative and for more on characterization.

USING A NUMBER OF CAMERAS

You have the option to set up a number of cameras, each with the lens and view of your choice, though you can only use one at a time. The benefit of creating more than one camera is that you can try out different views and camera lenses and angles as alternatives and return to those that you like best.

BASIC CAMERA MOVES

• **Zoom/FOV.** The camera remains static but the FOV (field of view) changes from long shot to close-up or vice versa. You

Fig. 3.74 Depth of field. Image © Simon Clarke, Advanced Rendering Technology Ltd.

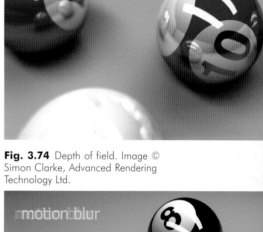

Fig. 3.75 Motion blur. Image © Simon Clarke, Advanced Rendering Technology Ltd.

set keyframes for your zoom angles by clicking on the FOV or zoom button at a particular frame and then adjust your camera view by the same means at a later point in the action, letting your software fill in the in-between frames to achieve the zoom in or out. The perspective of the whole scene can change according to the zoom setting you choose and the FOV. See examples: figs 3.71–3.75.

• **Dolly.** This gives a different effect to the zoom, as the camera itself moves forward or further away from the object, rather than the lens effect of the zoom.

• **Panning.** This is similar to when the camera is mounted on a tripod and is slowly swivelled from one side to the other.

• **Trucking or tracking.** This is similar to panning, except that the camera, itself, moves – it's like a horizontal form of orbiting with the camera on wheels.

• **Orbit.** The camera moves in a circle, i.e. orbits its target.

• **Tilt and rotate.** If you want complete freedom to rotate and tilt your camera about any axis, it is better to create a 'dummy' or 'null' (i.e. non-rendering) object that you can move and rotate as you want, and link a free camera to it. Target cameras can only rotate around their local Z-axis. The dummy will act as a parent to the child camera in this hierarchy and give you greater movement flexibility.

• **Safe frame.** Having set up a camera in the scene, set the safe frame facility on your camera viewport to the aspect ratio of the final output medium, e.g. for video it might be 4 × 3 or wide-screen (fig. 3.78). The reason for this is that the image shown in your computer monitor's viewport will show a greater area of your image than a television screen. The TV screen 'wraps' the image around the edges, and different screens vary with the amount of cutoff on different sides. The only way to be safe is to ensure that titles or other important parts of your scene fall well within this 'safe frame' or safe titling area. This applies if you intend to render your animation, lay it off to video and then show it on a video monitor or television screen. If you want a colour print of your scene, the printer will disregard the cutoff.

USING YOUR CAMERA TO EXPLORE THE ROOM

As there are no characters currently being animated in our room, it provides a good opportunity to let the viewers absorb the scene through the eye of the camera. Even with a simple

Fig. 3.76 Safe frame is the inner rectangle. Images inside this area will be safely in view on the TV or video monitor. The reason for this 'safe frame' inner rectangle is that televisions and some monitors cut off part of the image that is normally seen in full on a computer monitor. Staying well inside the safe area is particularly important for text and titling for video or TV output.

When you print a scene from one of your viewports, the printer will show the full outer rectangle.

© Marcia Kuperberg 2001.

scene like this, with no characters to animate, any movement of the camera will either be telling a story or 'setting the scene' for a story to begin. Someone going into a strange room might quickly glance here and there, but doing the same thing with a camera will give a 'hosepipe' effect.

You are the director and you will skilfully guide the viewers around the scene, hopefully without their being conscious of your guiding hand – all this through the framing and movement of your camera. Ideally, the camera movement should be smooth and unobtrusive, allowing viewers to absorb what you, the director, want them to see and absorb.

We could begin by looking out of the window, and then gently pull back while panning across the mantelpiece before pulling back further to see the room in long shot (fig. 3.77).

Fig. 3.77 Top viewport. Here a target camera is following the path and its target is linked to a 'look-at' non-rendering dummy. The total animation is 500 frames. The inset images show the camera's view at various frame numbers along the path.

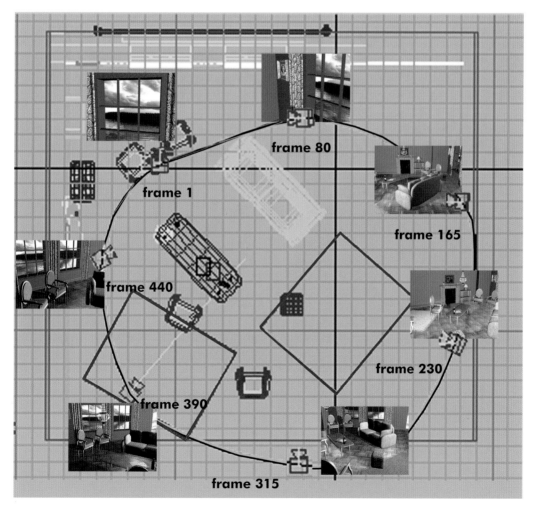

Fig. 3.78 The camera's trajectory has been converted into an editable spline with bezier curves. The shape can now be manipulated via the handles just like any other spline.

Fig. 3.79 Here the trajectory has been 'collapsed' into a path with the keyframes visible. Keys can now be selected and moved.

Images on this page © Marcia Kuperberg 2001.

CREATING CAMERA MOVES

Decide how many seconds you want your camera movement to be and set the relevant number of frames. Then turn on the *animate button* (in Max – use the equivalent in your software) and frame your scene in the camera viewport at each key change of camera position in the total timeline, thus setting up your camera keyframes. When doing this, take care that you don't raise or lower the camera or its target much from one key position to the next, or you will make your audience seasick! Render a test animation at low resolution. Your first effort may create camera movement that is way too fast, and not nearly as smooth as you would like. Your next step is to examine the camera's path, i.e. the trajectory that was created by these moves (in Max, you select any object – in this case, the camera – and view its path in the Motion section of the modifier panel). You may need to cut some keyframes.

The fewer the keyframes, the smoother and more natural the camera's motion will be. Your software may allow you to smooth the shape of the trajectory by converting it into an editable spline (fig. 3.79) or into a NURBS curve (NURBS curves are always smooth). If you convert to an editable spline, you'll be able to treat it like any other shape by going to the sub-object vertex level to use handles that you can manipulate to smooth the curve and give you the shape you want. Then, convert the spline back again to become the camera's new trajectory. If the camera's movement is too fast or slow you can slide keyframes along the timeline or along the path (fig. 3.80) to increase or reduce the number of in-between frames. You will probably also be able to tweak further by manipulating the type of movement between the keyframes affecting the slow-in/slow-out, sharpness or smoothness of movement (see figs 5.32–5.34 in Chapter 5).

Following a set path. An alternative that may give a more professional result is to draw a NURBS spline path in the top viewport and elevate it in the front or side viewport to gain the view desired. 'Tell' your software that the (free or target) camera should 'follow' this path. If you create a non-rendering dummy/null object that is linked to the camera's target (parenting the target), you can make your camera 'look' at the dummy which you place and animate, while the camera follows merrily along its path.

Rendering. If you've created your own room and animation, well done! Now refer back to Chapter 2 for information on rendering and read Chapter 8 for more 3D briefs. Have fun!

chapter 4

animation for multimedia and
new media
by Alan Peacock

Chapter 4
by Alan Peacock
Animation for multimedia and new media

INTRODUCTION

In interactive media, animation makes an important contribution to the user's experience. It contributes to the apparent responsiveness of the system and to the user's feeling of agency (their ability to act meaningfully within the artefact), to the engagement of the user and their feeling of reward. In its visual qualities and its pace, animation plays a significant part in creating the atmosphere or tone of the multimedia artefact.

Animation in multimedia has its own particular concerns and issues, some of which differ from those of animation within the filmic tradition of cinema and television display. In this chapter ideas about animation in interactive multimedia are explored first through a brief review of what animation contributes to interactivity, and then through a detailed discussion of particular issues, ideas and processes.

The design and realization of animated elements of a multimedia artefact involve many of the same aesthetic and technical issues as those discussed elsewhere in this book, but bring with them, also, issues that are particular to multimedia. Some of those issues are to do with different delivery means. Designing for a CD-ROM, for example, can be very different to designing for the networked distribution of the World Wide Web. These different delivery modes affect not only what can be made successfully, but also the strategies and processes used for making and for the ideas development and evaluation stages of any multimedia work.

Fig. 4.1 Animated objects are part of the everyday experience of using computers.

Other issues are to do with the very nature of interactive media. These issues are unique to the new media of interactive narrative, and animation has a particularly important role to play in the forms and structures it takes. Animation integrates in interactive multimedia in several ways:

• as the cursor tracking about the screen and changing to indicate the presence of a link or a different function
• as a rollover image which changes to give user feedback

- as on-screen movement of objects within the display
- as an embedded animated diagram or movie
- as scrolling screens and changing world views
- as a way of enabling the user's sense of agency and empowerment (these ideas are explored later)
- as a way of convincing the user that the system is working and 'reliable'.

When you have finished reading this chapter you will have a basic understanding of:

- How animation is a key element of interactive media.
- The main forms of animation used in, and as, interactive multimedia.
- Some of the ways animated elements are used in multimedia and on the web.
- Some of the technical issues that affect animation in multimedia and on the web.

MOTIVATION AND RESPONSIVENESS: ANIMATED OBJECTS IN MULTIMEDIA

In any animation there are two sorts of visual objects – ones that form the 'ground' on which other objects play. Ground objects are often static, or have contained movement (the swirling of water, the waving of trees, the drift of clouds), and these contrast with the 'figure' objects which are (or appear to be) 'motivated'. That is to say their movement has apparent purpose either in an anthropomorphic sense in that we can understand their actions and the motives for them, or in the way in which there is a play of cause and effect. It is these motivated objects, representational images of people, mice, ducks, cats, steam trains, that 'come to life', are animated in moving image sequences. Even if the animated world exaggerates or contradicts the rules of cause and effect as we know them from our day-to-day experiences, we quickly learn and accommodate the difference and derive pleasure from it.

In multimedia there is an extended range of objects, and a blurring of the distinction between them. Again there are 'ground' objects, either as static images or as contained animations cycling away, and there are 'motivated' objects which move around or change independently. In addition there are 'responsive' objects, things that move or change in response to the viewer's actions and interventions, such as a button that changes colour when the mouse is clicked on it.

It is in the presence of 'responsive' objects that the particular

Fig. 4.2 This screen shows the types of objects found in interactive media.

The outline shapes of the playing area are *ground* objects; the 'puck', centre left, is a *motivated* object whose behaviour is controlled by a set of rules about how its movement changes when it collides with side wall, obstacles and the players' 'bat'.

The 'bat' itself is a *responsive* object, directly controlled by the user's actions.

Fig. 4.3 Context sensitive cursors are a simple form of animation.

Fig. 4.4 Animation, as the change of a cursor or icon is an integral part of interactive multimedia.

concerns of animation in multimedia are most present and most clear. Not only because their appearance or movement changes with the actions of the user, but also because the intervention of the user may have other, and deeper, consequences also. The act of sliding a marker along a scale may adjust the speed at which (the image of) a motor car moves on screen, to the point where its behaviour becomes unstable and it crashes. Here the user's actions have determined not only the appearance of the control device but also the 'motivation' of a separate object, and have affected events that follow.

Responsive objects are navigation tools, they are ways of forming a story from the choices available. They need to be readily recognizable for what they are, and they need to have a way of indicating that they are working, of giving feedback to the user. The *affordance* of a responsive object is the way it is distinguished from other objects, and feedback is given in the way the object's appearance changes or through associated actions. Feedback, even at the level of something moving, or changing, is a form of animation.

Applying these ideas of objects to interactive media (both stand-alone CD-based works and web pages), allows us to identify certain features of the way animation is used and to recognize what is particular about animation in multimedia.

A Taxonomy of Animation in Multimedia

Type of Object	Typical examples and uses
Ground	Objects that define the general environment of the work, background colours and images, tiled repeats in web pages, sprite tiling in early computer games
Contained	Objects that move/change within a border and in an unsequential way; 'banner' images on web pages, animated logos, cycling movements (waves, fountain spray), movie objects with or without control panel
Motivated	Objects that move/change of their own accord or whose behaviour responds to other objects in their environment – artificial intelligence or artificial life objects such as the inhabitants of sim-games, opponents in a game which are under computer control, birds flying around in a flock, the ball or puck in a sports game
Responsive	Objects which change or modify the environment as a consequence of user actions, direct and displaced rollovers, context sensitive cursors, sliders, movable objects, avatars, character sprites, navigation devices

CHANGING MOVES: ANIMATION AND INTERACTION

It is difficult to think of interactive media that does not have elements of animation. Indeed some of the main applications used to author interactive media are used also to create animations. Packages like Macromedia Director and Flash have developed from tools for creating animations to become powerful multimedia authoring environments which combine timeline animation with feature-rich programming languages. Web authoring packages integrate simple animation in the form of rollover buttons and independently positionable layered graphics, often using a timeline to define movement.

In interactive media the user's actions produce change, or movement, in the screen display. At one level this takes the form of a cursor which moves, and in moving corresponds to the movement of their hand holding the mouse. At other levels actions, such as the clicking of a mouse button, have a cause and effect relationship with on-screen events triggering some, controlling others. Interactive media responds to the user's actions and seems to 'come alive'. This 'coming alive' quality of multimedia is an important part of the experience of interactivity – and 'coming alive' is itself a definition of 'animation'.

Visual elements in interactive media may be animated in their own right – moving around the screen independently of the user's actions, or sequentially displaying a series of images that suggest or imply a consistency and continuity of movement or change (fig. 4.5).

Fig. 4.5 In contemporary operating systems and interfaces image-flipping animation is used to provide feedback.

In interactive media, animation contributes significantly to the user experience in many ways and at a number of levels. It contributes to the apparent responsiveness of the system and to the user's feeling of agency (their ability to act meaningfully within the artefact), to the engagement of the user and their feeling of reward, and in the qualities and timing of movement it helps define the atmosphere or tone of the multimedia artefact.

The definition of 'changes or moves' we have used here includes also the development of virtual worlds that allow the users to experience moving around within a believable environment. Virtual worlds represent a special kind of animation, they provide convincing experiences of 'being there', of presence in a place, and of moving within a world

rather than watching it from the outside.

ANIMATION: AN EVERYDAY EXPERIENCE

Graphic User Interfaces (GUIs) are the dominant form of interaction with computers. In these simple 'change or move' animation is a part of the ordinary experience of using a computer. The visual display of contemporary computers is constantly changing: it seems alive with movement and change, and in this it embodies a believable intelligence. Icons in toolboxes change to indicate the currently selected tool or option, menu lists drop down from toolbars. Context sensitive cursors replace the simple pointer with crosshairs, hourglasses, rotating cogs, a wristwatch with moving hands. The cursor on my word-processor page blinks purposefully whenever I pause in writing this text. Status cursors appear when a mouse button is pressed to indicate the current action or its possibilities. Images of sheets of paper fly from one folder to another.

Our computers, left alone for five minutes, start to display scrolling text messages, Lissajous loops, flying toasters or company logos. We click on an icon representing a program, a folder, a file and drag it around the screen from one place to another. Our simplest and most profound actions are represented in animations. All this 'move and change' animation has become commonplace, almost invisible in our familiarity with it.

In interactive multimedia animation is an integral part of the communication. Movement brings emphasis to some sections; it structures and organizes the flow of information; it provides visual interest, pace and feedback. Used well, it promotes the overall meanings of the artefact effectively.

EARLY GAMES AND HYPERTEXT

At the end of the twentieth century the increasing accessibility of computer technologies, both economically and in terms of the knowledge required to create content for them and use them, contributed to the emergence of new media forms, and animation became a defining mode within them. Outside of commercial applications, the emergent computer industries in both leisure and military sectors adopted visual display technologies that became increasingly capable of 'realistic' graphics.

Early graphics were often crude blocks or lines, but they

Fig. 4.6 Sprite animation draws on separate images that depict each 'frame' of the animation. Each of these 'sprite images' is displayed in turn at the sprite's screen location.

An animated object may be made up of several sprites. In the example here the changing smoke trail could be separate to the image of the model train. In sprite-based multimedia these objects may have behaviours associated with them.

carried enough information to allow a viewer, willing to suspend disbelief, to accept the 'reality' of what was depicted. An important element of these early graphics, and a major feature of their 'believability', was change and movement – in short, *animation*. The on-screen location of the 'sprite' images used to construct the display can be changed in computer programming code relatively easily. If this happens fast enough (above 12 frames a second in interactive media) the changes are read as continuous action. Updating the location of a graphic object creates an apparent continuity of movement; changing its image creates a continuity of 'behaviour'.

Some graphic objects – the ball in *Pong*, the spaceships in *Space Invaders* – were *motivated* objects: they apparently moved or changed of their own accord and in increasingly complex ways. Other graphic objects were *responsive*, moving and changing in accordance with the player's actions – the paddles in *Pong*, the weapon in *Space Invaders*. Between these two sorts of graphic objects existed a play of cause and effect; the actions of the user manipulating the controls of a *responsive* object could bring about a change in a *motivated* object. Firing the weapon in *Space Invaders* at the right moment meant one of the alien ships would disintegrate in a shower of pixels, getting the paddle in *Pong* in the right place sent the ball careering back across the screen to the goal of your opponent. In the interplay of these graphic objects a new narrative, a narrative of interactivity, began to emerge.

Elsewhere, ideas about the nature of information (put forward by Vannevar Bush and others) were being used to develop computer systems. Those ideas, about associational thinking, about threaded pathways between pieces of information, predate computing technologies and the forms of Random Access storage (on chip and disk) that are associated with them. As computing technologies became more accessible there were a number of people exploring ideas about what Ted Nelson came to call 'hypertext' (1968). A hypertext is 'navigable'; it does not have a fixed and determined order but is determined by the choices and decisions of the user. Hypertext led to 'hypermedia' or 'multimedia' where the information sources included, alongside written word texts and the links between sections, images, both moving and static, and sound, as music, spot effects and voice.

Fig. 4.7 Narrative forms can be shown diagrammatically. Here the unisequential mode of the cinema-type animation is shown in the top diagram. Separate episodes follow a single consistent line that does not vary from showing to showing.

The middle diagram represents the narrative form or shape of interactive multimedia where links between sections are set and determined by the author. In this form of multimedia the user chooses from among fixed options, and although their personal pathway may be unique they remain limited to the prescribed links.

The lower diagram illustrates the kind of narrative form that comes with navigable 3D worlds. In these worlds the user is free to go anywhere they wish within the rules of the world.

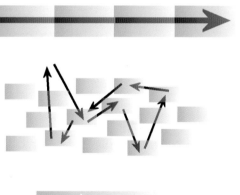

button

Fig. 4.8 *Affordance* is the visual qualities of a link object that allow it to be recognized.

Here, the bevelled edges and the text name make the object readily identifiable.

Fig. 4.9

The animated change from the arrow to pointy finger cursor is used in web browsers to indicate the presence of a hypertext link. Animation, movement and change, offers a high order of affordance as it makes multimedia objects readily distinguishable.

Affordance is a relative quality – it depends on context and surrounding imagery. An animated cursor is highly visible on an otherwise static background but may be less visible if there is a lot of on-screen movement.

The shape of a hypermedia narrative may be relatively undetermined, it may have no distinct starting point and no clear ending or sense of closure. This means that there is a very different relationship between the author and the work, and between the audience and the work, than those in traditional, unisequential media. In an important sense the author no longer determines the work and, in an equally important sense, the audience now contributes to the work.

WWW

The World Wide Web is a particular implementation of hypermedia, a particular kind of interactive multimedia. In its earliest form the underlying HTML (HyperText Markup Language) devised by Tim Berners-Lee and others at CERN in the early 1990s handled only written word text, it did not include images or many of the features later web browsers would implement. Marc Andreessen developed Mosaic, a browser that included the tag to identify, locate, retrieve and display an image in either .JPEG or .GIF formats.

Berners-Lee's development of embedding URLS in code so that a link could represent rather than state its destination, accompanied by Andreessen's integration of images, made HTML technologies into a readily accessible form of hypermedia – opening up the Internet to the general public.

It quickly became a convention that a link on a web page is indicated not only by a visual *affordance* of some kind – text coloured differently to adjacent words, overt 'button' design – but by a change in the cursor from arrow to 'pointy finger'. This simple context-responsive animation provides effective feedback to the user. It reinforces the *affordance* of the underlining and different colouring that have come to conventionally represent a hyperlink in WWW browsers. Further developments in HTML technologies and especially the integration of JavaScript into browsers meant that image flipping could be used for rollovers within web pages. This gave web page designers a simple form of animation, one which gives a distinct flavour to the user experience because the screen image reacts and changes as the user interacts with it.

Web pages may contain images and these can function as links. Usually and conventionally an image-link is marked by an outlining border in the 'link' colour. But this border is a parameter that the designer can alter – setting it to 0 means there is no visible border, and no visible indication that the

image is a link. While some images may have a high degree of *affordance* others may only be identified as a link by the 'arrow to pointy finger' animation when the cursor trespasses on the image. In a similar vein a web page may contain image maps. These are images (GIF or JPEG) which have associated with them a 'map' of hotspot areas which can act as links or may trigger other scripted actions. The image does not necessarily have any *affordance* that identifies the hotspot areas. The possibility of action is indicated solely by the context sensitive cursor change from arrow to pointy finger. These techniques enable an artist or designer to embed 'hidden' links or actions in an image so that the reader has to actively search them out through a process of active discovery and exploration. The simple animation of the cursor becomes the tool of discovery.

Web pages may contain other animated media, also. These usually require an additional 'plug-in' that extends the capabilities of the browser and extends the depth of interactivity that the user may experience. Common animation media that may be incorporated into web pages are Shockwave (a special highly compressed file from Macromedia Director), Flash (vector graphics), Quicktime (Apple's proprietary technology that allows the playback of linear) and various plug-ins that facilitate 3D worlds (such as COSMOPLAYER, CULT 3D). These media forms range from contained objects (Quicktime movies, AVIs) through to objects which are themselves separate instances of interactive media (Shockwave, Flash, VRML).

The web is a networked technology and this has considerable implications for the design of animated media components. There are issues of file size and bandwidth to consider, alongside such things as the diversity of browsers, plug-ins and hardware specifications of the computer on which the work is to be viewed.

Virtual worlds

Some of the early computer games and military simulations placed the user in a virtual environment. There, although

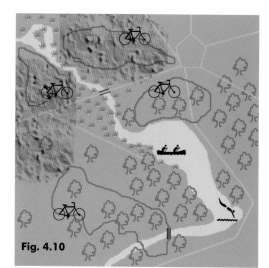
Fig. 4.10

Fig. 4.11

Fig. 4.12

Figs 4.10–4.12 Web pages may include image maps. The active areas (here the bicycles, diver and canoeists in fig. 4.1) are revealed when the map is explored by moving the cursor over the image. Any active areas are hotspots (shown in fig. 4.11). Their presence is shown by the arrow cursor changing to the pointy finger above a hot spot area (fig. 4.12).

The use of JavaScript allows the rollover event to trigger actions elsewhere; another image may change, a sound might play.

Fig. 4.13 Vector graphics draw and redraw quickly – for this reason they were used for early '3D' graphics in games and simulators. The green outlined shape on a black background became a strong referent meaning 'computer imagery'.

objects existed as pre-determined datasets (a tank, a space craft), what happened after the user entered the world is entirely the consequence of the user's interaction with the virtual world, its objects and rules. The early games and simulations, such as David Braben's *Elite*, took the form of outline vector graphics. These simple images allowed for a fast redraw of the screen and so a 'believable' frame rate and an apparent continuity of action/effect and movement within the virtual world (fig. 4.13).

As computer processing and graphic display power have increased so these applications have developed from vector graphics to volumetric rendered 3D spaces using texture mapping to create solid surfaces. This is typified in games like *Doom, Quake, Tomb Raider, Golden Eye*. These forms of interactive multimedia are included in this section because they fall within the concept of 'change and move' used to define animation within multimedia. The animation here, of course, is of the world view of the user in that world. This is a special form of animation because the user or viewer is the centre of the animated world. They are an active participant *in* it rather than a viewer *of* it. What is seen on the screen is the product of the world, its objects and the user's position and angle of view. Data about each of those is used to generate the image frame-by-frame, step-by-step, action by action. This is not animation as contained and held at one remove by a cinema screen, a television display, a computer monitor window. This is a believable world come alive around us, and generated for us uniquely, each time we visit.

ANIMATION IN iTV (interactive TeleVision)

Interactive media technologies are being adopted and adapted for interactive television. Many set-top boxes that receive and decode iTV signals contain a virtual web browser or similar technology. Move and change animation, in the form of cursors and rollovers, are key components of the responsiveness of this technology. As with the web there are many issues of bandwidth, download and image resolution for the iTV designer to deal with. This new medium provides further challenges and opportunities for animation and for animation designers.

APPROACHES AND WORKING METHODS

Animation and interactivity blur together not only in the user's experiences but in the ways in which authoring packages

work. Various software packages such as Macromedia Director, Flash and Dreamweaver are used to author interactive content for both stand-alone CD and web-based delivery. Although these are not the only authoring software packages available for creating interactive media content, each has been adopted widely in the industry and each illustrates a particular approach to multimedia content creation.

Director is, at heart, a *sprite* animation package that uses a timeline to organize its content. Sprites are drawn from a 'cast' and placed on a 'stage'. The attributes of the sprite (location, cast member used, etc.) are controlled through a score. In the score time runs left-to-right in a series of frames grouped together as columns of cells. These cells represent the content of that frame for a number of sprite 'channels' which run horizontally. These ideas are discussed again later and illustrated in figures 4.15, 4.16 and 4.30.

The timeline supports the use of keyframes to in-between sprite movements and changes to other attributes. This saves the laborious process of frame-by-frame detailing each sprite's position and properties. It is a fairly straightforward process to create sprite animations working at the score level.

Sprites are bitmap objects which can be created in Director's own Paint area but more often are prepared beforehand in a dedicated graphics application like Photoshop, PaintShop Pro or Illustrator. The prepared images are imported into Director and become cast members. These can be dragged onto the stage and positioned as required, or called by code to become the content of a sprite.

Director 8 supports real time rotation and distortion of sprites. Elsewhere, in similar authoring packages and earlier versions of Director it is necessary to create individual images for each small difference in a 'cast' member as in the tumbling hourglass that illustrates the first page of this chapter.

Within Director sits Lingo, a complete object oriented programming language. Lingo provides the opportunity for fine control of sprites, sound, movies and other media. It allows for elaborate conditional statements to monitor and respond to user's actions. Using Lingo the multimedia designer can craft rich interactive experiences for the user. However, it is not necessary to be a programmer to create interactivity in Director as there is a library of pre-set

Fig. 4.14 Vector draw and animation packages, like Flash, can produce in-betweened or morphed shapes.

In this example of a circle morphed into an eight point star, the colour properties of the object have also been morphed or in-betweened across the colour space from cyan to yellow.

Used in animations this process can result in fluid changes of both representational and abstract forms.

Figs 4.15 and **4.16** opposite

The timeline (fig. 4.15), a graphic representation of sprites and their properties is a common tool in multimedia authoring software. Usually time flows left-to-right and the vertical axis describes what is happening on screen frame-by-frame.

In this example the red dots represent keyframes and the red bars show in-betweening actions of the sprites.

The cells on the grid hold information about the sprite's location on screen, its contents and associated behaviours. These can usually be viewed in an 'expanded' display – an example is shown in fig. 4.16.

In this extended timeline display the first line in each cell is the number of the image drawn from the sprite bank, next come horizontal and vertical screen co-ordinates and then the properties of the sprite – here 'm' means a matte display. In the topmost cells a single image moves across the screen in 8 pixel steps. In the next line of cells sequential images change frame-by-frame to create an animated change and move across the screen in 8 pixel steps. Again the red boxed line indicates a 'keyframe'.

behaviours that enable basic interactivity.

Flash is inherently a vector animation package. Like Director it uses a timeline to organize and sequence events. This timeline is not the same as the Director score in that it contains only a single channel to start with. In Flash an object which is to be controlled separately has to be placed on an individual layer. As more objects are added more layers are added and the timeline comes to resemble Director's score. Flash layers do not only hold vector or bitmap objects – they may contain other Flash movies which in turn have objects with their own movement and behaviours.

Later versions of Flash use a programming language called ActionScript to support interactivity and programmed events. ActionScript is a version of ECMAScript, a standard definition that includes also JavaScript and Jscript. Like Director, Flash uses some ready-made script elements to enable non-programmers to create interactivity.

Flash graphics are vector-based and this means that they can be in-betweened in both their location and also 'morphed' in various ways. Morphing involves a procedure that recalculates the position and relationship of the vector control points. This means that objects can be rotated, stretched, and can be made to dynamically alter shape across a period of time. Because the shapes are vectors they remain true shapes and forms without the unwanted distortions that come when bitmaps are rotated, stretched, sheared, etc.

Web pages were originally static layouts. Early versions of HTML (the page description language that is used to create web pages) did not support movable or moving elements. Movement was confined to animated GIFs, rollovers and the cursor change that indicated a link. Later versions of HTML (the so-called Dynamic HTML) support the creation of independent layers within the page. These layers have their own attributes of location, size and visibility and can be made to move by restating their position within a screen update. This provides a simple way of moving elements around the screen. However, it remains slow (frame rates below 10 a second are common) and relatively clumsy in visual terms.

Dreamweaver and similar web authoring packages use a

timeline and keyframe concept to organize layered elements. Although these web authoring packages will generate JavaScript code for things like rollovers and mouseclick actions, they rarely provide access to the depths and power of the language. This limits what can be done in web pages in terms of interactivity unless the designer or artist is willing to learn how to program in JavaScript or Jscript. As Director and Flash files can be exported in forms suitable for embedding in web pages, the restricted animation and interaction possibilities of web authoring packages is not a limit to the creativity of designers and artists.

The graphics in a web page are external assets that have to be prepared beforehand in dedicated image creation software. There are two dominant image formats used in web pages, .GIF and .JPG (a third, .PNG, is supported in browsers but not widely used). In broad terms .JPG files are best used for photographic-type images. This format uses a lossy compression routine but preserves the visual quality of photographic-type images. The .GIF format is best used for images with areas of flat colour. This format uses a compression routine that works well and preserves the visual quality of this type of image. The .GIF format also supports a transparent colour option which means that images need not be contained in a rectangle. The .GIF 89a format supports image-flipping animation. This animation format is a pre-rendered bitmap mode; it holds a copy of all the images in the animation and displays them sequentially.

The timelines and keyframes

At the heart of multimedia authoring packages like these is a tool for organizing events across time – in most instances this is presented as a timeline of some kind.

The use of a timeline to construct a representation of actions makes creating animation (and interactive media) a kind of extended drawing practice. The timeline is a visualization of events that can be run or tested out at any point in its development. This means that ideas about movement, pace, timing, visual communication can be tried out and developed through a kind of intuitive test-and-see process. This playing

6	7	8
24 204 128 m	24 212 128 m	24 220 128 m
32 218 110 m	33 226 110 m	34 234 110 m

Fig. 4.15 (below) and **fig. 4.16** (above).

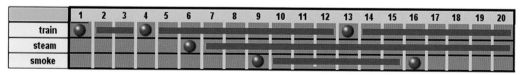

with versions is like sketching where ideas are tried out.

The majority of timeline tools include 'keyframes' and 'in-betweening' routines. In terms of a sprite object that moves across the screen from the left edge to the right edge there need only be two keyframes. The first will hold the left-edge co-ordinates of the sprite's position on screen – here 1, 100 (0 pixel in from the left on the horizontal axis, 100 pixels down from the top on the vertical axis). The second keyframe holds the sprite's co-ordinates at the right edge of the screen, here 800, 100 (800 pixels in from the left on the horizontal axis, 100 pixels down from the top on the vertical axis). The number of frames between the first keyframe and the second are used to decide the frame-by-frame 'in-between' movement of the sprite. So, if there are 20 frames between the keyframes the sprite will move 800 pixels/20 = 40 pixels between each frame, if there are 50 frames then 800 pixels/50 = 16 pixels between each frame.

Keyframes in multimedia can hold other properties also – the sprite's rotation, transparency, the size of the bounding rectangle it is mapped into. With vector objects keyframes may be used to 'morph' the shape. Morphing can apply to several of the object's attributes. To its shape because by recalculating the curves that make up the shape between frames it is redrawn. Colour values can be 'morphed', because they can be used to determine a number of steps through a palette or colour range. The line and fill attributes

Fig. 4.17 Interactive multimedia can be thought of as a series of looping episodes, each likely to contain animated elements. The user's actions 'jump' between the loops creating a 'personal' version of the story.

of objects can also be used for sequential changes across a range of frames (fig. 4.17).

Used for a simple linear animation the timeline represents the process from the first frame to the last frame of the sequence. For interactive multimedia the timeline is the place where the conditions and separate sequences of the work are determined and represented. An interactive artefact can be thought of as a set of looping sequences; within each loop there are conditions that allow a jump to another (looping) sequence or a change to what is happening in the current one. Those conditions are things like 'when the mouse is

clicked on this object go to ...', or, *'if the count of this equals ten then do ...'*. The authoring of these conditions, the programming of them in effective code that does what the designer or artist intends, is a large part of the challenge of creating interactive multimedia.

Some technical considerations

Animation in multimedia, in all its forms, is generated rather than pre-rendered. The presence, location and movement of elements are determined by the unique actions and histories of the user. This means that the designer of multimedia has to take aboard technical issues that impact on the quality of the animation. Those qualities are, essentially, visual and temporal. Visual includes such things as the colour depth and pixel size of sprites. Temporal includes things such as the achievable frame rate, the system's responsiveness to user actions. The designer's or artist's original idea may need to be redefined in terms of what can be done within the systems that the multimedia application will be shown on.

Technological advances in processor speed, graphics capabilities (including dedicated graphics co-processors) and the increasing power of base specification machines would suggest that these problems are less relevant than they once were. Unfortunately, while the power of readily available computers has risen exponentially, so too have users' expectations and designers' visions. A good example of this is the shift in the 'standard' screen display. VGA, once seen as a high resolution standard, is set at 640 × 480 pixels (a total of 307 200 pixels) and usually thought of in the context of a 14 inch (29 cm) monitor. Nowadays it is more common to have 800 × 600 pixel display (480 000 pixels) on 15 or 17 inch monitors and this is giving way to resolutions of 1024 × 768 (786 432 pixels) and above. Displays of 1280 × 1024 (over 1 million pixels) will soon be common. This is coupled with a similar advancement in colour depth from VGA's 8-bit (256 colour) display to contemporary 24-bit colour depths. Taken together these factors mean that the graphics handling capabilities of ordinary computer systems, things like the speed at which a buffered image can be assembled and displayed, remain an issue for animation in multimedia and on the web. While processor speed has increased massively since the VGA standard was established, the usual graphics display has nearly tripled in its pixel count and in its colour depth.

The expectations of the audience have increased considerably. When VGA first came out any movement on screen seemed almost magical. Carefully developed demonstrations meticulously optimized for the machine's capabilities would show checker-patterned bouncing balls, with shadows, in a 320 × 240 pixel window. Contemporary audiences expect much more, and future audiences will continue to expect more of the quality of animation in their multimedia applications.

The quality of animation in multimedia, the move and change of parts of the visual display, is affected by a number of factors. These are primarily technical but impact on the aesthetic qualities of the work. For smooth movement the display needs to maintain a frame rate of at least 12 frames per second and preferably twice that. While pre-rendered animation media can use advanced codecs (compression/decompression algorithms) to reduce both file size and the required media transfer bandwidth, a responsive multimedia animation is generated on the fly. This means that the system has to:

1. take note of user actions

2. calculate the consequences of the user actions in terms of sprite attributes (location, etc.) or in terms of vectors

3. locate and draw on assets (sprites) held in RAM or on disk, or recalculate vectors

4. assemble and render a screen image (place assets in z-axis order, place bitmaps, draw out vector effects, calculate any effects such as transparency, logical colour mixing) within the monitor refresh time

5. display that image.

Fig. 4.18 In a sprite animation package, like Director, the separate screen elements overlay each other. The value of the displayed pixel is the result of calculating which object sits in front of the others and how its logical mixing affects the values of underlying sprite images.

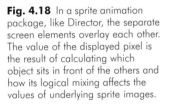

If all that is happening on the screen is a system cursor moving over a static image, smooth and regular movement is not a problem. The Operating System handles the cursor display and screen refresh. But more complex tasks can result in image tear (as the monitor refresh rate and the speed at which a new display is calculated fall out of synch) or a juddering custom cursor that is not convincingly tied in to mouse movements.

Using a large number of sprites, and using large sprites, using compound transparencies and logical mixing (Director's ink effects), all have an overhead in

terms of the third and fourth steps. Fetching bitmap sprites from memory takes time, fetching them from external asset sources such as a hard disk or CD-ROM takes longer. The larger the sprites are, and the more of them there are, the longer it takes to get them to the buffer where the screen image is being assembled and rendered.

The calculation of a final pixel value for the screen display can be thought of as a single line rising through all the elements of the display from the backmost to the foremost. If the elements simply overlay each other then the calculation of the pixel's value is straightforward, it is the value of the pixel in that position on the foremost element. If, on the other hand, the foremost element, and any other underlying ones, has a logical colour mixing property, then the calculation is more complex, and it takes longer to determine the colour value of the display pixel.

Although we are talking a few milliseconds for each 'delay' in fetching assets and in calculating pixel values these can still add up considerably. To refresh a screen to give a believable continuity of movement of 12 f.p.s. means updating the display every 0.083 seconds (every 83 milliseconds). To achieve full motion halves the time available.

A fairly ordinary multimedia screen may include a background image (800 × 600), possibly 10–15 other sprites (buttons with rollover states, static images, calculated animation images), a text box, possibly a Quicktime movie or AVI file, a custom cursor image dynamically placed at the cursor's current co-ordinates. And the machine may also be handling sound (from the Quicktime or AVI, spot sounds on button rollovers).

To achieve continuous smooth movement needs careful design bearing in mind all the factors that may impair the display rate. When designing for a point-of-sales display or for in-house training programmes, where the specification of the display machine is known, things can be optimized for the performance parameters of the display machine. Elsewhere, when working on multimedia that will be distributed on CD-ROM, the diversity of machines used by the wider 'general public' makes the design process more difficult. It is quite usual to specify a 'reference platform', a minimum specification on which the software will run as intended, and ensure that all testing and evaluation takes

Figs 4.19–4.25 Various forms of rollover showing *display* and *alert* states.

Fig 4.19 The red torus comes into focus which conveys a very literal message to the user about where their actions are centred.

Fig. 4.20 The indented surface suggests a plasticity and materiality that relates on-screen actions to real world tactile sensations.

Fig. 4.21 The button lights up, making the text clearer.

Fig. 4.22 The plastic duck dances with the rollover facing right then left and then right again when the cursor moves away.

place on a computer with that specification. That way the designer or artist gains some control over how their multimedia and animations will behave.

In web pages, where the animated multimedia forms happen within the environment of a browser, there is the additional computing overhead of the browser itself. When animating layers using (D)HTML/Javascript processes the usual display refresh speed is between 12 and 18 f.p.s. Shockwave files may run faster and Flash, using vector graphics, can achieve a much higher rate still.

But for web pages the big issue is, and for some time to come will remain, download time. The speed of connection determines how quickly the media assets of the HTML page become available. It is generally thought that users will wait 10 seconds for a page to appear. Designing web animated graphics (rollovers, GIF animations, etc.) that will download in that time on an ordinary connection is an important consideration of the web page realization process.

ROLLOVERS, BUTTONS AND OTHER RESPONSIVE OBJECTS

The rollover is a common animated element within multimedia. The 'come to life' change that happens as the mouse is moved over a screen object confirms the responsiveness of the application. At one level this is a form of phatic communication; it lets us know the thing is still working, that communication is happening. At another level rollovers contribute to our feeling of agency and to our understanding of what we can do and where we can do it within the application.

This section takes a broad view of what rollovers are to discuss some of the principles and issues involved in sprite animation as it is used in interactive multimedia.

Rollovers are *responsive* objects. They change when the user interacts with them. Other *responsive* objects include buttons that change when clicked on, objects that can be dragged around the screen, and text links. In the case of a rollover the change happens when the cursor enters the 'hotspot' that the object makes in the screen display. In the case of buttons and text links the change happens when the cursor is above the object and the mouse button is clicked. In some instances the responsive object includes both modes – the object changes when the cursor enters its area, and

changes again when the mouse button is clicked (and may change again while any action initiated by the mouse click takes place). These changes give a rich feedback to the user about the application's responsiveness, its recognition of their actions, and the user's agency within the work. Rollovers may be clearly marked (having a visual *affordance* that differentiates them from the surrounding image) and may be used as overt navigation devices. The user makes decisions about what to do after recognizing and reading them.

The category of Rollover includes also any 'hotspot area' in the display image. These are the active areas of image maps in web pages, and transparent or invisible objects in authoring packages like Director. The active area may only be recognized because of a change to the cursor or because an action is triggered somewhere else in the display. Hotspots, and rollover objects without clear *affordance*, make navigation a process of exploration rather than route following.

The change that happens with a rollover may be *displaced* or *direct*. That is the change may happen where the cursor is, in which case it is *direct*, or may happen in some other part of the display, in which case it is *displaced*. In some instances the change may happen simultaneously in more than one place – the area where the cursor is may light up to indicate what option is selected while an image elsewhere changes which is the content of that option.

Buttons are a particular kind of active area in multimedia applications. They have a high level of *affordance* which clearly distinguishes them from the surrounding image, and are used to indicate choices available to the user. Their depiction in the 'soft world' of the interface is sometimes a representation of a similar device in the 'hard world' of physical devices. This correspondence between the hard and soft objects means that such buttons have an 'iconic' mode of representation – the soft button looks like the hard physical object. So, a button may have a 3D appearance that gives it the appearance of standing proud of the surrounding surface. Some graphics editors (noticeably PaintShop Pro) have tools that 'buttonize' an image by darkening and lightening the edges to give a bevelled appearance to the image. When the mouse is clicked over these 'iconic' buttons it is usual that the change of state of the object simulates a real world action. The button appears to be pressed into the surface, it changes colour, or appears to light up, and often a

Fig. 4.23 When the picnic hamper is rolled over, it takes on colour and increasing detail; this kind of visual change provides clear *affordance* about actions and opportunities.

Fig. 4.24 The hand of playing cards fans open to suggest either a flawed flush, or a run with a pair, and this play with meaning contributes to the overall tone or atmosphere of the page.

Fig. 4.25 The button has a bevelled edge effect which makes it stand proud of the background surface; on rollover the reversed bevel creates a recess effect, giving a 'soft' version of real world actions.

sound sample provides aural feedback as a distinct 'click'. These literal, or iconic, buttons have many uses especially when a simple and clear navigation is required. Because of their iconic image quality they are suitable for use with audiences who are not familiar with using computers, or ones that have to work readily with a wide range of people.

The 'button' is a multistate object: the current state is dependent on the user's current or past actions. So, we can think of this kind of object as having these states or features:

- **display** – its appearance as part of the display, and to which it returns when not activated (usually)
- **alert** – its appearance when the cursor enters its bounding or hotspot area
- **selected** – its appearance when 'clicked on' to cause the action it represents to be initiated
- **active** – its appearance while the action it represents happens (and while it remains in the display if a change of display occurs)
- **hotspot** – while not a part of its appearance this is the part of the object's display area that is 'clickable'.

Not all responsive objects make use of all these modes. When GIF or JPEG images are used on a web page, for instance, it is the bounding rectangle of the image that is defined as the 'hotspot' area. This can mean that when a GIF with a transparent background is used to have an irregular shaped graphic object, the arrow to pointy finger cursor change that indicates the link, and the clickable area, do not overlay and correspond to the image exactly. By using an image map in a web page an irregular area can be defined as a hotspot separate from the image's bounding rectangle. Similar issues affect sprites used as rollovers in packages like Macromedia's Director, where the rectangular bounding box of the sprite can contain transparent areas. Lingo, the programming language underpinning Director, has a special command that makes only the visible image area of a sprite the active hotspot for a rollover.

Fig. 4.26 In web pages and in multimedia authoring, images used as rollovers need to be the same size otherwise they will be stretched or squashed to fit.

More things about rollovers and buttons

An important issue, in practically all situations, is making sure that images used for rollovers are the same pixel size. Web pages and multimedia authoring packages will usually resize an image to fit the pixel dimensions of the first image used. This has two effects: firstly images may be stretched, squashed and otherwise distorted, and so the designer loses

control of the visual design, and secondly there is a computing overhead in the rescaling of the image which may affect responsiveness and should be avoided.

Web authoring packages like Macromedia Dreamweaver make it relatively straightforward to create rollovers with 'display' and 'alert' states using two images. Usually these rollovers indicate a potential link, and the following mouseclick selects that link and sets in action the display of another page.

Rollovers can be used much more imaginatively than as two state links. Advanced use of Javascript in web pages and underlying programming languages like Lingo in Director, opens up rich possibilities for the artistic use of activated objects. These include randomizing the image used in the alert or selected states so that the user's experience is continually different, causing unexpected changes to other parts of the display than the current cursor position – creating *displaced* rollover effects – and playing spot sound effects or music along with, or instead of, image changes.

It is not necessary to return an activated object to its display state when the mouse leaves the hotspot area. By leaving the object in its alert state a lasting change happens that persists until the whole display changes. This can give the user strong feelings of agency, of effective intervention in the application. Blank or wholly transparent images which change on rollover can become parts of a picture the user completes through discovery and play.

Flash uses self-contained movie (symbol) objects for buttons. The Flash button/symbol editor has four boxes for images which will be used as a button; the first three are used for

Fig. 4.27 Flash uses a 4-state object as a button. The 'hotspot' area (the outline grey image on the right) is defined separately from the *display*, *alert* and *active* state images.

images, the fourth is a map area used to define the 'hotspot' of the symbol/button. The three images define the *display*, *alert* and *selected* states. Having an independently defined hotspot area means the designer or artist working with Flash is readily able to create irregular shaped images with a corresponding hotspot.

Activated objects do not have to be static images. In web pages an animated GIF may be used for the display state and another animated GIF for the alert state on rollover. In Flash the symbol/button images can be, themselves, Flash movies. A particularly effective approach is to use an animation for the display state and a static image for the rollover, alert, state – this has the effect of the user's actions stopping or arresting change in one part of the screen. Similarly in a package like Director where the contents of a sprite are defined in relation to a set of assets (in Director this is known as the cast) relatively straightforward programming can be used to change the cast member currently displayed in the sprite. This would create an illusion of animation. By changing a variable within the code, the order in which the cast members are displayed can be reversed, randomized, changed to another set of images, or whatever the designer's imagination dreams up.

GIF ANIMATION

Animated GIFs are a special form of the .GIF file format used in web pages. The principle and ideas involved in GIF animation illustrate a number of points about animation in multimedia generally as well as specifically for the web.

Animated GIFs are basically a form of image-flipping animation where one image overlays another in turn. The rate at which the images flip is an attribute of the file format and is independent of other surrounding media. This means that animated GIFs can be used for a slideshow (slow rate of change) or for character animations (fast rate of change). Another file level attribute is 'loop'; this can be set to continuous so that the animation plays over and again, and, if made to have a seamless repeat will appear to have no particular beginning or end. 'Loop' can also be set to fixed numbers; a setting of 1 causes the animation to play through once and stop on its last frame.

GIF animations are pre-rendered bitmaps that have a colour depth of up to 256 colours (8-bit depth). The compression algorithm used in the .GIF file format makes it especially useful for images with areas of flat colour – it is not very good at compressing photographic type images or images which are highly dithered. All the images that make up the animation sit within a bank of images that are displayed sequentially. The file size of the GIF animation is a product of

four factors. Three of those – image resolution (X, Y pixel size), the number of frames, and colour depth (2, 4, 5, 6, 7 or 8-bit) – are calculable by the designer. The fourth, the consequence of the compression algorithm, is not predictable without a detailed understanding of how the routine works. In general terms, large areas of continuous colour in horizontal rows compress very well; areas with a lot of changes between pixels will not compress well (fig. 4.28).

For example, the red letters 'GIF' scroll horizontally across a yellow background and disappear. They form an animation which is 100 × 100 pixels image size, which lasts for 25 frames, and which has a 4-bit colour depth (16 colour palette). This information can be used to calculate the 'raw' file size of the animation:

- 100 × 100 pixels = 10 00 pixels for each frame.

- 25 frames × 10 000 pixels = 250 000 pixels.

- 4-bit colour depth means 4 × 250 000 = 1 000 000 bits.

- Divide by 8 to translate to bytes means 1 000 000/8 = 125 000 bytes = 125 kilobytes for the raw file size.

Note: *this calculation is not truly accurate: there are in fact 1024 bytes in a kilobyte – but for ready reckoning 1000 is an easier number for most of us to use.*

Using the optimization tools in JASC Animation Shop 3.02 this animation is reduced to just under 4 kb (a 30:1 compression) and this is fairly standard for an animation that includes simple flat colour areas.

Some GIF animation optimizers will offer a temporal (delta) compression option. This form of compression is particularly suited to moving image work such as animation as it works by saving a reference frame (usually the first) and then saving only the differences between that frame and the next.

Using and making GIF animations

In web pages, GIF animations are flexible and can be used effectively in many situations. Used as the active state of a rollover they mean that a button or non-linked area of the screen can awaken, 'come to life', when the cursor passes over it. And when the cursor moves out of the area the activity may stop, suggesting a quieted state, or the animation may continue, suggesting something brought to life. This coming to life of the 'soft' surface of a button that slowly recovers

Fig. 4.28 GIF animations are pre-rendered bitmaps. The individual 'frames' are displayed sequentially to create the illusion of movement.

from the cursor contact may be simply decorative, providing richer visual interest than a static image. By placing a static image that is the same as the final image of a 'loop once' GIF animation on the screen, the move from static to moving image can be made apparently seamless. This 'continuity' of the visual display supports the user's experience of a responsive system and gives to their actions an appropriate agency within the work.

A wide range of software supports the creation of GIF animations. Some (like JASC's Animation Shop, and GIF animator) are dedicated software packages that import images made elsewhere and render and optimize the GIF animation. This sort of package will often also include some sort of generator for moving text, transitions and special effects. These features allow the user to create frames within the package by adjusting the parameters of a predetermined set of features. Typically the moving text generator tools will allow the user to create text that scrolls across from left or right, up or down, which spins in to the frame, with or without a drop shadow, is lit from the front or back by a moving light. Transitions and effects will offer dissolves, fades, ripples of various kinds.

While dedicated packages like these are very good at optimizing file sizes, care should be taken when using the generator tools. Firstly, because GIF animations are bitmaps adding a few frames for a transition soon increases the file; secondly, the effects add detail in both colour and pixel distribution, and this can increase the file size of the animation considerably. Taken together these factors mean the file will take longer to download. For many users this is something they are paying for in their online charges.

Many image editing and creation software packages (Photoshop, Fireworks, Paintshop Pro) either support the direct creation of animated GIFs or have associated tools that integrate with the main application. In some of these packages particular animation tools such as onion-skins, or layer tools, can be used to provide guides to drawing or positioning sequential images. These tools allow for a pre-visualization of the animation on screen, but when creating an animated GIF, the same as with any animation, it is a good idea to sketch out the idea and some simple images on paper first. We all feel less precious about thumbnail sketches than we do about on-screen imagery so when working with

Fig. 4.29

Individual sprite images can be used in many ways; the following code illustrates how an animated cursor can be realised in Director

set the locH of sprite 4 to the mouseH

set the locV of sprite 4 to the mouseV

This section of Lingo code places a sprite at the co-ordinates of the mouse pointer to create a custom cursor.

global n

set the memberNum of sprite 4 to n

set n to n+1

if n>24 then set n to 19

This Lingo code changes the image property of the sprite used as a custom cursor by sequentially changing the 'cast' member used for the sprite from 19 to 24 – as shown in fig. 4.30.

Note: the global variable n is declared at the start of the Director movie.

paper we are more ready to start again, to throw poor ideas away, to rethink what we want to say and how well we are saying it.

MOVABLE OBJECTS

In many multimedia applications the user can drag image objects around the screen. These objects may be static or animated, large or small, move singly or in multiples around the screen. Some may move relative to the mouse action, others may move independent of it because their movements do not correspond completely to the user's actions.

This category of movable objects includes the custom cursors. In most multimedia applications there are commands to turn off the display of the system cursor, to read the current X-axis and Y-axis co-ordinates of the cursor, and to place a sprite at a particular set of co-ordinates. A custom cursor is simply a sprite that is mapped to the screen co-ordinates of the mouse. By continuously updating the current cursor X-axis and Y-axis values for the sprite it appears to behave like a cursor.

If the image content of the sprite is changed in some way the cursor will appear to animate separately from its own movement. For example, the image asset used for the sprite may change through a sequence that appears to have a continuity within its changes – a dripping tap for example, or sand running through an hourglass.

A sprite has a 'reference point' which is the place mapped to the X, Y co-ordinates. Where this reference point is located (sprite centre, upper left, etc.) varies between applications but most allow the designer to alter it. In Director, for example, the reference point for bitmap graphics is initially the centre of the bounding rectangle of the cast member when it is created. The reference point tool in the Paint window allows this to be redefined. For drawn objects, in Director, the original reference point is the upper left corner of the bounding box.

Some multimedia programming languages allow for 'collision detection' algorithms which determine when a sprite overlaps, encloses or is enclosed by another. Using these it is possible to create movable objects that are dragged around and affect the movements and behaviours of other objects. A good example of this is an image puzzle where fragments of an image have to be dragged into place to complete the

Fig. 4.30 Sprite images that are to be used for sequential animation should be placed in numbered order.

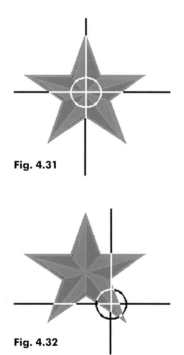

Fig. 4.31

Fig. 4.32

The registration point of a sprite, the point that places it at the screen co-ordinates, is usually in the centre of the bounding rectangle (fig. 4.31), but it can be changed to any point within the area (fig. 4.32).

image. Using movable objects and collision detection to determine when an object overlies another, this is relatively straightforward.

Having movable objects (animateable things) on screen allows the user to feel empowered. The user's experience is that their effect on the world of the artefact is not only what happens when they click on a button but has greater depth and consequence. Moving things around, altering the visual display permanently or for the moment, engages them at a deeper level, deepens the feeling of agency, and involves them in the world of the artefact more intensely.

ANIMATED WORLDS

There is a form of animation that is very different to any we have discussed so far. It is a truly animated medium, and potentially the most pure form of animation because it 'brings to life' not a representation of something contained in a frame of some sort, but a complete world which has no frames because the user is inside that world. What we are discussing here is 'Virtual Reality'.

Virtual Reality exists as a number of technologies of varying complexity, expense and accessibility. The forms to be discussed in detail, here, are ones that are readily accessible. They do not involve the rare, expensive and complex technologies employed for a work such as Char Davies' *Osmose* where the user enters a truly immersive Virtual Reality (for more information about this important VR artwork see *http://www.immersence.com/osmose.htm*). Such works involve Head Mounted Display units, elaborate 6-axis tracking and navigation devices and immense computer processing power. VR, of the kind we are concerned with, works within the display conditions of ordinary computer workstations or games consoles, using the mouse/keyboard or controlpad for navigation.

Importantly, the kinds of VR discussed are accessible in terms of making things because they can be realized on ordinary desktop computers. The first is the panoramic image typified by Apple's QTVR (QuickTime Virtual Reality) and similar products. The second is the volumetric 3D virtual reality typified by games such as *Tomb Raider* and *Quake*. These two forms also exemplify the two dominant approaches to computer graphics – the first is inherently bitmap, the second essentially vector driven.

QTVR

QTVR is a bitmap medium. It uses an image with a high horizontal resolution to form continuous 360-degree images. When viewed in a smaller framing window the image can be rotated from left to right and with some limited tilt. An anamorphic process, inherent in the software, manipulates the image in such a way it appears 'correct' in the viewing window.

Figs 4.33 and **4.34** Panoramic images, used in QTVR or similar applications, are stitched together or rendered as 360-degree sweeps with anamorphic distortion to compensate for the 'bend' in the image. This distortion is visible along the lower edge of fig. 4.33. The display area is a smaller fig. 4.34.

QTVR is generally used as a photographic-type medium. A series of photographs of a scene are taken and these are 'stitched' together into the panoramic format by software which compensates for overlapping areas and differential lighting conditions. Specialist photographic hardware (calibrated tripod heads and motorized assemblies) support professional practice, but good results can be obtained by using an ordinary hand-held camera if thought is given to planning. Apart from Apple's QTVR format and software there are several applications for the Windows platform.

Once the panoramic image set has been created the file can be viewed. When the user moves the cursor to the left edge the image pans in that direction, moving to the right edge causes the pan to reverse. Key presses typically allow the user to zoom in and zoom out within the limits of the image. Of course, as it is a bitmap medium the act of zooming in can result in a degraded, pixellated image. Some limited tilt up and down is available, accessed by moving the cursor to the top and bottom of the image respectively. This navigation puts the user at the centre of the scene, able to rotate and with some limited movement in and out the image field.

The photographic quality of the images and their responsiveness creates a genuine 'feel of presence' for the user and this is exploited in the usual kind of subject matter –

Fig. 4.35 The user's experience of a panoramic image is as if they stand at the centre of the scene and spin on the spot.

The visible 'window' onto the scene can be thought of as a 'field of view' – and it remains 'cinematic' in its framing rectangle.

Limited zoom in and out movement is possible, but the inherently bitmap nature of the image means that this is essentially a magnification of pixels process that leads to an unrealistic pixellated image.

landscapes, hotel rooms, archaeological excavations, great sights and places of interest. Panoramic worlds belong in the tradition of spectacle and curiosity like the dioramas and stereoscopic slide viewing devices of the Victorians.

Panoramic images are remarkably easy to use and to work with. Typing 'QTVR' into a web search engine will produce many examples.

QTVR itself includes tools to create 'hotspots', and to link panoramas together to create walkthroughs from a sequence of panoramic images. The richness of this experience, when compared to a slideshow sequence of consecutive images, comes when you stop to look around and choose to investigate a small detail.

Hugo Glendenning has worked with dance and theatre groups to create staged tableaux photographed as panoramas and constructed as interlinked nodes which can be explored to discover an underlying story. The imagery is of rooms, city streets and its strangely compelling air of fragile disturbance and mystery is carried effectively through the panning zooming navigation of images in which we seek narratives of meaning (see *http://www.moose.co.uk/userfiles/ hugog/* for more about this artist's work).

QTVR objects contain the opposite relationship between viewer and viewed as in panoramas. Where in panoramas the user sits or stands at the centre and looks out at the world as they rotate, with objects, the viewer looks into the space the object occupies. The user's actions control the spin and tumble of the object. This mode of animated imagery is a powerful tool for communicating the design features of small objects such as hairdryers, table lamps, chairs. There comes a point though where there is an increasing discrepancy to the supposed mass of the object and the ease with which its orientation is manipulated. After that point the believability of the object reduces and we perceive not the object but a representation, a toy. This of course returns us to an important feature of all animation – the 'believability' of the object as contained in its behaviour when moving. QTVR files can be viewed on any computer with a late version of Apple's Quicktime player software. They are easily embedded in web pages. Other similar applications may require Java or a proprietorial plug-in to make the panorama navigable.

Fig. 4.36 QTVR objects place the user in the opposite viewing position to that in panoramas. Here the viewer is outside the object which is tumbled in space by their actions.

VR

Believability is at the very centre of 3D navigable worlds. These worlds are generated on the fly in response to the user's actions and the visual image quality of these worlds is defined by the need to keep shapes, forms and textures simple enough to enable real time rendering. These are the virtual realities of *Quake*, *Super Mario World* and *Tomb Raider*. The narrative of these animations is a free-form discovery where the world exists without fixed choices or paths and the user can go anywhere they wish and, within the rules of the world, do whatever they want. These worlds are animated by the user's actions – if the user stands still in the world nothing changes. If, and as they move, the world comes alive in the changing point of view the user experiences and their (virtual) movement through the world.

At the heart of these *generated* animations is the engine which tracks where the user is in the virtual world, the direction they are looking and, drawing on the world model, renders as an image what they can see. To make the world believable the frame rate must be above 12 f.p.s., and preferably closer to 24 f.p.s., and there cannot be any noticeable 'lag' between user's actions and the display changing. Because the calculations involved are complex and computer intensive the virtual 3-dimensional models used are often simplified, low polygon forms. Bitmap textures applied to the surface provide surface detail and an acceptable level of realism much of the time.

To make navigable worlds is not difficult so long as you can use 3D modeling software. Many packages offer an export as VRML (Virtual Reality Modeling Language) filter that saves the datafile in the .wrl file format. Any bitmap images used as textures need to be saved as .jpg files in the same directory. The world can then be viewed using a web browser VRML viewer plug-in like Cosmoplayer. 3D Studio Max will export as VRML objects which you have animated in the working file so that your VRML .wrl can have flying birds, working fountains, opening doors, all moving independently and continuously in the virtual world.

3D navigable worlds of these kinds are used extensively for training simulators and for games. They can be seen to be the ultimate animation, the ultimate 'coming alive', as they create a world the viewer enters, a reality the viewer takes

Fig. 4.37 In a navigable 3D world the screen image (far side) is calculated from information about where the user's avatar (in-world presence) is placed, the direction they are looking in, their field of view, and the properties of the objects they look at (near side).

This immersive view of the world is readily convincing, disbelief is willingly suspended, aspects of the experience which are extended by the strong sense of agency and presence that characterizes the 'free-form' exploration of these worlds.

part in and which is no longer framed as separate by the darkened cinema auditorium or the domestic monitor/TV.

These immersive animations are a long way from hand-drawn early animated films, they mark animation as a medium that has, technologically and in terms of narrative content, matured well beyond the filmic tradition of cinema and television which nurtured it through the twentieth century.

CONCLUSION

In this chapter we have discussed the contribution that animation makes to our experience of multimedia and new media. We noted that in contemporary computer systems and applications animation is an ordinary part of the user's experiences – in things like image-flipping icons, rollovers, buttons, animated and context sensitive cursors that give feedback to the user.

We considered, also, the kinds of 'object' that are found in multimedia artefacts, noting that there are similarities with traditional filmic forms of animation and important differences. In the main those differences rest in 'responsive' objects which react to and can be controlled by the user's actions. This makes the overall narrative of the experience, and of the artefact, modifiable. The responsiveness of objects culminates in the 'navigable worlds' of Virtual Realities which are a special form of animation in that we, the user, sit inside the world they represent rather than viewing it at one remove.

We looked at important underlying ideas and processes involved in the forms of animation used in multimedia and the Web. We considered some of the factors that affect delivery, display and responsiveness. And we looked at the concepts of the timeline and keyframe as ways of thinking about, organizing and realizing multimedia artefacts. Those ideas underpin the sprite-based and vector-based authoring applications which are used to create multimedia and new media content in areas as diverse as educational materials, artworks, advertising, and online encyclopaedias.

Animation in multimedia and new media has an exciting future. Indeed it can be argued that it is with the development of powerful and readily accessible computers that animation has found a new cultural role. Not only have these technologies provided tools for creative invention, they also bring new opportunities for that creativity, new forms of distribution and new sites for its display in the form of interactive artworks, computer games, websites, and a hundred thousand things we have not dreamt of. Yet.

chapter 5

creating artwork for computer games: from concept to end product

by Martin Bowman

Chapter 5
by Martin Bowman
Creating artwork for computer games: from concept to end product

Fig. 5.1

Figs 5.1– 5.3 These images show the first pieces of concept art for a game called *Commando*. They evoke the feel and excitement that the game should have. Art by Martin Bowman, Faraz Hameed and Gwilym Morris. © King of the Jungle Ltd 2000.

INTRODUCTION

One of the many uses of digital animation today is in the field of Interactive Entertainment. Perhaps more widely known as computer or video games, this is one of the most ground-breaking areas of computer graphics development in the world.

The video games development industry is caught in an upward spiral of increasing development times and art requirements as the hardware that makes the games possible becomes ever more powerful. Ten years ago a game would require only one artist to create all the art resources. Five years ago a small team of five artists would suffice for most projects. In the present day, with teams working on PlayStation2, Xbox, Gamecube and advanced PC games, teams of twenty artists are not uncommon. This huge increase in the quantity and quality of art required by the modern video game has created a boom in the market for skilled artists. This makes the video games profession very appealing to Computer Generated Imaging (CGI) students, who, if they have the correct skills, will find themselves junior positions in the industry.

This chapter will look at:

• How a computer game is made, from concept to final product.

• How to create animations for the industry.

• Career options in the games industry and what skills employers look for.

You will find a list of references, resources and tutorials that may prove useful to the aspiring artist in Chapter 8 and on the website: www.guide2computeranimation.com.

The broad-based nature of this book does not allow for in-depth instruction of animation for games. The chapter will explain the different animation systems used in games and

how to work within them to create the best results from the limitations imposed by the hardware.

HOW IS A GAME MADE?

Although creating the artwork for a game is only one part of the whole work, it is a good idea to have an understanding of how a game comes into existence, is finished, published and sold. You will find that whenever you have a grasp of the big picture, it will influence your creativity to a greater beneficial level. This next section will explain the process behind game construction. As usual, the following pieces of information are guidelines only – all companies have their own ways of creating games, but most companies adhere to the following patterns:

The idea

The idea is the start of all games. This is either a concept created by an employee of the developer (usually the games designer) or it is an idea that a publisher has created. Publisher concepts are often the result of a licence that has been bought by them (common ones are film tie-ins, or car brands) and they desire to have turned into a game (figs 5.1–5.3).

Fig. 5.2

Fig. 5.3

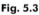

The technology demo

Once the concept has been decided upon, a Games Designer in the developer will write a short concept document outlining the aim of the game, how it is played, its Unique Selling Points (USPs), target platforms and audience, and perhaps an estimate of what resources (manpower and software/hardware) will be required to create the game.

The Games Designer will present this document to the company's internal Producer, who will evaluate it and if he then agrees with its validity, will arrange with the Creative Director to get a small group of artists to create art for the document. If the resources are available, some programmers may be attached to the project to create a real time concept utilizing the concept art (see figs 5.4–5.6). These productions are often known as technology demos, and, although rarely beautiful, demonstrate that the developer has the skills to create the full game.

Many publishers will tender out a concept to several developers at the same time to see which one creates the most impressive demo, and then pick that developer to create the full game. This makes technology demos a very important test for the developer as they know they may well be competing with their rivals for the publisher's business.

The evaluation period

Once the technology demo is ready it will be shown to the publisher who requested it, or if it is a concept of the developer, it will be taken to various publishers or they will be invited to the developer's offices to view the demo. On the strength of this demo the publisher will then decide either to sign the rights to the whole game with the developer, or as is very common these days, they will offer to fund the game's production for three months. This is usually a good indication that the game will be 'signed', a term meaning that the publisher will fund the developer throughout the game's entire development cycle. At the end of the three-month period the publisher evaluates the work that has been created and if it meets their approval, agrees to fund the project.

Contracts, schedules and milestones

The developer and publisher now spend considerable amounts of time with each other's lawyers until they agree a

Fig. 5.4

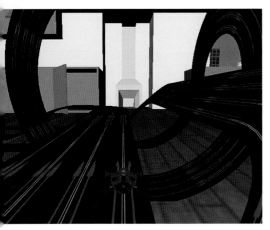

Fig. 5.5

Figs 5.4–5.6 These images show a glimpse of the first technology demo of *Groove Rider*, a game currently in development and due for release in Summer 2002. Art by King of the Jungle Ltd. © King of the Jungle Ltd 2000.

contract. This process can often take one to two months! Once the game is signed and in full production, the publisher visits the developer once a month to review progress on the game. These meetings or deadlines are called milestones and are very important to both publisher and developer, as the developer has agreed in its contract to supply a specific amount of work at each milestone. If these deadlines are not met to the publisher's approval, then the publisher can choose to withhold funding from the developer until the developer is able to meet these criteria. This all means that in order for the developer to get paid every month, it has to impress the publisher at each milestone which often causes great stress on the developer's staff in the days immediately preceding a milestone.

Crunch time

The game continues its development in this fashion until it gets to about three to six months before its agreed completion date. At this point two things happen. First, the publisher's marketing department start requiring large amounts of art to be given to them so that they can send it to magazines and websites to start building up some hype for the game. Second, the game should be at a point where most of its gameplay is available for testing. This fine-tuning can turn an average game into a highly addictive entertainment experience. Testing is primarily the job of the developer's games testers: employees who, during this period often end up playing the game 24 hours a day. Their constant feedback, as well as information from the publisher's games testers and focus groups, provide the basis for art and code revision, which will hopefully help create a better game.

Fig. 5.6

During the final months of the game's development cycle, the development team often has to work very long hours, sometimes seven days a week as bizarre bugs are unearthed in the code, or animations need tweaking for greater realism, or any one of a million different unforeseen problems. Localization issues happen at this time as most games have to be playable in different countries, with different social and language issues to contend with. Some graphics are not allowed in some countries – Germany for example bans the use of any form of Nazi imagery, which means that such art has to be altered in World War 2 games so that they can be sold in Germany.

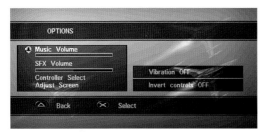

Fig. 5.7

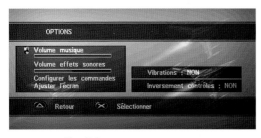

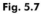

Fig. 5.8

Fig. 5.9

Fig. 5.10

These screen grabs show how cramped a User Interface can get when translated from English to French, German or Italian. Images from *Galaga, Destination: Earth*. Art by King of the Jungle Ltd. © King of the Jungle Ltd 2000.

Different countries mean different languages and at this point the developer often finds that the User Interface (UI) which looked so beautiful in English is now horribly crammed and confusing because translating into another language has increased the amount of letters in each word, causing them to be squeezed all over the display (figs 5.7–5.10).

Greater problems arise with games that require vocal samples in other languages. These often form longer sentences than the original English and so do not lip synch with character animations well, or take up too much extra memory because of their increased length. As an aesthetic consideration, there is also the problem of getting actors to record convincing speech in other languages. *House of the Dead*, an arcade zombie shooting game made by a Japanese company, had sections in the game where other characters would talk to each other or the player. These little conversations no doubt sounded like those of people in a stressful life or death situation in Japanese. However, once they had been translated into English, using Japanese actors with poor English acting skills, these sections turned from atmospheric adrenaline-filled scenarios into completely hilarious comedies, as the Japanese actors were unaware of which words or sounds to add the correct vocal stresses to.

If the already stressed developer is making a game for any other platform than the PC, then they have an additional trial to go through: that of the platform owner's evaluation test. Every game that is created for a console has to pass the respective console owner's (e.g. Sony with the PlayStation2, Microsoft with the Xbox etc.) strict quality requirements before it is allowed to be released. Games rarely pass submission first time, and are returned to the developer with a list of required changes to be made before they can be submitted again. The reason for these tests is to ensure that a game made for a console will work on every copy of that console anywhere in the world. This means that console games have to be technically much closer to perfection than PC-only titles, whose developers know that they can always release a 'patch' or bug fix after the game is released to fix a bug, and let the public download that patch when they need it. Although this is poor business practice, it is a very common situation in the PC games field.

The final product

Hopefully, at the end of this long process, the game is still on time for the publisher's launch schedule (although given the many pitfalls in the development cycle, many games are finished late) and the game is finally unveiled to the press for reviews about two months before it is due on the shelves. These reviews, if favourable, help drive demand for the game, while the publisher's marketing department tries to get the game as noticed as possible, with the hope of making a huge hit. The publisher also tries to get copies of the game on as many shelves as possible hoping to attract the eye of the casual browser. Sales of the game generate revenue for

Fig. 5.11 This is the final box art for the European release of *Galaga, Destination: Earth* on the PlayStation. Art by King of the Jungle Ltd. © King of the Jungle Ltd 2000.

the publisher, which then pays any required royalties to the developer, which in turn funds the development of another game concept and the cycle starts again.

ANIMATION IN THE COMPUTER GAMES INDUSTRY

Animation in the computer games industry can be split into two main areas: Programmer created animation and Artist created animation. Artist created animation can be split up further into different methods, which will be explained later.

Programmer animation

Most games players are completely unaware of how much animation in games is actually created by code rather than keyframes. Programmer animation can vary from the very simple (a pickup or model that bobs up and down while rotating – see figs 5.12–5.15), to the highly complex (all the physics that govern the way a rally car moves across a terrain).

The reason why the programmer would create the code that controls the movement of the car is because this allows the animation to be created 'on the fly' enabling the car to respond realistically to the surface it was driving across. An animator would have to create an almost infinite amount of animation sequences to convince the player that the car they are driving was reacting to the surface it was on in a realistic fashion.

Given that the car was animated by a programmer because of the complexity of its nature, you may assume that the previously mentioned pickup with its simple animation would be animated by an animator. This is however not the case. The reason why it is not is because of one simple game restriction on animation: memory. The code that makes the pickup or model spin in one axis (a rotation transformation) while bobbing up and down (a positional transformation) in another axis amounts to a few bytes of data. To get an animator to keyframe the same animation sequence would require several kilobytes of data, or at least 100 times as much memory as the code animation.

These figures of bytes and kilobytes may sound like paltry sums, but if you watch a game like a 3D platformer (*Crash Bandicoot* or *Mario 64* for example) and count how many different animated objects there are in each level, you will soon see why conserving memory space is so essential. If the

Figs 5.12–5.15 A few frames from a pickup animation sequence. Art by Martin Bowman. © Martin Bowman 2001.

platform runs out of memory, the game crashes! No game developer wants to release a game that does this as it has a very adverse effect on sales.

Just because a game contains programmer-animated objects in it, doesn't mean that the animator's skills are not required. A programmer may write the code that makes the pickup or model animate, but the opinion and advice on how it animates (its speed and the distance it travels in its movements) are usually best supplied by an animator working closely with the programmer. It is the animator's experience of knowing how fast, how slow, how much etc. the object should move that will bring it to life.

Another form of programmer animation that can involve the

Figs 5.16–5.19 The large image shows a variety of explosion textures that were mapped onto various 3D objects, which can be seen in the smaller pictures, and then animated using scripts to create a huge variety of effects from a very small quantity of textures. Art by Faraz Hameed (fig. 5.16) and King of the Jungle Ltd (figs 5.16–5.19). © King of the Jungle Ltd 2000.

animator is scripted animation. Scripted animation is animation made using very simple (by programming standards) scripts or pieces of code. A script is a series of events defined by a programmer to perform a certain action. Each event can be assigned values determining when it can happen and to what degree by animators so that they can achieve more interesting effects. Different explosion effects would be a great example of this (figs 5.16–5.20) – the programmer would write a series of scripts that would govern transformation, rotation and scaling, give them to the animator who would then add his own numerical values to adjust the rate and effect of the animation and apply them to the desired object. This frees up expensive programmer time, allowing them to concentrate on more complex issues. Meanwhile the animators are able to ensure that they get the movement or behaviour of an object correct without having to sit next to a programmer for several hours, while the programmer tries different values to achieve the animation that is in the animator's mind.

Animator animation

Most of the work that animators create in games takes the form of character animation. Character animation is the art of transforming an inert mass of polygons and textures into a boldly striding hero, a skulking sneaky thief, or anyone of an infinite number of personalities. When animating a character or any object that needs to deform – most animators use a system of bones (figs 5.20–5.21), regardless of whether the final game animation contains them or not. Animating these bones is a skill in itself and understanding and creating animation of a professional richness take time and training. There are a number of ways of animating these bones, and these techniques tend to fall in one of two categories: forward kinematics animation or inverse kinematics animation.

Forward kinematics (FK) & Inverse kinematics (IK)

These are the two main ways of animating a character. Before we look at their uses in computer games, it is a good idea to have a brief explanation of how they work, as many artists do not have a firm understanding of the differences between them.

Basically there are two ways of moving parts of a character's body so that they appear to move in a lifelike fashion. As an

Figs 5.20–5.21 A 5000 polygon Tyrannosaurus Rex designed for the Xbox console. Fig. 5.21 shows the model as the player would see it, fig. 5.22 shows its underlying bones skeleton superimposed on top. Art by Faraz Hameed. © Faraz Hameed 2001.

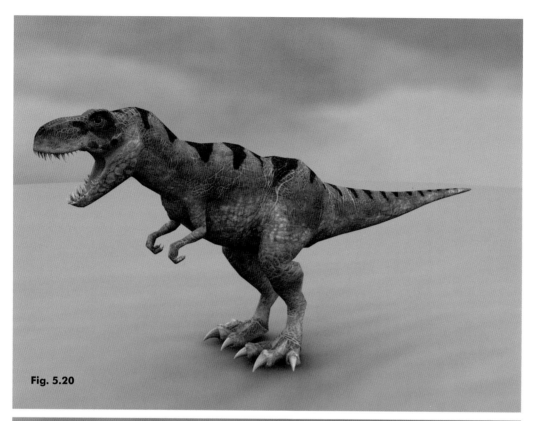

Fig. 5.20

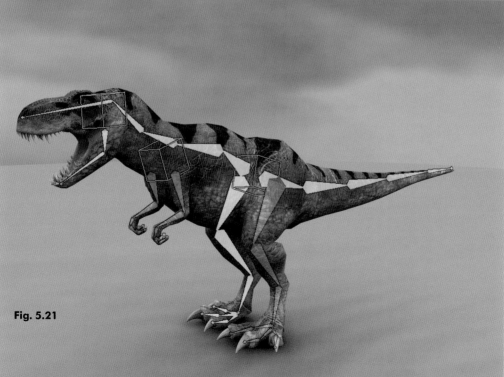

Fig. 5.21

Fig. 5.22

example we will take a situation where a character picks up a cup from on top of a table. If the character was animated with FK, the animator would have to rotate the character's waist so that his shoulders moved forwards, then rotate his shoulder so that his arm extends towards the table, then rotate the elbow to position the hand next to the cup, and finally rotate the wrist to allow the hand to reach around the cup. This is because the forward kinematics system of animation only supports rotation animation. All the body parts are linked together in the character, but cannot actually move like they do in real life, they can only be rotated into position, whereas in reality the hand of the character would move towards the cup and the joints in the body would rotate accordingly based on the constraint of the joint types to allow the other body parts to move correctly.

Inverse kinematics is a system that models far more accurately the movement of living creatures in reality. If the character had been animated using an IK system, the animator would have moved the character's hand to the cup, and the IK system (assuming it was set up correctly) would rotate and move the joints of the body to make the character lean forward and grasp the cup realistically without the animator having to move them himself. Although the process of setting a character up for IK animation is quite lengthy and involved, once correct it is a major aid to animation. All the animator has to do in this instance is move one part of the character's body (the hand) and the rest of the body moves with it in a realistic fashion. Compare the simplicity of this system with the lengthy process of forward kinematics where every joint has to be rotated separately, and you will see why inverse kinematics is the more popular animation system.

Bones

Animators use bone systems to assist them in creating character animations. Animation of 3D characters doesn't have to be done with bones, but the results of using such a system can usually be generated quicker, more realistically and are easier to adjust than any other way of animating. Underneath the mesh (or skin) of every 3D game character is a system of bones that

Fig. 5.23

act quite like a skeleton does in the real world on any creature (figs 5.22–5.25). The bones keep the model together (if it is composed of a series of separate objects, often known as a segmented model) when it moves and also deform the shape of the overlying mesh (in the case of seamless mesh models) so that the character moves realistically without breaking or splitting apart. These bones, when animated move the surface of the body around, much in the same way as muscles on real world bodies move them about and alter the shape of the surface skin. Bones systems, just like real bones act as a framework for the rest of the model to rest upon, just as our bones support all the muscle, skin and organs that cover them.

Depending on whether a model's bones system is set up for FK or IK will determine how an animator will work with the model.

Forward kinematics bones systems

FK bones have certain limitations in that all animation that is keyframed to the parent bone is inherited or passed down to the child bones in the same chain. The parent bone is also known as the root and is usually placed in the body in the area that the animator wants to keep as the top of the bone system hierarchy. This is usually the pelvis, because it is usually easier to animate the limbs, head and torso of a character from this point as every part of the human body is affected in some way by the movement of the pelvis. A chain is any sequence of linked bones, such as might be drawn from the waist to the torso, to the shoulder, to the upper arm, to the forearm and finally to the hand, to create a chain that could be used to control the movement of that part of the character.

When it is said that child bones inherit the animation of their parents, it means that if an animator rotates a bone in a chain, any bone that is a child of that bone is rotated as well. This happens whether the animator wants that part of the body to move or not. As has been previously described, this makes the process of animating a character that wishes to pick up a cup from a table (or execute any

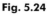
Fig. 5.24

Fig. 5.25

Figs 5.22–5.25 A 3D character from the film *B-Movie* showing its internal bone skeleton, and also showing how bones can be used to deform a mesh to create the effect of muscle bulge. Art by Gwilym Morris. © Morris Animation 2001.

other animation sequence) quite long winded. The animator must first rotate the parent bone which bends the character at the waist, then rotate a shoulder bone to bring the arm round to point in the direction of the cup, then rotate the elbow to aim the forearm at the cup and then finally rotate the wrist to allow the hand to come alongside the cup. Animating the fingers to grasp the cup would require even more work!

Forward kinematics systems are very easy to set up and also easy to animate with (for the beginner), but become difficult and slow to use when an animator wishes to create complex animation sequences. This is why they are rarely used to animate characters anymore. Inverse kinematics, their more advanced cousin, is by far the most popular form of bones system in use today.

Inverse kinematics bones systems

Inverse kinematics systems require much more forethought when setting a character up than FK does. Once set up though, they are considerably easier to animate with, requiring far less work on the part of the animator. IK systems are more complex because in order to create the most life-like movement possible, the joints of the character (the top of each bone) require constraints to be set on them so that they cannot rotate in every direction freely, just like the joints in any real creature. If these constraints are not set up correctly, then when the character moves part of its body (e.g. the hand towards a cup), while the hand may move exactly where the animator wanted it to, the bones between the hand and the parent may flail about randomly, spinning like crazy as the IK

Figs 5.26–5.30 A few frames from a Morph Target Animation sequence for a low polygon segmented model. Art by Gwilym Morris. © Element 1999.

Fig. 5.26 Fig. 5.27 Fig. 5.28

solver (the mathematics that calculates the movement and rotation of bones between the effector and the root) is unable to work out exactly at what angle of rotation a joint should lock and stop moving or rotating. It is normal practice in computer game animation to set up each IK chain to only contain two bones. This is because when more than two bones are connected in a chain, the mathematics to animate their rotation can be prone to errors as it would require too much processing power to perform proper checking on every joint on every frame, so a simpler real time form of checking is used instead. As long as the animator remembers to only use two bone chains, then there won't be any unwanted twitching in the model. If a limb or body part requires more than two bones to animate it correctly, then the best solution is to set up one two-bone IK chain, and then link another one, or two-bone chain to it, and then repeat the process until the limb is correctly set up.

ANIMATION TO GAME

Whatever animation system the animator uses (FK or IK) to create his animation sequences, animations are converted into one of three main forms when they are exported to the game engine. The three main forms are morph target animation (MTA), forward kinematics and inverse kinematics. Each has their own benefits and drawbacks, which accounts for the variety of additional versions of each form, as well as the fact that every new game requires something different to every other game's animation systems.

Morph target animation in computer games

Morph target animation (MTA) works by storing the position of every vertex in the model in space at every keyframe in the animation sequence, regardless of whether any of the vertices moved or whether the original sequence was created using FK or IK. The programmer would take the animation sequence and let it play back on screen, and the model would appear to move because the position

Fig. 5.29

Fig. 5.30

of all of its vertices would morph between all the keyframes in the animation sequence (figs 5.26–5.30).

MTA is the easiest form of animation for programmers to export into a game engine and also requires the least amount of CPU time and power to play back on screen in real time. This made it very popular with programmers in the early years of 3D games. For the animator it offered a simple system whereby as long as the target platform had the power to playback the animation in real time, then what the animator had created would be pretty similar to what was displayed on screen.

One last useful function of MTA is its ability to have the playback time of its animation sequences scaled up or down, as well as the physical size of the model. This enables sequences to be sped up or slowed down if desired without the animator having to reanimate the whole sequence again.

However, MTAs have many serious drawbacks. Because all vertices' positions must be stored as keyframes even when they are stationary, a huge amount of memory must be allocated to storing all this animation data. The early 3D platforms, like the PSOne, had the CPU power to animate MTA characters, but were hampered by only having a very small amount of memory in which to store these animations. This led to characters having very few animation sequences attached to them and with very few keyframes in each cycle, which in turn led to unrealistic motion and characters not having an animation sequence for every type of game interaction that was possible with them. The classic example would be death animations – whether a character was killed by a pistol or a bazooka, the death animation sequence would often be the same to save memory! As you can imagine, this made for some unintentionally hilarious motion on screen.

MTA sequences also suffer from a stiffness of movement, caused when a character has to execute a sudden vigorous movement that must be completed by the animator in a very small amount of frames. Walk and run cycles were often made in 8 frames, and if the character needs to run in an exaggerated fashion, then the character's limbs would appear to snap from frame to frame in order to cover the distance between each keyframe. This effect is very similar to what happens to models in traditional stop-frame animation if the animation process is not being directed very well.

Because MTAs are a totally rigid, fixed form of animation, the characters animated with this system cannot react exactly to their environment in a believable fashion, without an event-specific piece of animation being created for that particular event. The most obvious example of this would be a character's walk animation. If an MTA character was to walk along a flat surface, then as long as the animator can avoid any foot slide, the character will appear to walk realistically across that surface. However, as soon as the MTA character starts to climb a hill, unless a specific 'walk up hill' animation sequence has been created, the model will continue to use the default walk cycle and a programmer will ensure that the whole body of the character is offset from the hill geometry as the character walks uphill. This causes the character's feet to look as if they are walking on an invisible platform that is pushing them up the hill, while their whole body is not touching the hill geometry and almost appearing to float in the air, just above the ground! This very unrealistic solution to how to get a character to walk uphill explains why so many games take place on flat surfaces. Where terrain variation does occur, it is either a very shallow angle so the player is unaware of the fact that the character's feet are no longer attached to the ground, or it is so steep that no character can walk up it.

Forward kinematics in computer games

Forward kinematics animation is the animation system used by most games developers. This is because IK animation still requires more processing power than most platforms have, and it is far more complex to code for than FK. In-game FK animation may be created using IK or FK in the 3D program, and the programmers control the conversion of whatever animation data the animators create into the in-game FK system they are using, including the conversion of bones into the game. FK systems are quite varied from game to game, so not all will have the functions detailed below, and likewise the information below does not cover every possibility.

Unlike normal MTA, a forward kinematics sequence only stores keyframes for every vertex of the model when the animator has specified keyframes in the 3D software's timeline. These keyframes are stored in the bones of the character, just like they are in the 3D program that the animator used to create the original animation. A character's

arm movement, which may have a keyframe at frames 1, 8, and 16, will only store keyframes at these frames. This saves a huge amount of memory compared to MTA sequences which would save the position information of every vertex at every frame regardless of movement.

The FK sequence plays back on screen by interpolating the movement of the vertices between the keyframes the animator has set up. This makes FK animation appear to be more fluid and smooth than MTA. However, it does require enough CPU power to deform the model's geometry in real time, which older platforms rarely had available to them. Of course, this real time deformation is only required if the model to be animated is a seamless skin (one with no breaks or splits in the surface of its mesh). Segmented models (ones that are made of individual parts, usually for each joint section) only require their vertices to be moved by the bones system.

Because an FK animation sequence is composed of specified keyframes separated by 'empty' frames with no keyframes in them, the model animates between those keyframes using a process known as interpolation (figs 5.31–5.33).

There are many different types of interpolation, and most games use either standard linear interpolation (sometimes called rigid interpolation – see fig. 5.32) which is best thought of as a simple linear movement from one frame to the next with no blending, or smooth interpolation (see fig. 5.33), where the movement from keyframe to keyframe is smoothed out on those frames that lie between the keyframes, which gives a more natural appearance to the animation than linear interpolation can. Smooth is the usual choice for FK animation sequences. Bezier (see fig. 5.34), another form of interpolation, is similar to Smooth but adds the additional control that the way the animation is interpolated between keyframes can be altered to allow it to speed up or slow down dramatically. It is rarely used outside of IK animation as it requires far more processing power than smooth interpolation, although it does allow the most realistic animation movement.

Another benefit that FK animations have over MTA sequences is that they enable the programmers to blend different

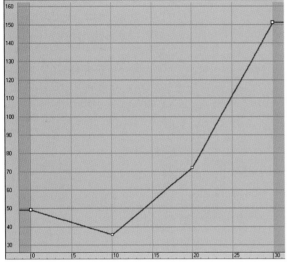

Fig. 5.31

Figs 5.31–5.33 Examples of Linear, Smooth and Bezier interpolation as displayed in a 3D program's Track or Keyframe Editor. Art by Martin Bowman. © Martin Bowman 2001.

animation sequences from different parts of the body at the same time, unlike MTAs which must have a separate 'whole body' animation sequence for every action they need to display. An FK animated character could contain separate animation sequences for each of its body parts within the same file. This means that the character's legs could be animated (a walk, crouch or run cycle) while the upper body remained static. The arm movements would be animated (waving, throwing or firing a weapon) in a different part of the file while the lower body remained static.

During game play, the programmers could allow separate animations to play back at the same time, which means the run cycle could be mixed with the waving arms or the throwing arms or the firing weapon arms. This ability to mix and match separate animation sequences frees up lots of memory. If the same amount of animations were required as MTA sequences then a considerably larger quantity of animation files would have to be created, because a separate sequence would have to be created for a run cycle with waving arms, a run cycle with throwing arms, a run cycle with weapon firing arms and then the whole process would have to be repeated for the walk cycles and crouching movement cycles.

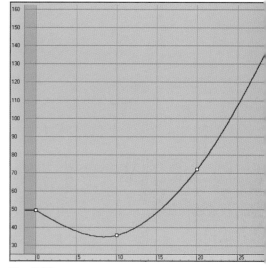
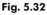

Fig. 5.32

FK animation can also scale its playback and size in the same way as MTA, however, FK animation is able to interpolate the frames between keyframes in a smoother fashion, whereas MTA often can't. The gaps between keyframes still retain their original size as a ratio of the original animation, and these ratios cannot be altered, but by scaling the start and end keyframes towards or away from each other, the entire length of the sequence speeds up or slows down accordingly. This is a very useful function when a games designer suddenly invents a pickup that allows a character to run at twice his normal speed, and there isn't enough memory for that sequence to be made. A programmer just has to write a piece of code that acts as a trigger for whenever the pickup is collected that causes the run cycle animation to be scaled down by 50%, which makes it play back in half the time, creating the illusion that the character is running at twice his normal speed.

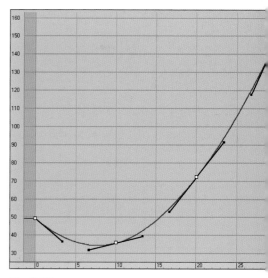

Fig. 5.33

One last very powerful facility of FK animation is that it has the power to contain or be affected by simple collision

detection and physics information. Not all games using FK use this function because it does require a lot of processing power. The bones that move the character can have their normal animation sequences switched off by a programmer if required, and changed from FK to IK, to allow non-animator generated real time deformation to occur. This is most commonly used when a character is struck with a violent blow, or a powerful force moves the character. It enables the actual energy of the force to be used to deform the character's body in a way that still respects the constraints set up in the original 3D program, or uses programmer created ones. This means that a character falls off a moving vehicle, the game engine switches from a movement animation sequence to real time physics to calculate the way the body deforms and moves when it strikes the floor. Of course this physics system also requires collision detection to be built into the game engine so that the character can hit the floor surface, and be deformed correctly by it, regardless of whether the floor surface is a flat plane or a slope. This sort of collision detection is usually only done on the whole body; more complex requirements (such as detection on individual parts of the body) are usually left to IK animation systems.

Inverse kinematics in computer games

IK animation is beginning to be used by a few developers, which means that it will be a few years before the majority of the games development community use it. This is due to the fact that it requires much more processor power than any other form of animation, and is also more complex to code for, as it allows a lot of potentially unforeseeable effects to happen. When an IK animation sequence is converted from the 3D program it was created in to the game, it still retains all the constraints that the animators built into it, but can also hold information on collision detection (collision detection is the process that allows the body of the model to impact with and be repelled by any other physical surface in the game world) and physics at the level of every bone in the character, as opposed to FK systems which can usually only hold this sort of collision detection as a box that surrounds the whole of the character.

IK offers many benefits over FK. It can contain all the constraint information that the animator uses to set up the animation sequences in the 3D program, but keep them in a form that can be used by the game engine. This allows the

model to understand collision detection in a realistic fashion. Rather than having to set up an animation for running up a hill, the animator would just create a run cycle on a flat surface, and if the character ran uphill in a game, the IK system would angle the character's feet so that they were always flush with the floor surface when they touched, unlike FK which would make the character's feet look like they were on an invisible platform above the hill surface. Because the model contains the constraint information, it understands where it can bend or rotate when it is struck by another object (this is often referred to in the games industry as Physics). This adds a huge amount of realism to games where characters can be shot or hit with weapons – their bodies will move in response to the force of the impact of the weapon, and also in a lifelike fashion. They will no longer be constrained to a single death animation that disregards the power of the killing weapon.

A character can be shot in the shoulder and will be spun about by the impact in the correct direction and may fall to the floor, or against another object and also be deformed by this interaction in a realistic fashion, which convinces the player that the model does actually contain a skeleton underneath its geometry. If the IK system is powerful enough, the character may actually dislodge other objects that it comes into contact with if the game's physics engine calculates that they are light enough to be moved by the force the character applies to them.

An IK system also allows 'joint dampening' to be used on the model's body so that when it moves, there is a sense of weight and delay in the movements of the joints of the model. Joint dampening is an additional set of instructions that the animator builds into the bones along with the constraints so that some joints can appear to be stiffer than others or have their movements delayed if the model picks up a heavy object, for example.

WHAT ART POSITIONS ARE THERE IN THE GAMES INDUSTRY?

This section will give a quick overview of the many possibilities open to the artist who is interested in working in the games industry.

There are roughly eight different art positions currently in existence, although as the technology advances, new skills

are required, and therefore new positions are created all the time. This may sound like the industry requires artists to be very specialized in their chosen area of expertise, but in reality most companies want artists who can demonstrate as wide a portfolio of skills as possible. Many developers, especially smaller ones, will have their artists performing many of the roles listed below. However, if an artist works for a large developer he may find that he has a very defined position and rarely has the opportunity to try new areas of computer graphics.

The list below is not meant to be an exhaustive survey of all the job types available, but it covers the majority. The actual name of each job position and the exact requirements of each vary from company to company.

Art/Creative Director

The Art or Creative Director is the highest position an artist can hold and still have some direct input on the art in the game. The Art Director is in charge of the entire art department of the company. He has the final say on all game artwork, allocates the correct artists to the respective game, hires new artists and is the main art contact with the publisher of the game and the publisher's marketing department. He makes the decisions about buying new software. He will liaise with the game designers to solve potential gameplay/ art issues, preferably before they arise. He answers directly to the Managing Director. This company structure is common in Europe and America, however, in Japan there is a Director for every individual project who takes this role only for that specific project. He concentrates on the look and feel of the game. This role is becoming more popular in America. Underneath him the Lead Artist solves all the logistical and technical problems.

Lead Artist

The Lead Artist is the artist in charge of all the art staff on one project. Lead artists usually have several years of experience as other types of artist before they become Lead Artist. They decide which art tasks are assigned to which artists. It is their job to oversee the quality of all art on their project, to research and solve technical issues and to be the main art contact with the programming team on the project. They will also give advice to the other artists on how to improve their work and demonstrate and teach any new software that the

Fig. 5.34 (opposite) A sequence of stills from an FMV sequence for *Galaga, Destination: Earth*. Art by Faraz Hameed and Martin Bowman. © King of the Jungle Ltd 2000.

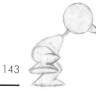

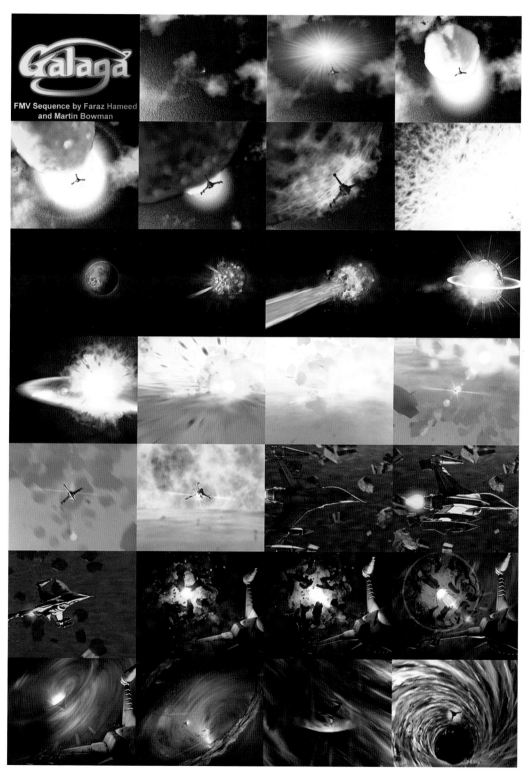

art team may use. They are also the main art contact for the developer's own internal producer.

FMV/Cinematic Artist

The FMV (full motion video) Artist is usually an artist with a very high technical knowledge of a wide range of software, as well as a trained visual eye for creating animations both of the rendered kind (FMV), and also the in-game rendered cut scene variety. FMV sequences are increasingly expected to achieve the same level of beauty that Pixar or PDI create in their CGI films. The FMV sequence is usually used as an introductory movie to bring the player into the game world's way of thinking and explain the plot. See fig. 5.35.

A large developer may have its own FMV department, whereas smaller companies may either outsource any FMV requirements to an external company or utilize the talents of the best of their in-game artists. The FMV artists' skills may combine animation, high detail modeling (polygons and higher order surfaces), texturing, lighting, rendering, compositing and editing, as well as more traditional animators' skills such as character design, storyboarding and conceptual work.

Lead Animator/Animator

An animator is an artist who has specialized in learning how to create lifelike, believable animations (see fig. 5.36). As good animators are very rare, they are usually employed to do nothing but animate – modeling and texturing skills are left to the modelers and texturers. An animator will know how to animate skinned and segmented characters, by hand or possibly with motion capture data, within the tight restrictions of the games industry. He may also have knowledge of 2D animation techniques – skills that are highly regarded for character animation. The Lead Animator fulfils the role of the Lead Artist, except that he is in charge of the animators on a project, and reports to the Lead Artist. In practice, usually only large developers or companies working on animation heavy projects have a Lead Animator.

3D Modeler

3D Modelers, together with Texture Artists make up the bulk of the artists in the games industry. Quite often the two jobs are mixed together. The modeler's job is to create all the 3D models used in the game. The modeler may research and

design the models himself, or he may work from drawings made by a Concept Artist. Good 3D Modelers know how to make the most from the least when it comes to tight polygon budgets (fig. 5.35), as the platforms for games never have enough processing power to draw all the polygons an artist would like. They may also have to apply textures to their models, a process of constantly reusing textures, but in clever ways so that the game player is unaware of the repetition.

Fig. 5.35 A model sheet showing example poses and expressions of a character created by a Lead Animator, which can be used as reference by other animators. Art by Faraz Hameed. © Faraz Hameed 2000.

Texture Artist

The Texture Artist is the other half of the bulk of the artists in the games industry. He needs to possess an excellent eye for detail, and have a huge visual memory of materials and their real world properties. He should have a good understanding of how real world conditions alter and adjust materials, and be able to draw these images. He should be capable of creating seemingly photorealistic imagery, often with very small textures and restricted palettes of colour, but for more

Fig. 5.36 A sports car made of 3000 polygons designed for the PlayStation2 game *Groove Rider*. Art by Martin Bowman. © King of the Jungle Ltd 2001.

advanced platforms he should be able to draw very large 24-bit textures, often up to 1024 × 1024 pixels in size! He should also know how to draw seamless textures – ones that can be repeated endlessly without the viewer detecting the repetition (see figs 5.37–5.38). It is the work of the texture artist that convinces the player that he is interacting with a 'real' world, no matter how fantastic its nature.

Figs 5.37–5.38 Two examples of repeating seamless textures. Both were drawn by hand without any scans and created for use in *Groove Rider*. Art by Martin Bowman. © King of the Jungle Ltd 2001.

Concept Artist

The Concept Artist is skilled in traditional art techniques. He works closely with the Games Designer to provide imagery that describes the look of the game or evokes the atmosphere the Games Designer hopes to evoke in the game. Many of the Concept Artist's drawings will be used as reference by the 3D Modelers to create game objects (figs 5.37 and 5.40). This means that the Concept Artist's work must be beautiful and descriptive at the same time. A Game Concept Artist's

skills are very similar to those used by Concept Artists in the film industry. Potential Concept Artists can learn a huge amount from the wealth of concept material created for films such as *Blade Runner* or *Star Wars*. Usually only large developers have dedicated Concept Artists, so usually the Concept Artist doubles up as a Modeler or Texturer as well.

Fig. 5.39 The concept sketch used to create the car model in fig. 5.36. Art by Martin Bowman. © Martin Bowman 2001.

Level Designer

The Level Designer, or Mapper, works with the Games

Designer to create the levels or environments in the game. Sometimes they will design the levels themselves, other times the Games Designer or Concept Artist may provide a plan and additional drawings of the look of each level. Level Designers usually use the developer's in-house tools to layout and map textures onto the game terrain and place objects made by the 3D Modelers into the game environment. See fig. 5.41. The Level Designers give the finished levels to the Playtesters who make alteration suggestions to improve game play. Level Designers need a thorough knowledge of the in-house tools, and an understanding of the more common free level editors (e.g. Q3Radiant, Worldcraft etc.) is helpful.

Summary

As you can tell, the art department in a games developer is an intricately woven construction. All the parts depend on each other for support, with the Lead Artist or Creative Director at the centre making sure the right tasks are done correctly by the people for the job. Making a successful computer game requires a strong team of artists who work well together and can support each other in times of stress.

Fig. 5.40 A montage of the original level design plans, wireframe of the level's geometry and final textured and lit level model from *Groove Rider*. Art by Martin Bowman. © King of the Jungle Ltd 2001.

WHAT SKILLS DO EMPLOYERS LOOK FOR?

This is a question that many CGI students, or people who wish to work in computer games fail to ask themselves. Most students are unaware that the reason they do not get jobs, or even interviews at least is because the portfolio they sent to the developer does not demonstrate any skills that could be used in computer game development. Unfortunately the work most students create, which may be exactly the right sort of animation or art to achieve high marks in higher education courses, is very far from what a developer wants to see in a portfolio. This does not mean that a student needs to learn two different sets of skills, one for higher education and one for getting a job, it's just that the student needs to focus their creative efforts while still at college to make work that will pass the course criteria and also look great in a portfolio for approaching games companies with. Many animation students have portfolios with different bits of animation in that are neither specific to Games or to Post-Production, the other job market for CGI animation students. If the student wishes to apply to a company successfully, their portfolio must contain work that relates to the artwork the company creates, or the person reviewing the CV will see no point in inviting them to an interview.

Artists applying to games companies should consider first, what type of art position they want and skew the imagery in their portfolio towards this end, and second, include additional general work that demonstrates skills that could be used in many positions in the company. The reason for this is that although the applying artist may have a definite idea of what job they want (e.g. an animation position), they are unlikely to have good enough or technical enough animation skills for an employer to hire them. If they can present examples of animation for games and also some examples of concept art, modeling, texturing or level design, then they stand a good chance of being hired as a junior artist. If an animation student applies with only animation work in their portfolio, unless it is of outstanding quality (and it very rarely is) they will not get a job because they do not demonstrate the additional general art skills required by a junior artist in a games company.

A junior artist is a general position, meaning the artist creates low priority work while learning about how to create art for

computer games. Most animators start off as junior artists, creating models and textures while learning the animation techniques and restrictions from other animators. If they continue to practise and improve then hopefully they may eventually be given the opportunity to move into an animation position.

So what skills does an employer look for in a portfolio? If the artist is applying to be an animator, then they should have examples of the following animation types in their portfolio:

• **Looping animations** (animation sequences which repeat forever without having a visible start or end) using low polygon count models. A walk cycle (in 8 frames or 16 frames) and a run cycle (same criteria as the walk). See figs 5.41–5.44.

• **A spoken sentence**, lip synched to a close-up of a character's face.

• **An example of two characters interacting** (e.g. fighting, talking etc.).

• **An example of a character standing still** (no one ever stands exactly still, and animations are made of the slight unconscious movements people make when they stand still to prevent a motionless character from looking unreal. Look at *Metal Gear Solid 2* or *Half Life* for examples of this type of animation).

Additional animations that demonstrate good skills would be a walk or run cycle of a four-legged animal such as a horse. Also creating a character that has been exported into a popular PC game, e.g. *Quake 3*, and utilizes that games animation restrictions shows excellent games animation skills, but may prove to be a very complex task for a non-industry trained animator. Character animations are also a good bonus, with the movement of the character exaggerated to fit its appearance and demeanour – look at the way characters in Warner Brothers cartoons of the 1940s and 1950s move. Of course it is vital that the animations actually occur at a lifelike speed – most animation students animate their characters with extremely slow movements. In reality, only the ill or very old move this slowly, and this type of animation

Figs 5.41–5.44 A sequence of stills from a walk cycle from the film *B-Movie*. Art by Gwilym Morris. © Morris Animation 2001.

immediately points an applicant out as being a student, and this is not what is usually desired. It is best to impress an employer by appearing to be a professional, not an amateur.

An artist applying to be a Modeler, Texture Artist, Concept Artist or Level Designer should have examples of some of the following in their portfolio:

• **Concept art.** If you have any traditional drawing skills then use them to create concept images of characters, buildings, environments. Few artists in the games industry have decent traditional skills, and ability in this field will help you get a job even if your CG skills are not quite as good as they need to be. However, these conceptual drawings have to be good – characters must be in proportion, buildings drawn in correct perspective etc. and of a style that is very descriptive so that the drawings could be given to another artist to turn into a 3D model (see figs 5.39 and 5.45). If you do not possess traditional art skills then it is better to spend your time enhancing your modeling/texturing skills than wasting it trying to develop a talent that takes most people years to learn.

• **Low polygon models.** It is quite extraordinary how many students apply to a games company without a single example of a model that could work in a real time environment. Admittedly the term 'low polygon' is becoming a misnomer these days with new platforms like the PlayStation2, Xbox and high end PCs capable of moving characters with polygon counts of anything from 1000 to 6000 polygons, unlike the first 3D game characters which rarely had more than 250 polygons to define their shape. If possible it is advisable to demonstrate the ability to model characters or objects at different resolutions. Create one 5000 polygon character, another at 1500 polygons and one other at 250 polygons. This shows the ability to achieve the maximum amount from a model with the minimum of resources available, an important skill as there are still lots of games being made for the PlayStation One (fig. 5.48).

Other important types of low polygon models are vehicles and buildings. Of course these models should be fully textured with texture sizes in proportion to what would be expected of a platform that uses these polygon counts. For example you would probably have either a single 128×128 pixel texture at 8-bit colour depth for the 250 polygon

Fig. 5.45 A concept sketch of a character for a fantasy game. Art by Martin Bowman. © Martin Bowman 2001.

character or perhaps 4–8 individual 64 pixel textures at 4-bit colour depth. A 1000 polygon character would probably have a single 256 × 256 pixel texture at 8 bit or 24 bit with possibly an additional 128 pixel texture for the head. The 3000 polygon character would probably have a 512 × 512 pixel texture at 24 bit with another 256 pixel texture for a face. Of course all these guides are very general – some game engines and platforms can handle far more graphics than this, others considerably less.

• **Textures.** The Texture Artist doesn't just create textures for characters, he has to be able to create textures for any possible surface that might appear in a game. Excellent examples are terrain textures, e.g. grass, roads, rocks and floor surfaces. See figs 5.39 and 5.46.

• These must tile correctly (which means they can be spread many times across a surface and not have a visible seam at their edges, or contain any pixels that cause a pattern to form when they are repeated) and also look in keeping with the style of the game, whether that is realistic or cartoon.

• Many Games Artists can only create textures from scanned photos, but if you have the ability to hand draw them and make them better than scanned textures, then this will get you a job as a Texture Artist. Other good texture types are clouds, trees and buildings. Also try to have textures from different environments, e.g. mediaeval fantasy, modern day, sci-fi and alien. Textures should be created at different resolutions to show the artist is capable of working with the restrictions of any platform. It would be a good idea to have a few 64 pixel, 4-bit textures from a 15-bit palette to show ability to create PlayStation One textures, with the bulk of the textures in the portfolio at 256 pixels in 8 bit or 24 bit with a few 512 and 1024 pixel 24-bit textures for platforms such as the Xbox. It is also a good idea to provide rendered examples of low polygon models with these textures on them, to show the artist's skills in texture mapping.

• **Vertex colouring.** Another useful skill for the Texture Artist is how to paint a model using vertex colours, or enhance a textured model's appearance with vertex colouring. Vertex colouring is a process where the artist colours the model by painting directly on the polygons without using a bitmap (fig. 5.48).

Fig. 5.46

Fig. 5.47

The top image shows a hand-drawn, non-scanned floor texture from *Groove Rider*. The second image shows how well the same texture can be repeated across a surface without a visible repetition occurring.

Every vertex in the model is assigned an RGB (red, green, blue) value, and this value fades into the value of the vertex next to it, creating smooth gradient blends from one colour to the next. Vertex colouring is also good for tinting textures with colour so that the same texture can be reused in the scene more than once and still appear to be different. This saves VRAM memory (the memory on a platform assigned to store textures) which is always helpful as every game in existence runs out of VRAM space at some point in development, and textures have to be removed from the game to ensure that it continues to run at the correct frame rate. Vertex colouring is good at creating nice gradients and subtle light/shadow effects, but it requires lots of geometry to accurately depict a specific design. As it is a subtractive process, if it is to be used with textures, those textures may have to be made less saturated than they normally would be, and possibly lighter as well, because otherwise the vertex colour effects will not be visible on top of the texture (figs 5.49–5.50).

The other reason why vertex colouring is very popular in games is because polygons with only vertex colouring on them render faster than polygons with textures. Some examples of beautiful vertex colouring in games would be the backgrounds in the *Homeworld* game (all the stars and nebulas), and the characters and skies in *Spyro the Dragon*.

• **Level designs.** These are of greatest importance to an artist who wants to become a Level Designer, but they are excellent additional material for any artist to have as they demonstrate the ability to think spatially, and understand how players should move about their environment. Paper designs are nice, but really need to be backed up with some actual levels created for games such as *Quake* or *Half Life*, which are always installed at every developer's offices, so that they can test a prospective level designer's skills out first hand, and look around their levels. Before designing a level, the

Fig. 5.48

Fig. 5.49

Fig. 5.50

Fig. 5.48 A model coloured only with vertex colouring apart from a bitmap used to draw the eyes. Such models use very little VRAM and are often used on consoles that have low amounts of VRAM. Art by Faraz Hameed. © King of the Jungle Ltd 2000.

Figs 5.49–5.50 An example of the lighting simulation possible using vertex colouring. The top image shows a level from *Groove Rider* with just flat vertex colours and textures. The bottom image shows the level after it has been vertex coloured. Vertex colouring and room creation by Martin Bowman, other art by King of the Jungle Ltd. © King of the Jungle Ltd 2000.

designer really should research the sort of architecture he is planning to recreate digitally. Although most real world architecture rarely fits the level designs you see in games (unless they are set in the real world), it still provides an inspirational starting point.

Another great source of material for level designs is stage or theatre design, which is often created on a deliberately vast scale for visual effect, just like computer games. A lot can be learned about lighting a level to achieve a mood from books on these subjects. Lastly, archaeological books can be great reference for creating tombs, dungeons, fortifications etc. that actually seem real. Although many of the Level Designers that create 'castle' levels for games have obviously never seen the real thing, it shouldn't stop them from getting some books on the subject and creating more believable, immersive environments.

Summary

As you can see, it is vital that the prospective artist decides what sort of position he wants before he applies to a company. If the art in the portfolio tallies with the position that the applicant is applying for, then they have a much greater chance of getting a job than someone who just creates a random collection of work and asks if they can get a job as an 'artist'. Sadly enough, this is exactly what most students do, so in order to stand out from them, it is a good idea to follow some of the advice given above.

CONCLUSION

This chapter has provided a brief glimpse into the fascinating and constantly evolving computer games industry. Hopefully you will have as many more new questions about the industry as were answered in this short text. If you are one of the many students who wish to work in the industry I wish you good luck and advise patience and perseverance. If you really believe you want this job, then never doubt yourself or give up and perhaps someday I may well be working alongside you! Those of you who want further information and tutorials should turn to Chapter 8, where you will also find useful references for the prospective junior artist.

chapter 6

tv case studies: looking behind
the scenes at the creation of
network idents and commercials

by Marcia Kuperberg

Chapter 6
by Marcia Kuperberg
tv case studies: looking behind the scenes at the creation of network idents and commercials

INTRODUCTION

Television is so much a part of our daily lives, it's hard to imagine life without it. Consider this: the average person in Britain watches over 25 hours of television per week* and in the USA, over 26 hours**. By age 65, that adds up to nearly nine solid years glued in front of the tube! We're entertained by TV; we're informed by TV and we're *persuaded* by what we see on it. In other words, TV represents mega bucks and has a major influence on our lives.

In recent years we've seen huge changes in television: the advent of digital TV, new styles of viewing such as hard disk recording with instant playback, Internet TV, pay per view of specialist programmes or films via satellite or cable, and last but certainly not least, an extraordinary proliferation of channels and networks – offering a huge range of programmes that cater to our every whim and interest.

How to find your way through the jungle of such choice? Enter the advertising agencies, design studios, and production houses whose job it is to help you find your way to *their* network, *their* programme or *their* product.

In this chapter you get a chance to look behind the enticing imagery that may catch your eye on TV and lead you consciously into an evening's viewing entertainment or, perhaps unconsciously, towards buying a particular product.

Four top creatives from two major production companies (3 Ring Circus based in LA, USA and FrameStore CFC, in London, UK) explain the thinking behind their creative decisions and take you through the production processes involved in rebranding TV networks (3 Ring Circus) and making award-winning product commercials (FrameStore CFC).

*Source: British Broadcasting Corporation; BARB; Taylor Nelson Sofres Ltd; RSMB Ltd; RAJAR/RSL Ltd (1999). **A.C. Nielsen Co. (1998).

To fully understand and appreciate the work you really do need to see the actual moving images. To do so, log onto www.guide2computeranimation.com

FrameStore CFC is the largest visual effects and animation company in Europe. Formed in 2001 through the union of FrameStore and The Computer Film Company, FrameStore CFC has over 30 years' combined experience in digital film and video technology. The company has won numerous international awards, including two Technical Academy Awards from the Academy of Motion Picture Arts and Sciences, and eight Primetime Emmy Awards.

Fig. 6.1

Through the long history of excellence in visual effects they have built up strong relationships with major studios and with individual film directors such as John Woo, Guillermo del Toro, Chris Columbus, Stanley Kubrick, Nick Park, Joel Coen, Neil Jordan and Tim Burton. The commercials department consistently produces award-winning work such as the breathtaking 'Odyssey', Jonathan Glazer's latest contribution to the Levi's campaign, and Daniel Kleinman's spectacle, Chrysler 'Golden Gate'. We look behind the scenes at the making of this and the Cingular Wireless commercials.

3 Ring Circus specializes in developing powerful brand identities for television networks and entertainment companies alike.

In the US, it has developed on-air identities for ABC, Fox Family, Showtime, A&E, Discovery Communications, The Travel Channel, Telemundo, and DIRECTV, to name a few. International clients include Sony Entertainment Television (India, Taiwan and Latin America), Telecine (Latin America), Mega Channel (Greece), RTL (Germany), Viasat (Scandinavia) and Astral Television Networks (Canada). Other companies that have looked to 3 Ring Circus to help shape the world of entertainment and emerging technologies today include Canal+, US Technologies, DES, Netscape, CreativePlanet.com, TechTV, Discovery Digital Networks, and MultiChoice-South Africa.

Fig. 6.2

This multi-faceted company employs a range of strategic thinkers from design, animation and production disciplines, to research, marketing and promotion. 3 Ring Circus is also parent to 3 Ring Circus Films, an independent feature film company. In this chapter, we look at four of its recent major network rebranding projects.

Fig. 6.3 Elaine Cantwell a.k.a. 'Fire Eater'.

Fig. 6.4

TECHTV San Francisco, California, USA

by Creative Director/Director/Designer, Elaine Cantwell

ZDTV's reincarnation as the technology network TechTV began with a re-evaluation of the entire network brand, the technology landscape and the competitive market.

The process of developing the visual interpretation of the brand position for the re-launch of TechTV was defined directly by the creative platform 'Connectivity': how and where the viewer used technology was the inspiration for the journey and context of the four network image spots.

Each spot explores the transformative effect of technology through visual and conceptual perspectives. The viewer is taken on a journey that clearly connects people, products and places through technology.

This tangible expression of the idea of 'Connectivity' is visually simple yet complex in tone and manner. Flat 2-dimensional people transform into full 3-dimensional live action through the touch of a button. Each moment of transformation becomes the catalyst for the next, connecting the dots until resolving finally, with the TechTV logo. The project comprised an entire network re-launch package, from logo development to an image campaign of four spots that all conveyed the message of 'Connectivity'. 'Connectivity' was the common thread that carried through from the series of four 30-second image spots: 'Communicate', 'Connect', 'Convenience' and 'Community'.

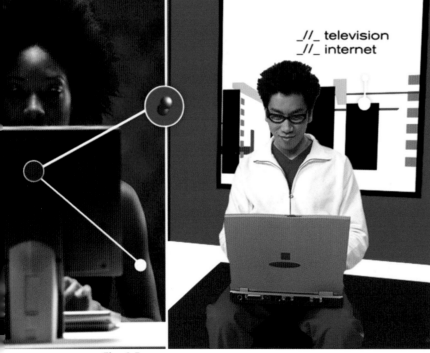

Fig. 6.5

The post-production methodology was experimental in arriving at the most appropriate solution. Many options were explored before arriving at the conclusion of traditional rotoscoping as the most effective way to visualize the transformation from flat to real. Each 2-dimensional environment was created in 3D and expanded as the spot developed. The flat-to-live action transformation began with green screen footage of talent. Each shot was carefully planned and choreographed to anticipate the animated environment in which it would be placed. Each action was then minimized down to basic flat shapes in Henry while still maintaining the essence of fluid live-action motion. Combining both on Inferno completed the effect conveying all the magic of technology at work. The final composite on Henry brought each of the separate elements from Inferno, After Effects and 3D together culminating in a multimedia collage of people using technology in everyday situations.

Fig. 6.6

The effects of interactivity both on the traditional platform of television and the Internet are visible within the TechTV re-launch. In communicating the landscape that technology exists within, the limitations and opportunities of both became the inspiration for the visual interpretation of the message. Connecting both heralds the future of technology as the vehicle that facilitates rather than limits enhanced communication across all boundaries.

Fig. 6.7

Log on to
www.guide2computeranimation.com
to see the commercial.

Figs 6.7 and **6.8** illustrate the theme of *Community*, whilst maintaining the common thread of *Connectivity* at the touch of a button.

Figs 6.4 and **6.5** directly express the idea of *Connectivity*, the common theme of these four network identity spots.

Fig. 6.8

The minimal colour palette of red, black, white and blue was evocative of the ZDTV on-air identity and history, but expanded upon to include blue as an additional element in the TechTV visual language. Combined with the distinctive visual style, this defined the network in a distinctive and fresh manner evoking clear brand recognition in the very aggressive market of technology brands.

Fig. 6.9

Figs 6.9 and **6.10** *Convenience* is the theme portrayed here, one of the primary themes of the TechTV spots to rebrand this network.

Figs 6.11–6.13 below convey the theme of *Communicate*.

Spots of this nature must also carry through the promo elements of 'lower thirds', 'promo opens' and 'closes'. This means that the TechTV identity remains visible but only occupies part of the screen, enabling other programme material to take precedence.

Fig. 6.10 (below)

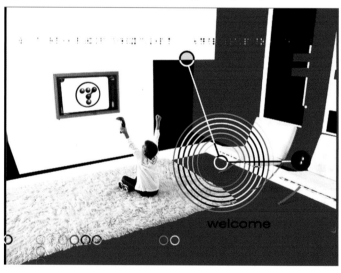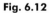

Fig. 6.11

Fig. 6.12

Fig. 6.13

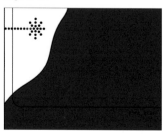

Fig. 6.14 **Fig. 6.15** (below) **Fig. 6.18**

Figs 6.16–6.18 show the character actions minimized to flat shapes using Quantel Henry. The end result transforms the action from these flat moving shapes to live action, placing the characters into a multimedia collage to convey the magic of technology at work.

The final composite was done on Henry, but intermediate stages used Discrete Inferno and Adobe After Effects in addition to 3D animation, the latter evident in figs 6.14, 6.15 and 6.18.

Credits:

3 Ring Circus for TechTV

Executive Producer: Anne White

Producer: Beth Elder

Creative Director/Director/ Designer: Elaine Cantwell

Off Line Editor: Jeremy Quayhackx

Director of Photography: Andrew Turman

Henry: Paul Geiger and John Ciampa, Ring of Fire

Post-House Producer: Casey Conroy, Ring of Fire

After Effects/Inferno/CG: Ring of Fire

Music Composer: Joel Beckerman, Man Made Music

Fig. 6.16 **Fig. 6.17**

Fig. 6.19

Fig. 6.20

Fig. 6.21

MOVIEPIX Toronto, Ontario, Canada

by Creative Director/Director/Designer, Elaine Cantwell

The Moviepix personality was clearly defined through its brand attribute of 'retro-hip', communicating the nature of the programming content through the brand positioning of discovering 'your favourite movies again or for the first time'.

The iconic element of the logo became the inspiration for the entire brand re-launch and creating a place that was recognizable as Moviepix. The simple three-dot element symbolically representing a film reel expanded to become 'Reelworld'. This world established Moviepix as a tangible destination where you can be guaranteed the best in your favourite movies again and again. The three dots were the thread that carried consistency throughout the on-air package while allowing the individual characteristics of the brand personality to come through.

The project comprised of a series of hero ids, with genre ids developed to more strategically target the specific audience. Each id featured a series of film icons, shot in silhouetted style against green screen. By capturing signature icons – the international spy, the starlet, the action hero and the western hero – and actions associated with them, connected the breadth of the Moviepix programming base with the viewer in an emotional context. Each talent was then composited into the 'Reelworld' of Moviepix in After Effects. The environment of 'Reelworld' is entirely comprised of dots, drawing the viewer into the Moviepix experience. The dots were animated in After Effects beginning in the drama of a black world and filling with rich colour as the journey progressed.

The logo resolve in each id was created in 3D to achieve the seamless transition from the Moviepix logo and its mother brand Astral Media, while still maintaining the simple graphic language of the network. The three-dot icon (fig. 6.19) was the common thread that appears as the cornerstone element of the network from Promo Opens, Endpages, Lower Thirds (see following pages) to forming the world for hero ids and feature leads for franchises such as Spotlight Presentation and Reel Premiere.

Fig. 6.22 The Action genre is portrayed primarily using reds and black.

The limited palette of black as the primary colour and the warm portion of the colour wheel – orange, red and yellow – provided a consistency of visual tone while allowing the separate genre characteristics to take on a personality of their own. The golden hues of the environment within the Glamour genre id were more in keeping with the character of the starlet and that era of movie-making. Red hues were chosen to support the more action-oriented id featuring the skydiver. This colour system can also be expanded over time as the Moviepix brand evolves. Maintaining the graphic world of the dots allows for flexibility in exploring other palettes while still belonging to the Moviepix brand.

Fig. 6.23 Signature icons indicate breadth of programming content: shown here and fig. 6.24, international spy; figs 6.25 and 6.26, glamorous starlet.

Fig. 6.24

Figs 6.25 (left) and **6.26** (above) Glamour genre uses recognizable iconic figures and golden hues to target its audience.

Figs 6.27–6.29 These three storyboard concepts were created by 3 Ring Circus for client, Astral TV network, the mother network for Moviepix.

Credits:

3 Ring Circus for Moviepix

Executive Producer: Lori Pate

Producer: Patty Kiley

Creative Director/Director/Designer: Elaine Cantwell

Production Manager: Judy Tanke

Editor/Post-Production Supervisor: Jeremy Quayhackx

Director of Photography: Patrick Loungway

Colorist: Dave Hussey, Company 3

Animator: Josh Graham

3D Animator: Tory Mercer

Henry: John Eineigl, Complete Post

Henry: Bob Engelsiepen, View Studio

Music: Dave Baron, Baron & Baron

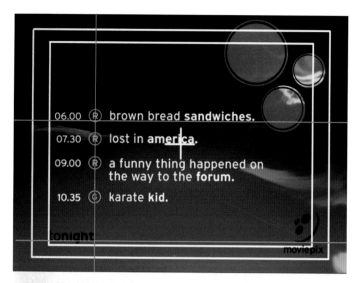

Fig. 6.30 A typical 'endpage' for the Moviepix network using a standard red toned background. The guidelines indicate correct positioning for the various elements that typically make up the screen.

Fig. 6.31

Fig. 6.32

The network identity is carried through the various nights of the week by use of the themed colour backgrounds and the standard positioning of the elements as shown here in figs 6.31–6.36.

Fig. 6.33

Fig. 6.34

Fig. 6.35

Fig. 6.36

Fig. 6.35 is a 'lower third' matte. The black part of the screen allows programme content to show through, leaving the lower third white area (replaced on the TV screen by the graphics of fig. 6.36) which carries through the network id.

Fig. 6.37 Matthew Hall a.k.a. 'High Diver'.

Credits:
3 Ring Circus for The Movie Network

Executive Producer: Lori Pate
Producer: Patty Kiley
Creative Director/Director/ Designer: Matthew Hall
Production Manager: Judy Tanke
Editor/Post-Production Supervisor: Jeremy Quayhackx
Director of Photography: Patrick Loungway
Colorist: Dave Hussey, Company 3
Animators: Matthew Hall, Tory Mercer, Josh Graham
CGI: Amalgamated Pixels
Flint: Dan Carrington, Milne fx
Henry: John Eineigl, Complete Post
Music: Mad Bus

THE MOVIE NETWORK Toronto, Ontario, Canada

SUPER ÉCRAN Montreal, Quebec, Canada

by Creative Director/Director/Designer, Matthew Hall

The Movie Network is an English-based channel that delivers the best of Hollywood to their Canadian viewers and Super Écran offers a wide array of French and French-Canadian films. The network was in need of a complete overhaul that would make a big splash and help solidify it as the source for premier movies in Canada. To package the network, we developed an epic environment that captures the drama and spectacle of classic Hollywood.

The first step in repositioning The Movie Network as the source for premier movies in Canada began with a strategic analysis of the market and an internal audit of The Movie Network's resources. This process helped to define the parameters that the creative must live within.

The second step was to develop conceptual platforms in written form that supported the overall brand strategy. These are broad-stroke concepts that form the backbone of network packages. In this step, the client is exposed to a wide range of ideas before beginning the process of visual development.

The conceptual platform for The Movie Network

Guidance. The Movie Network and Super Écran are virtual pipelines that link viewers to the world of cinema. The Movie Network and Super Écran deliver the latest releases from all the major studios around the world. 'Guidance' positions The Movie Network and Super Écran as the premier showcase for world class cinema. Their virtual networks tap all of the film hotspots around the world and bring the movies directly to the viewer's door.

The ids, through the distinction of 'Guidance', direct viewers to a quality movie experience by drawing them into a rich and sensual environment that elicits an emotional connection. This

epic environment projects an attitude that is full of pageantry and drama, turning the act of viewing movies at home into a big theatre experience. It creates a reverence for the quality of the films that are shown and for the networks themselves.

The ids are the hallmark of the networks, setting a standard for the entire package. The language and attitude of the ids are defined by the following elements: the epic scale of the id environment, the sense of movement and attitude of the live action talent, colour and textural palettes that exist with this environment and a sense of mood and rhythm created by the composed music. All of the supporting package elements must be derived from the ids to create a coherent identity.

The Movie Network and Super Écran use the promo package to guide viewers to movies that they will like. This may seem

Fig. 6.38

Fig. 6.39

Fig. 6.40

Fig. 6.41

like a straightforward statement, but it is not. It is an intellectual process that requires the delivery of information in a clear, consistent voice to assist people in forming their opinions. This can be accomplished through enhancing promo information to include 'directed by... starring...' or adding genre headings. Presenting promo information with attention to detail will reinforce the reverence for a quality movie experience and help support the attitude generated by the ids. Visually, the promo package will be derived from the ids by using similar elements. Transition elements will be created using the live action talent, the fabric and light elements from the logo. Information graphics will be presented on background textures that are generated from the colour and texture palette in the ids. Used properly, these elements create a rich and informative identity for The Movie Network and Super Écran.

There is also an analytical/intellectual component of the 'Guidance' concept that can only be expressed through interstitial programming. Presenting behind the scene coverage – critical review, celebrity film intros and 'film festival blocks' – adds credibility and depth to the pageantry and drama of the network package. In short, it completes the movie-going experience.

The third stage is visual development. Redesigning The Movie Network as the source for premier movies in Canada began with new logo design. The Movie Network logo was based on a stylized film leader (fig. 6.44). The logo isn't a literal interpretation of this movie icon but rather an abstraction that subtly makes reference to it. The entire logo design process took place over a couple months from beginning to end, which included many iterations and refinements.

From here, we moved on to visual development consisting of storyboards and style frames designed and composited in Adobe Photoshop and Adobe Illustrator. The goal of the storyboard is to create a sequence of images that convey the concept as accurately as possible. In this case, it involved shooting fabric with a digital camera, compositing it with graphic elements and found imagery for our 'goddess'.

The production was fairly complex. It involved an elaborate green screen shoot with female talent whose role in the overall design package was to unveil the logo by

pulling off a shroud of fabric. It sounds simple but to create monumental scale in the Hero id we used 3D fabric simulations because the real piece of fabric would have been 60 feet wide by 45 feet tall. Once the elements were created, the whole job was composited in Adobe After Effects. Below is an example of that compositing process.

Green screen. The Goddess's wire harness was rotoscoped out. Then a key was pulled using Puffin's Primatte Keyer and the green was suppressed (fig. 6.42). This provided a matte with which to key the Goddess into the computer generated environments.

Light rays. A series of light rays was created using light effects shot on digital video and applying Ice Effects Light Blast (fig. 6.43). These were then composited in conjunction with the 3D logo to create the final logo resolve (fig. 6.44).

Background. The background was created using stock photography and animated elements from Electric Image and After Effects providing a monumental backdrop for the logo and Goddess to exist within.

Final composite (fig. 6.45). Each element was finally brought together in After Effects to complete the visual interpretation of 'Guidance' to the wonderful world of movies.

Figs 6.39–6.41 The goddess was hoisted eight feet in the air wearing a wire harness that gave the impression that she was flying. A techno-crane was used for multi-axis camera moves that helped with the illusion of flight. See the complete animation on www.guide2computeranimation.com.

Fig. 6.42

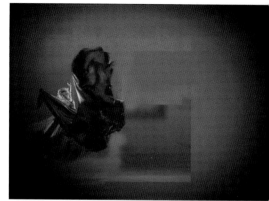

Fig. 6.43

Fig. 6.44

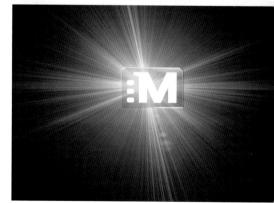

Fig. 6.45

Fig. 6.46 Markus Manninen.

Fig. 6.47 Reference for motel bed.

Fig. 6.48 Final composite frame of logo character, Jack, bouncing on motel bed.

BEHIND THE SCENES OF CINGULAR WIRELESS: TWO 30-SECOND TV SPOTS

by Markus Manninen, Co-Head of 3D Commercials, FrameStore CFC

After having spent some time talking to BBDO South during January 2001 about a cool attitude commercial for Cingular Wireless featuring 'Jack' (the character) on a Harley Davidson motorbike, speeding down a highway with style and attitude, things went quiet for a while. Nothing seemed to be happening, until one day our producer Helen Mackenzie came in looking a bit guilty.

It turns out that the six-week motorbike spot had 'turned into' four weeks and two entirely different spots. My first thought was 'ok, we have four weeks. That's not terrible'. Then it dawned on me, we had two weeks until the first one was to deliver, and then another two weeks until the second one.

Having looked at the boards for the spot, things seemed quite straightforward (see fig. 6.50). The clients were looking for a Motel 6 type of bed with a retro-looking coin box in a simplistic graphical environment. The main issue was obviously making it all in two weeks, and then doing it again for the next spot with the same team.

Martin Carroll, Ulf Lundgren and I had a brief discussion on how to work out the kinks of the production. What could we streamline, what people could be part of it, what could they do most efficiently, and so on (see schedule, fig. 6.60). Since I was going to direct the commercial I thought we could keep the overhead of decision and presentations to a minimum, allowing us up to 40% more efficiency since I could direct the process as it was happening and without any preparation needed from the animators.

After the first conversation with the creatives at BBDO South (Bill Pauls, Steve Andrews, Christina Cairo) a different scenario appeared than the original board (see fig. 6.50). The storyboard was a throw away as far as animation was concerned (which we had almost assumed already). Bill and Steve at BBDO South had something else in mind, and we loved what we were hearing.

The concept behind the commercial is to promote Cingular's 'no time limit' talk time during nights and weekends, where the customer can talk all they want for free. What basically happens in the commercial is that Jack is about to enjoy the vibrating bed. He puts his quarter in, and jumps on to the bed. Almost immediately the Magic Box reaches the time limit and the bed stops vibrating. Hence the time limit. Jack obviously gets upset. Since we didn't want to make him violent we decided to make his reaction of anger a lot more 'cartoony', i.e. funny. The voice-over takes us into the pack shots explaining the benefit of Cingular. As an end gag when Jack finally has given up and walks away from the bed, the bed then starts shaking again.

So how could we think of ways to get things moving fast enough to make it happen? Basically we made a decision to go for a 'shoot first ask questions later' approach. Because of the time limit I wanted all the animators to be as efficient as possible, and not wait around for input or possible changes. We knew what the look was, we should just 'do it'. Things we were happy with, the client would love.

I started doing a previz of the 'Good Vibrations' spot in Softimage|3D at home in the evenings coming to work with a new version ready to send to US for discussion. We tried out rough animation scenarios exploring how much Jack could move and how we could make the camera work interesting in such a graphical environment (read 'WHITE'). We set up a daily 4 pm telephone conference with BBDO South in Atlanta (USA), and started to email quicktime movies and JPEG images to them between 2 and 4 pm every day. The quicktime movies were compressed using Discreet Combustion.

Bill and Steve at BBDO made a new storyboard (fig. 6.51) based on my initial previz from which I then re-designed the previz. During this time Martin created a model of Jack and set the character up in Alias|Wavefront Maya for animation (fig. 6.52).

Fig. 6.49 Jack, Cingular logo character.

Fig. 6.50 (far right) BBDO South (US) storyboard.

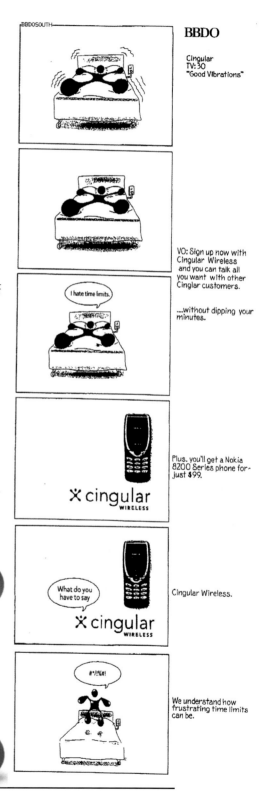

BBDO

Cingular
TV: 30
"Good Vibrations"

VO: Sign up now with Cingular Wireless and you can talk all you want with other Cinglar customers.

...without dipping your minutes.

Plus, you'll get a Nokia 8200 Series phone for just $99.

Cingular Wireless.

We understand how frustrating time limits can be.

Fig. 6.51

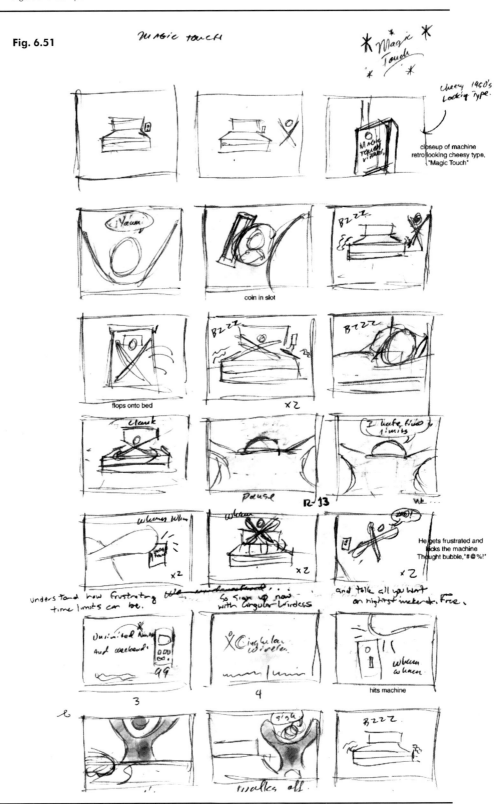

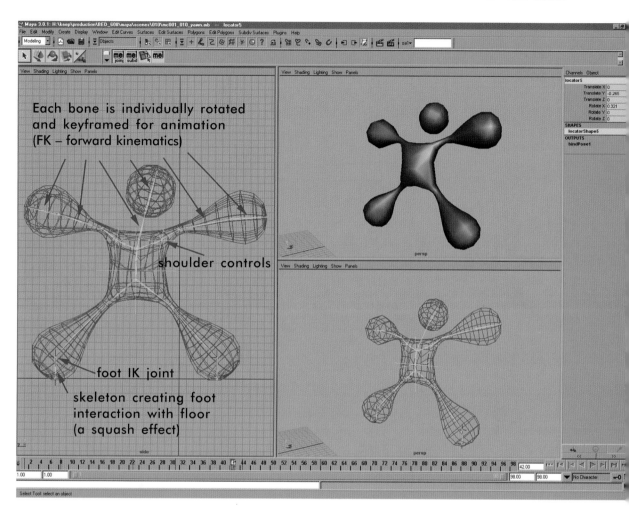

Each bone is individually rotated and keyframed for animation (FK – forward kinematics)

shoulder controls

foot IK joint

skeleton creating foot interaction with floor (a squash effect)

Martin started testing out some of the most important animation of Jack in the spot, including the yawn (see this in the movie of the commercial by logging onto the book's website: www.guide2computeranimation.com). The clients loved the animation, but sadly it was decided that Jack would mainly be in his logo pose most of the time, making our animation a lot subtler. Later (well, two days later) Martin really got to push the subtlety on the shots where Jack is jumping on the bed and when he's kicking the Magic Box. We were trying to make Jack still feel like he was in his original pose, but still have the dynamic motion of a character shifting his weight and reacting to the environment. I think we were successful.

Fig. 6.52 Jack was mainly an FK (forward kinemation) setup, but he had IK (inverse kinemation) controls for both feet and arms if needed. I believe we used the IK on his feet when he was jumping on the bed, but for the rest it was all (FK) keyframe animation. Martin also built in some subtle animation controls allowing us to shrug his shoulders and breathe.

Fig. 6.53 Bed fabric design.

Fig. 6.54 Wrinkle material.

Fig. 6.55 Bed cover.

Fig. 6.56 Bed with cover.

At this point Ulf was still on another job, but he still managed to find time to establish a look for Jack. First in Softimage XSI (fig. 6.50), using 'final gathering' – a way to get realistic lighting – and then matching this look in Maya which turned out to be a major work around because of Maya's limited lighting tools.

Things were starting to pick up in speed. We had a previz 90% there, and we needed to move on to get the animation of the bed to start simulating the cloth. We brought in the previz scenes into Maya from Softimage.

About this time Antony Field came aboard to help us with the simulation of the bed cloth. We decided to go for a non-tucked blanket, giving the cloth a more airy feel of the motion (since the pillow wasn't holding it down). Martin made a rough animation of the shot where Jack landed on the bed, with the bed now moving in Maya. Antony got some good first results of the cloth simulation using Maya Cloth in a scene which we sent to the client (see movie 'cloth-demo' on this book link on www.guide2computeranimation.com). They loved it.

Ulf was working full steam on the building and getting the look of the bed. We had purchased a fabric to get wrinkles of the fabric photographed for texturing as a bump map (fig. 6.54). We couldn't find the perfect looking pattern though. We did talk to BBDO about a sawtooth pattern, so Ulf created a blue pattern using four different shades. On top of this he added a bump map to give the cloth the thick feel of seams in the fabric (fig. 6.55). Steve at BBDO thought the colours were right, but that it would be interesting to see more detail as we get closer to the fabric, so Ulf re-addressed the pattern, adding additional shades in it to give a richness that was mostly visible as we moved closer to the bed. This was looking very good.

Ulf was also designing a wood look. Early on, we showed wood pattern to BBDO that had been downloaded from the web. Because of the limiting size of these web images, we had to find a new wood sample. The one we decided on was close: actually underneath our keyboards. The wood from our tabletops was photographed and adjusted in Adobe Photoshop to work as the wood on the bed. We had a light wood frame and a dark panel making the frame look quite 'tacky', but the client preferred a complete dark version.

Framestore 28/ 2/ 2001

This is crude but here's what i was talking about "ribbing"

Fig. 6.57 Metal reference.
Fig. 6.58 (right) Three angles of
The Magic Box designed by Ulf.

Ulf also did some really amazing work on the Magic Box. The client sent us a reference of the metal look (fig. 6.57) and we talked about getting a cheesy Las Vegas style look to the box. Ulf used this information and came up with a design for the box that made it work with the simplicity of Jack and the bed (fig. 6.58). The agency absolutely loved it. Steve at BBDO took it into Photoshop in Atlanta and added some thoughts into an image (fig. 6.59) that we then used to finish the box. The only change that happened was the cord of the box leading back to the bed. During the compositing we had to remake the cord, making it a little thicker.

I also made this
a little bigger

* I was wondering if
we could make
this type a bit heavier?

Fig. 6.59 Magic Box with further thoughts added by Steve at BBDO.

Antony was using every trick in the book to get the cloth to stay on the shaking bed (see this on the animations link on www.guide2computeranimation.com). The bed mattress and the pillow were both set up as dynamic objects – using soft bodies in Maya – to get the extra effect of the shaking bed. This way they were both struggling to keep up with the motion of the bed, making the effect less rigid. This made the cloth simulation more dynamic and less likely to stay on the bed. The cloth was finally pinned on both sides of the bed, and on the top (beyond the pillow).

We had tried during production to send properly rendered versions of each scene to the US as quicktimes, but since the schedule was so short and the creatives were knowledgeable about the animation process we did convert to sending even Maya playblasts that were quickly converted to quicktime format. This way we could show the creatives at BBDO at 4 pm what we'd done until 3 pm the same day, and keep working on the latest feedback.

After a week of production we were crunching to get the film done in time for compositing. Martin was turning out some

	Markus	Martin	Ulf	Antony	Agency / Client Approval	Agency to supply ideal dates
22nd Feb.	PREVIS/CV	SET UP JACK	TEXTURE JACK AND LIGHTING			BED IMAGERY
23rd. Feb.	PREVIS/CV	ANIMATION	MODEL BED		SIGN OFF ON JACK MODEL	MAGIC BOX REFERENCE. TYPE AND SIDE
24th Feb.						
25th Feb.						
26th Feb.	MODEL BED	ANIMATION	MAGIC BOX MODEL BED	BED DYNAMICS	APPROVE PREVIS - GV - APPROVE MODELS OF BED	FINAL BED PATTERNS AGREED
27th Feb.	ANIMATION	ANIMATION	BED TEXTURE	BED DYNAMICS	APPROVE ANNIMATION TESTS OF OF JACK IN VARIOUS SHOTS	AGENCY TO SEND PHONE TO UK
28th Feb.	ANIMATION	ANIMATION	BED TEXTURE	BED DYNAMICS		
1st March	ANIMATION	ANIMATION	MAGIC BOX TEXTURE		APPROVE BED DYNAMICS & KEY JACK MOTION SCENES	
2nd March	ANIMATION	ANIMATION	LIGHTING SET UP		APPROVE FURTHER JACK ANIMATION SCENES. SEND PHOTOS OF PHONE TO AGENCY FOR APPROVAL	
3rd March	RERENDERING	RERENDERING	RERENDERING ALL SCENES AND PASSES			
4th March						
5th March	ROUGH COMPS OF ALL PLAYERS	KEY CHANGES	KEY CHANGES		SUGGEST AGENCY ARRIVE??	
	KEY CHANGES	KEY CHANGES	KEY CHANGES		** OBVIOUSLY CHANGES WILL BE LIMITED!!	
7th March	RERENDER KEY PASSES	(SEE FLIPPER SCHEDULE)	RERENDER KEY PASSES			

Fig. 6.60

amazing and fast animation of Jack in most shots. I added a hand in a few shots to give Martin time to really get the 'hero' shots perfect.

Kevin McGowan had been working on the fish bowl for the second Cingular spot ('Goldfish'), and was brought in to help Ulf out with the lighting and rendering of 'Good Vibrations' in Maya. We had a meeting with Avtar Baines discussing our options to create the look. We decided to try to make the look come together in compositing, since the Maya lighting tools didn't allow us to create the look that we'd had originally in Mental Ray: the look of Jack had to be soft with a hardback light creating a nice edge effect. This, however, forced us to use five to six light sources on Jack alone. So we ended up setting up a major light (a sun), casting shadows from Jack on to the bed, and the floor. Then we had associated lights that only affected Jack, or the bed, or the Magic Box, to get the look we wanted on each of the objects. Then we split up the rendering so that each object was rendered separately in passes, allowing Avtar to gain control of the look in Inferno render passes (figs 6.61–6.70).

About this time the creative team from BBDO South arrived in London for the compositing. We had an early 'show and tell' of a very rough version edit in Inferno together with Avtar

Baines. Some timing changes were discussed to make Charlie Sheen's voiceover work, but nothing major seemed to be changing. We kept on texturing, lighting and rendering the scenes to get a more complete edit to Inferno. The creatives spent a couple of days on a live-action pack shot of the phone.

This is when lightning struck. Suddenly someone realized that the bed cover wasn't tucked under the pillow. Tuesday night, compositing starting Wednesday, and every shot was possibly incorrect. To re-simulate with a tucked in fabric seemed likely to fail on such a short time scale (less than a day).

After a restless night, we decided to try to fix the problem. Helen had thought of a possible solution. We could animate the fabric around the pillow by hand on top of the cloth simulation, which would then only have to simulate with the moving mattress. This sounded like a workable solution. So Wednesday morning Antony set up the scenes to simulate without the pillow, and I started keyframe animating a moving cloth piece around the pillow. Wednesday evening we were done (see this stage on the animations link on the website: www.guide2computeranimation.com).

At the same time our next problem became apparent. The Maya Render wasn't rendering our passes correctly. Some

Fig. 6.61 Sharp (raytraced) shadow matte on the floor (from bed).

Fig. 6.62 Soft (raycast) shadow matte on the floor.

Fig. 6.63 The carpet texture of the floor (only visible in the shadow).

Fig. 6.64 The final composite after Avtar had his way with it.

RENDER PASSES FOR COMPOSITING IN INFERNO

Fig. 6.65 Jack's beauty pass.

Fig. 6.66 Jack-bed-bounce-matte.

The bed was giving Jack a blue tint as he landed on it, this matte allowed for it.

Fig. 6.67 Bed beauty.

Fig. 6.68 Bed without highlights, allowing knocking the highlight back. This bird's eye view was picking up a lot of unwanted highlights.

Fig. 6.69 Bed without shadows of Jack, allowing for colour correction of Jack's shadow on the bed.

Fig. 6.70 Magic Box beauty.

Fig. 6.71

Fig. 6.72

Fig. 6.73

passes just stopped mid-rendering, some passes rendered with artefacts making them unusable for compositing. So for the next 48 hours we were re-setting up scenes for rendering and baby-sitting our render farm. Friday evening at 10 pm I finally walked out of the building. Every pass was working, and Avtar was getting it all done in Inferno with the help of Nick Bennett, although he was looking as tired as I was feeling. But the spot was looking alright.

Saturday morning. I woke up immediately remembering that I had to start working on the previz for the next Cingular spot 'Goldfish' – to be completed in 13 days. But that's another story.

In retrospect this first Cingular commercial was done with a little bit too short of time for comfort, but the team did make it work brilliantly. We started off with two animators and had another three plus two Inferno operators by the end. We could have possibly made things a little easier using our pipeline tools more, but these changes were implemented for the 'Goldfish' spot – and made all the difference when finishing the second spot. It was a testimony to how good people can do good work together.

TOOLS:
Previz: Softimage | 3D v3.9 Extreme
Softimage XSI v1.0
CG software: Alias | Wavefront Maya v3.0 Unlimited
CG simulation: Maya Cloth
CG render: Maya Render
3D compositing (work in progress): Discreet Combustion v1.0
CG hardware: Max Black 2 × 800 MHz Intel P3 (Windows NT). Max Black 1.33 GHz Athlon (Windows NT)
Compositing software: Discreet Inferno
Compositing hardware: SGI Onyx

CREDITS:
Animation and Post-Production: FrameStore CFC
Director: Markus Manninen
Producer: Helen MacKenzie
3D
Markus Manninen
Martin Carroll
Ulf Lundgren
Kevin McGowan
Antony Field
Inferno Artists
Avtar Baines
Nick Bennett

Advertising Agency: BBDO South
Agency Producer: Christina Cairo
Group Creative Director: Bill Pauls
Art Director: Steve Andrews
Copywriter: Mike Weidner

THE MAKING OF CHRYSLER'S 'GOLDEN GATE'

by Andrew Daffy, Co-Head of 3D Commercials, FrameStore CFC, UK

A twisted idea

I came into work one spring morning to find a storyboard had been left on my desk. It had been faxed to FrameStore CFC overnight but something in the transfer had caused it to be highly degraded with large black noisy areas covering the frames. At a glance I could see cars, a Chrysler logo, and some tugboats. It was only after closer inspection that I realized I was looking at a suspension bridge, which had been bent into a series of S-shaped curves, similar to a racing course!

I remember thinking 'they're not thinking what I think they're thinking!'

Fig. 6.74 Andrew Daffy.

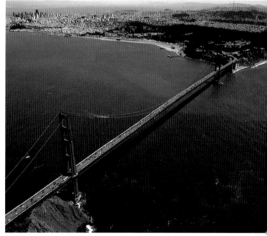

Fig. 6.75 The Golden Gate Bridge, San Francisco.

Fig. 6.76 Storyboard faxed to FrameStore CFC by advertising agency, FCB Detroit.

The board had been sent by the US agency FCB Detroit, so when the US woke up later that day, we got them to send it again. The idea had come from FCB's copywriter and creative director, Mike Stocker – the idea being hundreds of tugboats hooking themselves onto the Golden Gate Bridge in groups, and pulling in opposite directions. The resulting twists gave the Golden Gate a theme-park-style, twisty road, perfect for testing the new range of Chryslers, named Sebrings (fig. 6.76).

Of course we took to the idea immediately, more so when we found out it was to be a 60-second spot. Finding out that Daniel Kleinman had been asked to direct it was the icing on the cake.

Daniel Kleinman is one of the UK's leading commercials directors. On top of this he has directed the last three James Bond opening sequences. His commercials always have had a wonderful dry wit, and he owns more awards than you could shake a stick at. Bertie Miller was the UK producer for the project. Bertie works out of Spectre, where he is MD. Lance Anderson was the US producer for the project, working out of Ritts Hayden.

First contact

To co-supervise the effects on the job, William Bartlett came aboard. He would also be the principal compositor. He had worked on Daniel's projects before, and possesses vast experience on sets, so it was more than useful having him around. The day before our first meeting with Spectre, William and I received a copy of Daniel's treatment. The treatment is usually a one-page synopsis of the spot. It discusses things like mood, pace and motivation of a piece.

The initial meeting was scheduled, which was where Daniel could share his thoughts with William and me. By that point, Spectre hadn't yet chosen the post house to award the project. These initial meetings can often be daunting. It's our chance to sell our team, our technology and creative ability. In its simplest terms, we're being interviewed for the job! We have to tread carefully though. We are aware that too much input at such an early stage can sometimes make us appear overpowering. We merely try to instil confidence at this point.

The meeting was mainly driven by Daniel explaining in detail how he saw the piece taking shape. His main concern was

for the CGI bridge. He wanted to make sure that in every shot of the final spot, it looked utterly realistic. I remember slipping up a few times by entering 'quites' and 'almosts' in the conversation when we were discussing the CGI bridge's reality. I was quickly corrected!

There were many complicated compositing issues with the project. Therefore William questioned Daniel in depth, and offered up lots of solutions to Spectre's queries.

I was keen on introducing Daniel to previsualization. This is a process that goes beyond the animatic. Created in 3D software, it's basically a technique of setting up virtual cameras in simple blocky versions of the actual environments in order to 'previsualize' a sequence before it gets made. This is hugely beneficial to effects laden work. We even have a previz showreel at FrameStore CFC highlighting this process created for these types of meetings. Introducing new tools to a director needs to be done with care, especially if it affects the way they shoot their film.

Daniel also wanted a really good storyboard drawn up. In general though, we find that there is inevitable artistic license in both 2D animation and in storyboards. This is fine to define a mood, but can be fatal when images that are visualized without referring to real dimensions get sold to clients, and then turn out to be impossible to realize within a film camera or in 3D software. Therefore Daniel suggested that the artist could take reference from angles visualized from our simple CGI bridge. The design of the bridge was the first of many challenges to come (fig. 6.77).

The core team

There were four key people overlooking the project at FrameStore CFC, who led eleven other FrameStore CFC operators and animators. We figured that these four main people would be able to cover the creative, technical and political angles of the production.

Helen MacKenzie – Producer. Helen is a senior producer at FrameStore CFC who deals almost solely with the CGI department. In her role on Chrysler, she would attend all the meetings, quote the job, discuss and plan the schedule, deal with Spectre, the production company, and FCB Detroit, the agency, organize FrameStore CFC's involvement with the shoot, and generally make sure that the

2D and 3D operators had the suites and the tools required to perform their tasks. Then throughout the production, she would monitor our progress and ensure the deadlines were met.

William Bartlett – VFX Supervisor. The success of this commercial would be dictated on the whole by its realism. Therefore William would ensure he had all the correct elements to bring great shots together, i.e. he'd have a say in the plates Daniel shot in San Francisco. He'd make sure our CGI version of the bridge looked good enough to composite into his photorealistic scenes. He'd also be using Discreet Logic's Inferno to composite the bulk of the shots himself. Ben Cronin would assist William, by painting mattes, bridge removal, tugboat replication, and would carry out full composites on a few shots also.

Andrew Daffy – CGI Supervisor. We wanted to make sure that Daniel was always heard throughout the production. I've found that directors tend to fear the CGI process. I think it's partly down to where 3D has come from. Unreliability, slow render times and the old-school digital look have all aided in giving it a bad name. Though I find the main problem comes from the fact that the director never has much influence over the shots once in the CGI realm. We therefore decided that I would be the liaison between Daniel and our department.

As well as making sure that Daniel was looked after, I also wanted to make sure our team was running as efficiently as possible. It was becoming more apparent that we'd be having to deliver the commercial sooner than we'd have liked. Therefore I was keen to make sure that we were only doing work that was relevant. With a great deal of shots to contend with, plus an abundance of creative input from all angles, we felt that I should be present with Helen at all meetings, hear every comment, attend the shoot in San Francisco, previsualize (previz) the commercial, and supervise the whole 3D production, so that everyone else in the team could focus on their work, and not be bogged down with other issues.

Andy Lomas – R&D, Technical Supervisor. Andy at the time was Head of 3D at FrameStore CFC. A visionary in the field, Andy always keeps his ear to the ground and has a knack of pre-empting the next big thing about to shake the CGI world. He then thinks of a way of turning that concept into a tool

that can be implemented into the FrameStore CFC system. For example, we decided early on to split the work between Avid's Softimage and Alias|Wavefront's Maya.

We have all of our animation, previz and tracking tools in Softimage, whilst Maya is capable of natural cable dynamics, and has wonderful deformation tools which would aid the bridge's bend.

Our problem arose out of transporting scenes between Softimage and Maya, which had always been a challenge. Off-the-shelf software only took us so far in the transfer. Therefore with our senior developer Alex Parkinson's help, Andy set about the challenge of writing the FrameStore CFC conversion software.

Design

Distorting simple geometry in 3D is quick and easy. Fig. 6.77 shows the progress of the bridge design, each time after comments by Daniel. After the design was approved, he was keen to see how it would look in the real bay.

Spectre, the production company, searched archive after archive of GGB photos. After sending us five, animator David Hulin and I endeavoured to match the angles in the computer. We then used Adobe Photoshop to replace the original bridge with our 3D rendered version. These stills and others were sent to the storyboard artist, Temple Clark, who with Daniel's brief, began to draw (fig. 6.78).

Fig. 6.77 Design for the twisted bridge.

Our previz

As mentioned, we're very keen on helping directors realize their film by offering previz as a tool that can help plot out their whole commercial. Before this though, a 60-second 'animatic' usually gets made. The pace of a commercial needs careful timing. The animatic helps by inserting storyboard frames over the length of the sequence. This will only go so far in aiding the production of a commercial. The previz uses virtual cameras that match those on set, including

lens information that can be fed straight into cameras on a real film shoot, making it a far more useful process.

The expense of finding interesting camera angles in 3D is vastly lower than doing it with a crew of 50 people on location. 3D operators have never had much of a presence on location shoots until the last few years. Our live-action-based commercials rely on a 3D operator to assist the director and modify the previz online.

Fig. 6.78 Storyboard mockup of twisted bridge (illustrations on right of the above board) compared with the real bridge (shown on the left).

As we couldn't film the Chryslers driving along a bent bridge, we needed to film them on an area of road that was broad enough to re-enact the girth of a bent bridge. Also, reflections in the metallic car would need to be minimal (we'd be adding our own bridge reflections later). It was

decided that a disused airport runway in the Californian desert would be ideal (fig. 6.80).

How does this affect the previz? Well, we found previzing the action with a digital bridge very good at easing the minds of clients who for a few weeks would be used to seeing a lone car driving through a desert, when eventually it would be driving along the bendy bridge. Naturally, this interim stage can make clients rather nervous.

Our previz ended up being a combination of 3D shots and storyboarded images (fig. 6.79). Shots that would start and end as live action such as a hand on a tugboat throttle needn't be prevized: in such cases, the storyboard frames would do fine.

Shooting plates

The shoot would be based both in San Francisco Bay and in the Californian desert, a total of ten days. We decided that both William and I should be in San Francisco, and then I'd go back to the UK to deliver and organize the near 500 photographic stills I'd taken, which could then be mapped onto the bridge. In the meantime, William would assist the desert shoot of the Chrysler cars.

I remember when we travelled from the airport towards the bay, seeing the bridge, far off in the distance, greyed out by the fog, early evening, it felt like a mission. A crew of people in a black Spacewagon, setting out to 'shoot' the bridge!

The morning calltimes were early, but that was balanced by the luxurious hotel and the excellent food that we were treated to out there.

We prepared for the shoot by scanning a map of the bay area we found on the web. Multiple copies of this were made, one per shot. Then from taking measurements from the 3D environment, plotted co-ordinates drawn on the map would guide the helicopter-assisted Wescam where to be, in order to match the angle from our previz.

William was up in the helicopter with the pilot and cameraman, whilst I attended the other crew and Daniel on the boat. It was amazing seeing the overnight rushes each morning, seeing the real bridge shot based on my computer co-ordinates. I kept in touch with the progression of the work back in the UK via the Internet.

Fig. 6.79 Three stills from the previz.

Back at base

Senior animators, Kevin McGowan and Jake Mengers, had gone a long way in figuring out the most efficient way of modeling and texturing the bridge.

They had the tremendous task of making a bridge that would look utterly realistic, from a distance, and close up, underneath and overhead. Never before have we used a 3D model so extensively from every angle. And as it was Daniel's number one cause for concern, it was our main priority to get modeling as soon as we received go-ahead. Both Kevin and Jake specialize in using Maya. They split the bridge into 15 sections, and two versions were made of each, one low resolution and one high resolution. A low resolution version would comprise 75% of the composition of a shot. After a certain distance, granules in the road, rivets in the bridge aren't seen, so to keep render times down, these 'low-rez' versions were essential. The 'high-rez' bridge would be used for those extreme close-ups and the foreground areas that the Chrysler cars would drive over.

Alongside, Andy had written systems that bent bits of fencing automatically, shook the suspension cables so they reverberated like harp-strings and created the hawsers connecting the bridge to the 101 tugboats. And again the hawser rope had Maya dynamic properties so that it sagged when loose and sprung when taut. It should be said though that these incredible Maya dynamics are only automatic when set up correctly. Careful crafting is required to give them the right attributes in the first place. These were set up by our Senior Technical Animator, Antony Field. Antony also was responsible for animating those few cables that snapped during bend phase due to them reaching their extremes. Of course, after Antony made the fall of these cables look so convincing, we knew that we should feature them more in the main commercial. Visit the website www.guide2computeranimation.com and notice the shot at the end of *dynamics.avi*, the shot dedicated to his dynamic cables. See the cable dynamic tests – *hawser test.avi* – on the website.

The cut

There are some things that can't be previsualized. There is an energy to top car commercials that's hard for a CGI team to capture. Therefore the dynamic timings were carefully edited and finessed by top UK Soho editor, Steve Gandolfi, of Cut And Run.

Where shots were to be completely digital, bits from the previz were laid into the edit. See *previz.avi* on the website.

Matching virtual to reality

In a 60-second edit with around 40 cuts, 30 of those would need a CGI bridge inserting to replace the original. Therefore, once all of the background plates had been shot and cut to length, they got graded and scanned into the computer using a Spirit. This pricey piece of kit takes the 35 mm film and transfers it to digital frames. In the process, the hues, contrast, and saturation of the film can be altered or 'graded' to suit the needs of the director. This was done by our Senior Colourist, Dave Ludlam.

Once the frames were on our network, Chris Syborn, David Hulin and I began the arduous task of tracking. This is the process of matching camera angles and objects shot for real with virtual cameras and virtual objects, such as our Golden Gate Bridge. Frame by frame the two bridges would need to line up together. Having prevized the shots to begin with helped somewhat, but due to real camera shake and all the other imperfections of a non-digital move, it was almost like starting from scratch. Tracking long shots of the bridge proved fiddly, but not difficult. Because the original bridge stayed in frame throughout, we always had a good solid reference to lock to.

Tracking shots that were hand-held of cars in the desert were more of a problem. Our only reference to what would really be going on in the scene was the swerved road markings on the ground.

Software exists that can do tracking semiautomatically, but we chose to do it all by hand so as to have absolute control of the environment. You can also see this on the website: look for the link to *bg plate – tracking marks – with cars .avi*

Animation

In animation terms, bending the bridge to its full amount over 40 seconds doesn't immediately suggest a lot of special work. But Daniel was very keen to feature certain shots where the tugs gave the bridge an initial pull, and to see the whole bridge shake and reverberate. Almost like loosening it up, before they really start bending it. It was a very tricky thing to do when you're trying to convince your audience that this situation is plausible. Varied amounts of shake were added

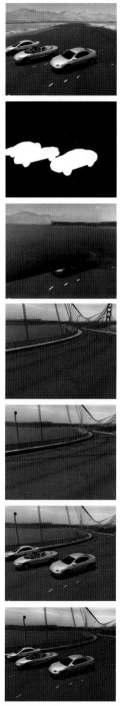

Fig. 6.80 The cars running on the desert track are later cut and matted into the CGI twisted bridge.

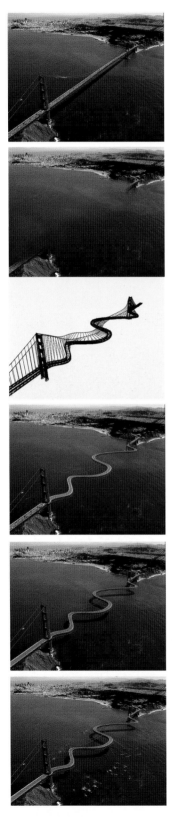

until we got the right balance between barely noticing and it being too light and bendy. I wanted people to be thinking 'did I just see that bridge move?'.

Final touches

The matte painting team under William and Ben's instruction was set to the task of removing the real bridge from the long shots: sections of water are taken from areas located near the bridge and 'pasted' over the bridge, thus removing it from frame.

The Chryslers that were filmed in the desert would need removing from their sandy background in order for them to be inserted onto our CGI bridge, which in turn would lay onto the digital San Franciscan bay. The cars therefore needed mattes; these black and white images are painted frame by frame by our matte artists team. They are basically a silhouetted version of cars. In the compositing process in the edit, the computer uses these to calculate which part of an image to use and which to throw away, a bit like a pastry cutter (fig. 6.80).

Things like shadows, digital motion blur and the reflections of the bridge in the sea, all help make CGI look realistic. Daniel needed to approve the bridge structure before we generated all of these 'passes' involved in making it photoreal. Therefore we rendered a basic pass of each shot, which we composited roughly over the background. From this, Daniel could see his whole commercial at an accurate level of detail, but without the bells and whistles that would finish it off.

Then Jake, Kevin and 3D animator, Jamie Isles, started to tweak different settings in Maya that would affect the digital lights that would allow the bridge to casts shadows, and the motion blur tools to help match the 3D image to that created in a real camera. Reflections were also made of the bridge in the sea.

We also couldn't shoot more than one tug at a time, making a distant shot featuring 101 tugboats impossible. CGI stepped in again and based on photos we took, the mass of boats were replicated and placed over the background, each churning their own digital wake.

Fig. 6.81 Stages of the transformation of the Golden Gate Bridge.

The compositor would blend all of these elements together along with the matted cars in order to create a completely realistic scene.

With all shots complete, Daniel's final job at FrameStore CFC was to reuse the talents of Dave Ludlam in Spirit to give the whole commercial a final grade. Daniel was keen that the shots should not look like those seen in a picture postcard. The newly contrasty grade made the spot that bit edgier and contemporary (fig. 6.82).

The commercial was a huge success worldwide, quickly becoming a very recognizable piece of work in America. Our international friends in the animation industry were full of praise for the spot. It also received the 2000 London Effects and Animation Festival (LEAF) award in the 'best live action commercial category'. We are delighted with the results, but more so, knowing that Daniel enjoyed the experience!

Fig. 6.82 Final film grading avoids the picture postcard look for added realism.

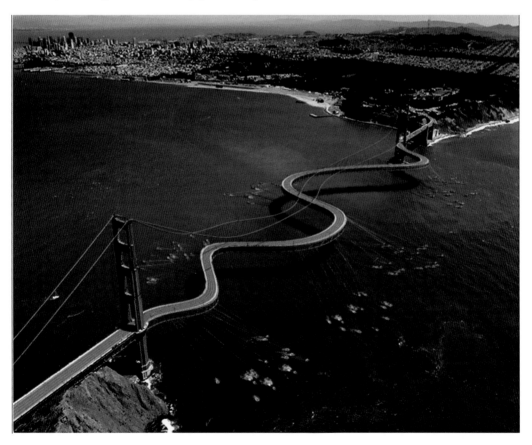

Chrysler Golden Gate Commercial Credit List

Special Effects	VFX Supervisors: William Bartlett, Andrew Daffy	FrameStore CFC, London, UK
	Inferno Artists: William Bartlett, Ben Cronin	
	Matte Artist: Darran Nicholson	
	Spirit: Dave Ludlam	
	Post-Producer: Helen MacKenzie	
	(For CGI/3D team see 'Animators' below).	
Director	Daniel Kleinman	Spectre, London, UK
Copywriter	Mike Stocker, Creative Director	FCB Detroit, MI, USA
Art Director	Robin Chrumka, VP Art Director	FCB Detroit, MI, USA
Executive Creative Director	Bill Morden	FCB Detroit, MI, USA
Producer	Bertie Miller	Spectre, London, UK
Set Designer	Evan Jacobs	Vision Crew, LA, CA, USA
Production Companies	Spectre, Ritts Hayden	Spectre, London, UK
		Ritts Hayden, LA, CA, USA
Advertising Agency	FCB Detroit	FCB Detroit, MI, USA
Agency Producer	Jack Nelson	FCB Detroit, MI, USA
Animators	3D: Andy Lomas, Andrew Daffy, Kevin McGowan	FrameStore CFC, London, UK
	Jake Mengers, Antony Field, Jamie Isles, Dave Hulin	
	Chris Syborn, James Studdart, Dan Mahmood	
	3D Development: Andy Lomas	
Editor	Steve Gandolfi	Cut and Run, London, UK
Sound Design	Stephen Dewey	Machine Head, LA, CA, USA
Music Arranger	Rob Hughes	Tape Gallery, London, UK
Account Handler (Agency)	Jon Curcio	FCB Detroit, MI, USA
Marketing Executive (Client)	Jay Kuhnie, Director: Chrysler Brand Global Communications and CRM	
	Olivier Lecocq, Senior Manager: Chrysler Brand Global Advertising	
Client (Company)		Daimler/Chrysler, MI, USA
Director of Photography	Jean Yves Escoffier	

chapter 7

the art and craft of telling a story:
narrative and characterization

by Marcia Kuperberg

Chapter 7
by Marcia Kuperberg
The art and craft of telling a story: narrative and characterization

INTRODUCTION

Animation as you know, can be as simple as a word flashing on and off to entice you to visit a website. It can be interactive, requiring your participation to lead you to an end goal. It can be a flying logo at the end of a 20-second TV commercial to remind you of a product name or an 'architectural walk-through' of, say, the 3D room you constructed after reading Chapter 3. These are common uses for animation, but at some stage you may take up the challenge of telling a story through your art.

Fig. 7.1 Wallace and Gromit. © Aardman/W&G Ltd 1989.

Narrative and characterization are inextricably linked. Characterization relating to animation within a narrative is explained in this chapter with practical tips to help you create and animate interesting characters to help bring your narrative to life.

After reading this chapter you should be able to:

• Identify some common structures that underlie most forms of narrative.

• Understand the different purposes of the pre-production stages of idea/synopsis/script/treatment/storyboard/animatic or Leica reel.

• Understand movie-making terminology: camera angles and camera movement – and and how this can help you better to convey the story to your audience.

• Take an initial idea, turn it into a narrative, write a synopsis and translate that into both script and treatment.

• Create a storyboard from your script and treatment.

• Gain an insight into characterization: character design and construction, facial expression and lip synchronization.

THE IMPORTANCE OF UNDERSTANDING FILMIC TECHNIQUES WHEN CREATING SCREEN NARRATIVE

If you come from an illustration/graphics background and have minimal experience of video production you'll find that developing an understanding of filmic pace and drama can be extremely useful to you in your efforts to convey a storyline. This involves knowing, for example, when to use long shot/close-up/mid-shot etc. – when to use transitions – how long shots should remain on screen – when to use camera movement in a scene and what type – the purpose of storyboards and how to create them.

These areas are illuminated here: they apply to both 2D and 3D animation. In 2D animation you simulate camera movement by the framing of your screen shot whereas in 3D you directly replicate live action filming techniques by using virtual cameras.

Nick Park, of Aardman Animation, is one of the UK's best known animators. He won both Oscar and BAFTA awards with his very first two short films: *Creature Comforts* (Oscar) and *A Grand Day Out* (BAFTA). He has no doubts of the importance for animators of understanding filmic language and techniques. With Wallace and Gromit (figs 7.1 and 7.2), he created two unforgettable characters and set them loose in a series of comic, quirky screen stories. His medium is stop-frame model animation rather than 2D or 3D computer animation but all have much in common.

Fig. 7.2 Wallace and Gromit.
© Aardman/W&G Ltd 1989.

After leaving high school, Nick went to Sheffield Art School to study film where he specialized in animation, followed in 1980 by postgraduate studies in animation at the National Film School in London (the first Wallace and Gromit film, *A Grand Day Out*, was his graduation project while there).

Nick believes that much animation suffers from not being very good filmmaking. His first year at the Film School was spent developing general filmmaking skills: writing, directing, lighting and editing, before specializing in animation. In Nick's opinion a lot of animation is 'either too indulgent or doesn't stick to the point of the scene. I think what I love about 3D animation is that, in many ways – the movement of the camera, the lighting, etc. – it's very akin to live action'.

Fig. 7.3 Kenny Frankland's sci-fi web narrative, *A Bot's Bad Day,* features a world populated by robots (www.tinspider.com). Naddi is pulled into an adventure by accident but provides the important function in the narrative of helping the hero with his quest as well as adding romantic interest in the form of 'complicating actions'.

© 2001 Kenny Frankland.

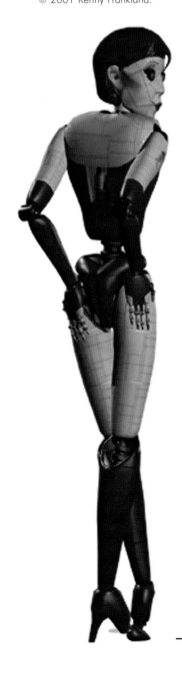

This in no way negates the fact that animation excels at creating the impossible, and certainly in 2D, is the art of exaggeration – where you can push movement and expression to the extreme.

Structures that underlie narrative: structuralist theory

Linguists and film theorists have struggled for years to define and explain the concept of narrative. Vladimir Propp, for example, in his *Morphology of the Folktale,* first published in Russian in 1928, described and analysed a compositional pattern that he maintained underlay the narrative structure of this genre. Others have followed with various attempts to formalize a common structure to narrative. For example, Tzvetan Todorov suggested that narrative in its basic form is a causal 'transformation' of a situation through the following five stages *(Todorov, Tzvetan. 'The Two Principles of Narrative'.* Diacritics, *Vol. 1, No. 1, Fall, 1971, p. 39).*

1. A state of equilibrium at the outset

2. A disruption of the equilibrium by some action

3. A recognition that there has been a disruption

4. An attempt to repair the disruption

5. A reinstatement of the initial equilibrium

Edward Branigan, in his book *Narrative Comprehension and Film* (Routledge, 1992), examined the whole concept of narrative.

He suggested that it could be looked at, not just as an 'end product' (the 'narrative') but as a way of experiencing a group of sentences, images, gestures or movements, that together, attribute

• a beginning

• a middle

• and an end to something.

With this in mind, he suggested the following format as a basic structure behind any narrative:

1. Introduction of setting and characters

2. Explanation of a state of affairs/initiating event

3. Emotional response (or statement of a goal by the protagonist)

4. Complicating actions

5. Outcome

6. Reactions to the outcome (*Branigan, 1992:4*).

If you are interested in creating an animation from your *own* story idea, the main point of the above is to remind yourself that every story has an underlying structure. The particular structure that underlies your narrative will undoubtedly be affected by the *genre* of the screenplay, i.e. whether the narrative is a 'love story' (romantic comedy or drama-romance), a 'western', or a 'thriller' for example. Here is a typical structure for a love story put forward by Philip Parker in his book, *The Art and Science of Screenwriting*:

1. A Character is seen to be emotionally lacking/missing something/someone.

2. Something/someone is seen by the Character as a potential solution to this problem – the object of desire.

3. Barriers exist to stop the Character achieving a resolution with the object of desire.

4. The Character struggles to overcome these barriers.

5. The Character succeeds in overcoming some, if not all, of the barriers.

6. The story is complete when the Character is seen to have resolved their emotional problem and is united with the object of their desire.

Writers 'write' stories but filmmakers 'make' stories. It's easy for a novelist to explain in words an entire 'back story', i.e. the history of a place or what has happened in characters' lives prior to the beginning of the narrative that is about to unfold. Novelists can write the thoughts of characters just as dialogue. Not so with a movie, whether animation or live action.

Everything that you want your audience to understand must be laid before it, sometimes through spoken dialogue and/or voice-over but always through *action on screen* that the audience can interpret to help them follow what is happening.

You may think you're at a bit of a disadvantage in not being able to explain the plot in written form as a writer can. Fortunately, if you're going to make an animated narrative, you have an ally, and that is that self-same audience.

Fig. 7.4 Perhaps you're creating an animation with a romantic theme. This is Patricia designed by Larry Lauria, Professor of Animation at Savannah College of Art and Design, Georgia.

If you want to make the heroine look alluring, he suggests using the classic device of making her look in one direction, whilst facing her in another.

© 2001 Larry Lauria.

AUDIENCE PERCEPTION

Your audience has been well educated in the art of understanding what you will put before it. Your smart audience, through a constant diet of so much television, cinema and video, has come to understand the conventions of filmmaking and will comply with you in creating illusion, given half a chance.

For example, your audience will happily accept that shots from various camera angles, that you cut together to form sequences that in turn form scenes, together make up a narrative. Another example is the learned cinematic perception that a close-up of an object which has been seen in an earlier shot at a wider angle is that same object, merely given more emphasis. This understanding is, in effect, a perceptual 'code' that is a part of our culture. It informs our ability to understand the conception of screen-based narrative.

In the first chapter perception was discussed in terms of how we perceive moving images: the physical fact of the human eye's ability to turn a series of static images into what appears to be a single moving image. As you can see, perception, in terms of moving imagery, goes far beyond this. The process, not just of individual frames, but of shots, sequences and scenes, all affect our ability to understand film and video as a whole.

In looking at an image, we make our own inferences, therefore performing both voluntary and involuntary perceptual activities. Similarly, in following a narrative, we make assumptions, drawing on what we know already to arrive at our own conclusions about the story. 'What a person sees in a film is determined to a certain extent by what he or she brings to the film . . .' (Asa, Arthur & Berger, I (eds) Film in Society, Transaction Books, New Brunswick, 1980:11). No wonder we don't all like the same movies!

Narrative theory gone mad: let the computer take over! If perceivers (i.e. members of the audience) play such an important part in constructing the narrative by bringing their perceptions of their own worlds to bear upon the story, and the narrative can be deconstructed into a formula (such as those by Propp, Todorov, Brannigan, Parker and others), you might well ask: why bother with a screenwriter at all? After all, in these circumstances, a computer could generate countless stories and the audience could relate to them or otherwise,

Fig. 7.5 When the audience sees the close-up of the character below **(fig. 7.6)** a little later in the narrative, the audience's learned perception is that this is the same character, merely seen closer or from a different angle.

© 2001 Aardman Animations, by Nick Mackie.

Fig. 7.6

according to their own experiences. This has indeed been proposed! *(Calvino, Italo. 'Notes toward the Definition of the Narrative Form as a Combinative Process', Twentieth Century Studies 3, 1970. Pp 93–102).*

But then, it has also been proposed that eventually, we could do away with real life actors and actresses and replace them with 3D generated characters that can be controlled more easily and never have 'off' days! This possibility can't be too far away when you consider the characterization in films such as *Shrek* (2001). Right now, we can produce exciting full length feature films in 2D or 3D (or combinations of both) that thrill audiences as much as live action movies. At the same time we're all aware of the incredible CGI special FX that make the impossible appear to happen in live action movies: read Andrew Daffy's account of making the award-winning Chrysler commercial in Chapter 6 where the Golden Gate Bridge in San Francisco was pulled by tugs into a series of 'S' bends as cars sped across it. Effects such as realistic looking hair and fur, previously only available on very expensive high-end systems are now within the reach of many (figs 7.7, 7.8 and 7.36) and animators delight in using every device available to push their art to the extremes (fig. 7.8).

This chapter does not attempt to duplicate film-studies-style textural analysis. Here we have touched upon some basic narrative theory but animators interested in scripting and wanting to know more about narrative in general may wish to explore more of the great body of academic material that exists in this area.

Back to Nick Park's contention on the importance of animators understanding filmic techniques: this boils down to the fact that *you*, as a filmmaker, must provide the visual clues to help your audience understand the story.

NARRATIVE THEORY IN PRACTICE

From idea to synopsis to treatment, to script, to storyboard, to animatic or Leica reel, to screen.

You may have an idea for a story but how do you translate that idea into an end product that will appear on screen and be enjoyed by your audience? The following takes an example of a short (four-minute) combined live action/animation film. Each of the narrative stages is shown, together with how one stage leads to another.

Fig. 7.7 This giant hairy 3D spider was created by Kenny Frankland. Visit www.tinspider.com
© 2001 Kenny Frankland.

Fig. 7.8 The fly to end all flies.
© 2001 Aardman Animations, by Bobby Proctor.

The idea

The idea for *The Creator* began because I wanted to make an experimental film that combined live action with computer animation. Could the two be seamlessly integrated using low-cost desktop technology? By today's standards, this was very low-tech indeed as the computer used at the time (1993) was a 386 IBM compatible with only 16 Mb RAM! The heavy processing was done using a Spaceward Supernova framestore. Software was the original DOS release 1 of Autodesk 3D Studio.

Audience perception plays a large part in a video of this sort. It was important for the audience to be entertained for the illusion to work – the illusion being that of a digital teapot which turns into a real teapot with attitude!

Fig. 7.9 Swings in the balance of power. This happens when a simple 3D teapot designed by Steve on his computer ends up swapping places with him. See an extract of the animation on www.guide2computeranimation.com.

Teapots are a bit of an 'in joke' with 3D computer animators as they have acquired a special significance as modeling icons since seminal test work was first carried out by Martin Newell in 1975 using a teapot to demonstrate modeling techniques (3DS Max shares this joke with animators by providing a teapot amongst its ready-made 3D primitives). It was in this context that I decided to make a teapot one of the lead 'characters' in my film. Before writing the story, I sketched out personality profiles of each character: Steve, his boss and the teapot. The storyline for *The Creator* then began to take shape.

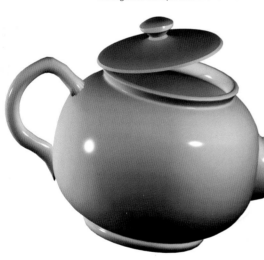

The synopsis

A teapot designer has his latest teapot design rejected by his boss as being 'too ordinary'. He is told to return to his desk and design a 'teapot with a difference'. Frustrated, back at his computer, he stares at his rejected design still on screen, and threatens out loud to destroy all his teapot model files. At this, the teapot jumps out of the screen in fright and attempts to escape. He chases it and tries to recapture it but without success. The 'ordinary' teapot finally proves it is far from ordinary by turning the tables on its creator and trapping him inside its own world – behind the monitor's colour bars.

The synopsis is the basic plot – i.e. the storyline with no frills. By reading it, you know what is meant to happen. It gives an indication of the characters involved together with the genre (e.g. mystery/thriller/romance) but there is relatively little indication at all of how it will be treated visually. For this, you need the next stage, the treatment.

The treatment

This four-minute video gives the general appearance of a live action film shot in a design office location, but the antics of the teapot are computer generated – to give seamless visual integration with the live action.

The scene is that of a product designer's office. We see Steve, the teapot product designer, sitting slumped at his desk, facing his computer. On the monitor screen there are television-style colour bars. Also visible are a number of novelty teapots. In one hand, Steve is clutching a colour printout of a teapot. His posture indicates despair.

In flashback, we see him entering his boss's office and presenting her with his latest teapot design. We can see immediately from her expression that she does not like it. Recalling her words – 'Honestly, Steve, this design is so ordinary! Can't you, just for once, come up with a teapot that's a little bit different?' – Steve scrunches up the printout and angrily throws it at his wastepaper basket. He attacks his keyboard, and stares bitterly at the monitor screen. The colour bars wipe off to show an image of a 3D pink teapot, the same image as shown previously on the printout.

We hear him mutter that he will destroy this teapot along with all the other teapot model files on the network. At these words, the teapot on screen jumps halfway out of the monitor. Steve's mouth drops open in shock.

Steve tries to block the teapot's exit as it dives past him but it eludes him, slipping out under his outstretched hand. He swivels and twists in his chair, trying to catch it but to no avail. Suddenly he spies it: it has re-entered the monitor and is deep within its dark recesses. It has changed into a kind of female teapot shape and is beckoning him – calling with a taunting melody. He puts his face very close to the monitor and peers inside. The colour bars reappear from the sides of the screen and slide across with a clearly audible click forcing Steve backwards into his chair. He then tries to scrape open the colour bars to retrieve the teapot whose melody can still be heard faintly. He finally forces the bars open and we see the teapot's startled reaction to the large face peering at it.

In an instant he is sucked right in, headfirst. We see his feet disappear into the monitor and in the last few seconds, the teapot squeezes out between his shoes. Just as it escapes, the

Fig. 7.10 The teapot has escaped from inside the monitor. A sinister note is struck when we see its reflection settle on Steve's face as he looks around for it. This 4-minute film blurs reality by mixing such FX with live action and CGI animation.

Fig. 7.11 Projecting the reflection of the teapot onto Steve's face for the effect shown above. The flying teapot will be added in post-production.

Images on this double page spread
© Marcia Kuperberg 1994.

colour bars slam shut with a loud clanging sound leaving Steve trapped inside.

The teapot dances triumphantly around Steve's desk, its signature tune quite strident. It flies out of shot. We are left with the scene of Steve's empty chair, desk and monitor. The monitor shows static colour bars. The scene fades out.

The treatment develops the story and helps us visualize the synopsis. It should be written to show clearly only what would be shown on screen or heard as part of the soundtrack – hence the style of language, e.g. 'we see/we hear'. Don't be tempted to write as a novelist, e.g. 'Steve thinks' or 'Steve is fascinated'. Instead, translate that into *on-screen action* so your audience understands what is in Steve's or the teapot's mind. The clearer the visual description of the action, the easier it will be to translate the treatment into a shooting script and to storyboard it. Each stage brings us closer to what the audience finally sees on screen. From the treatment, we can visualize the action and write the shooting script.

Fig. 7.12 Steve peers into the monitor, the colour bars slide shut.

The shooting script

INT. DESIGN OFFICE fade in

1. i/s Steve sits, slumped at his desk. On the desk, the large monitor displays television style colour bars. He is holding a computer printout in one hand. He looks up and glances around at the teapots that surround him on all sides.

2. m/s (Steve's POV) camera pans round teapots on shelves above his desk.

3. m/s Steve turns his eyes away from the teapots to look down (miserable expression) at the computer printout in his hand. It depicts a pink shiny teapot.

4. c/u Colour printout of pink teapot – hand holding.

5. Slow dissolve to INT. BOSS'S OFFICE

m/s of Steve handing over the printout to a woman sitting behind a desk. Camera follows movement to show

6. m/s woman takes printout. She looks at it and then looks back to Steve, saying scornfully:

Hillary (boss):

'Honestly, Steve, this design is *so ordinary*. Can't you, just for once, come up with a teapot that's a little bit different?'

Dissolve back to

7. c/u Steve's hand holding the printout. He scrunches it up, knuckles white, fist clenched and throws it out of shot.

8. m/s (cut on action) scrunched up paper lands near waste-paper bin next to desk. Camera tilt up to Steve who turns angrily to keyboard and begins typing. He looks up at his monitor screen. The colour bars wipe off to show the image of the 3D pink teapot that was on the printout.

9. c/u Steve's face:

Steve:

> 'I'd like to smash up every last teapot on this planet.'

He turns savagely toward the screen and leans forward:

> 'and as for *you*, I'll wipe *you* and every other teapot model file off this hard disk *and* I'll destroy the backups!'

10. m/s (over the shoulder) Steve, desktop and monitor. Teapot jerks up and leaps halfway out of screen. Its lid pops off and its spout begins to wave agitatedly from side to side.

11. c/u Steve's astonished face (POV teapot).

12. m/s (over the shoulder – back view of Steve) teapot is now out of monitor and is ducking from left to right, trying to get past Steve who is also moving left and right to block it.

13. c/u teapot moving up, around, left and right – camera following – fast motion – Steve frantically trying to catch the teapot.

14. m/s Steve swivelling around in his chair arms in all directions as he tries to capture the teapot.

15. c/u Steve's face and hands as he moves, eyes darting (camera following movement). Suddenly Steve stops moving. His eyes narrow. His head moves forward slowly (POV of monitor).

16. c/u opposite POV (over the shoulder shot of Steve) peering at monitor. Camera slowly dollies forward, past Steve's shoulder into

17. b/cu of monitor screen dimly showing glimmer of pink teapot.

Camera continues to dolly very slowly toward teapot which morphs into female teapot shape, swinging its 'hips' and

Fig. 7.13 Steve tries to catch the escaping teapot.

Fig. 7.14 Combining live action with CGI. The teapot animation has been produced separately to the live action and the two come together in post-production (compositing: part of the editing process). For this reason, the storyboards must show accurate positioning of the imaginary teapot so that Steve looks in the right direction as he makes a grab for it.
© 1993 Marcia Kuperberg.

beckoning from within the monitor's dark recesses.

18. b/cu Steve's face. Face moves closer to camera. Cut on movement to

19. m/s of back of Steve's head moving toward screen where teapot gleams and beckons. Just as his head nears the surface of the screen, colour bars slide in from each side, meeting at the centre with a click. Steve's head jerks backwards.

20. c/u Steve's hands try to scrape colour bars open. Finally, his fingers seem to enter the screen and the colour bars open with a creaking sound. His head enters frame as he moves forward.

21. c/u inside of the monitor: the teapot swings around upon hearing the creaking sound of the bars opening.

22. bc/u Steve's face – eyes wide – peering (POV from within monitor). There are colour bars at each side of Steve's head.

23. m/s of Steve from behind. His head is partially inside monitor. Suddenly, he is sucked headfirst into the darkness of the monitor screen. As his feet go in, the teapot squeezes out between his shoes and flies into bc/u filling the screen before flying out of shot.

24. bc/u Monitor – The undersides of Steve's shoes now fill the screen area. The colour bars slam shut at the centre of the screen with a loud clanging sound.

25. mi/s the teapot flies round and round the desk and monitor (its signature tune is loud and strident) before disappearing off screen.

26. c/u Monitor on the desk. Colour bars on screen. Slow zoom out to l/s. Scene is now the same as the opening shot – minus Steve. Fade out.

An experienced director will be able to read a treatment and immediately begin to 'see' the action in his or her mind's eye. In doing this, the director is beginning the process of creating the shooting script – the shot by shot visualization of the treatment. If this doesn't come naturally to you, the following description of the commonly used camera angles will help you formulate your own inner vision of your narrative.

USING CAMERA ANGLES AND FRAMING TO TELL A STORY

(Also see Chapter 3: using virtual camera lenses.)

Different camera angles help you tell your story. In the following explanation, examples are given in brackets.

A long-shot (shows whole body) establishes a scene and gives the viewer an understanding of where they are and an overview of what is happening.

Fig. 7.15 Two-shot from 'A Bot's Bad Day' by Kenny Frankland.

Two-shots and mid-shots

(cut characters at around waist level) are often used when two characters are talking to each other (fig. 7.15). It allows the audience to concentrate on the limited area shown on screen – without distraction.

A close-up (shows head and neck (fig. 7.16)) centres the viewer's attention on particular aspects of the action or character. In the case of a close-up of a face, its purpose is usually to indicate facial expression or reaction. Sophisticated computer

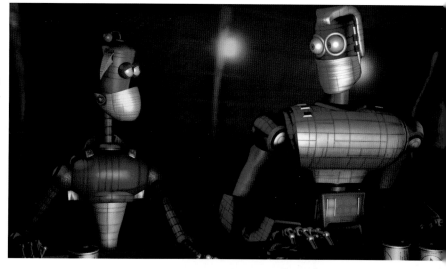

techniques can simulate real camera telephoto lenses by having the close-up foreground in sharp focus while the background is blurred, giving an out of focus effect as shown here.

A big close-up (in the case of a face, it shows part of the face, often cutting top of head and bottom of chin) – an exaggerated form of a close-up, its purpose is to add drama.

Cut-aways (usually close-ups of associated actions) are good for linking other shots that otherwise would not cut well together in the editing process. They're also important in that they can serve to emphasize the significance of a previous action by showing another character's *reaction* (fig. 7.16). They are also often used to show 'parallel action' – something that is happening elsewhere, at the same time.

Robots © 2001 Kenny Frankland.

Fig. 7.16 Close-up of Canny Tevoni (to find out a little more about this robot, see fig. 7.21 and visit www.tinspider.com).

A shot with a wide-angle or 'fish-eye' lens exaggerates perspectives and keeps both foreground and background in focus whereas a telephoto shot flattens the whole perspective and puts the background out of focus. A common usage is a camera tilt up a city skyscraper to show towering buildings narrowing in perspective.

Tilt up on a character. A camera placed near ground level and tilting upwards toward a character makes that character seem taller and more powerful (fig 7.17).

Tilt down on a character. Similarly, a tilt downwards diminishes a character's persona. Use zooms sparingly and for good reason, e.g. where the action requires the scene in long- or mid-shot, and you want to move the viewer's eye toward some point that requires more attention.

Camera movement

Just as in live action, you do not always need to have your camera 'locked off'. A static camera is commonly used in animation due to its traditional hand-drawn 2D roots, when to move around the characters and the scene meant impossible work loads for the artists who would need to draw perspective changes for thousands of frames.

There is nothing wrong with moving your camera to follow the action as long as it is imperceptible and used for good framing or dramatic purpose, e.g. if a character rises from a chair, the camera can tilt up to follow so that the head remains in frame. This is easy to accomplish with your software's virtual camera, as the camera can be invisibly linked to whatever object it should follow. BUT don't move your camera unnecessarily during the shot just because it is easy to do so. Such movement will distract from the action and irritate your audience.

Fig. 7.17 Tilting up on Kenny's robot Mkii makes him appear taller and more powerful.
© 2001 Kenny Frankland.

Don't cross the line! You'll confuse the audience.

You've probably heard of this cinematic rule but you may not be aware of its exact meaning. It is as easy to make this mistake with your virtual movie camera as with a real one.

Here's the scenario: you have two robots on opposite sides of the table to each other. This is possibly your first establishing

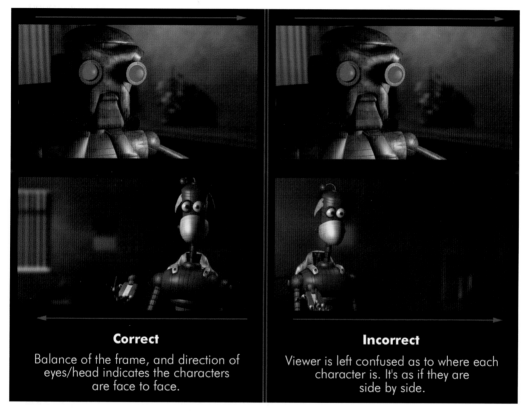

Correct	**Incorrect**
Balance of the frame, and direction of eyes/head indicates the characters are face to face.	Viewer is left confused as to where each character is. It's as if they are side by side.

Fig. 7.18 Effects of 'crossing the line'.
© 2001 Kenny Frankland.

shot: a mid-shot of robot A shot over the shoulder of robot B (establishing with your audience that both robots A and B are together in the scene, talking to each other).

Robot A is speaking animatedly. You now want to show the reaction or response of robot B. Imagine an invisible line connecting the two characters across the table. The camera can move anywhere on one side of this line to look at the faces of either character. As long as the camera does not cross this imaginary line, visual continuity will be maintained (fig. 7.18) and the audience will be able to follow the action.

Dolly in and out. I think of the camera's view as being the audience's eyes. If the audience needs to move forward in order to see something better, that is equivalent to the camera dollying in toward the subject. You can think of the camera itself as the audience's body, and the camera's target as the point where the audience's eyes are focused. What the 'eyes' actually see is obviously affected by the particular lens used by the camera (see Chapter 3 for more on the visual effects of using different lenses). A **zoom** will give a different effect to a dolly; in a zoom (in or out) the camera remains stationary, while the focal length of the lens changes. This affects the amount of background shown in the viewfinder/viewport.

Panning is a commonly used camera movement. You pan across a scene to see other parts of it or to follow the action. Plan your camera target's keyframes to direct the audience's eyes naturally: try not to force them to look in a particular direction during the pan by inserting additional keyframes. This is likely to create jerky movement.

You can make your camera **follow a given path** as explained in Chapter 3. An alternative type of pan is the **'zip' pan** which deliberately 'zips' across the scene very fast to show a sudden change of scene/subject. In 2D animation, this is likely to be accompanied by 'speed lines' and/or image blur so that the eye can link big changes to individual frames; in 3D an image motion blur will enhance the effect.

Only move the camera when the scene demands it. Although you can create all kinds of camera movement you'll mostly keep the camera still and let the action unfold before it.

Scene transitions. There are all sorts of effects available to you in non-linear editing programs that can be used to change from one scene to another. These should be used to indicate transitions in time or place, e.g. in the script of *The Creator,* a dissolve has been used to signify to the audience that the scene of Steve presenting his design to his boss is a 'flashback'. A general rule is to stick to one type only and use only if the narrative or scene demands it.

You are the 'narrator', the storyteller, the filmmaker. It is up to you to decide how best to convey the narrative. Your camera and other subtle visual devices will help you do so.

THE SOUNDTRACK

Typically the soundtrack is created prior to the creation of the animation, particularly if there is on-screen dialogue. The lip and mouth movements of the characters must be synched to the pre-recorded spoken words.

In a digital soundtrack, each part is recorded on separate tracks, e.g. background music (in sections)/dialogue/spot sound effects (known as 'foley FX'). You can then import tracks into your animation software to sync sound to image (fig. 7.19). Listening to well acted dialogue and evocative music may be of great help in visualizing both character and action.

Fig. 7.19 Screen grab from 3DS Max. Scrubbing through the wave form, you can fine-tune your animation to sync sound and action. If you zoom up on a given piece of dialogue, it is sometimes possible to 'read' the wave form word by word. Here, the words are: 'Hi, my name is Marcia.'

© 2001 Marcia Kuperberg.

THE STORYBOARD

No matter how well a sequence is scripted in words, there is always room for misinterpretation. The storyboard, a shot by shot visualization of the shooting script, can be used in a number of ways.

Concept storyboard (pre-production). The director will create an initial rough storyboard to show the intended action of the characters, the camera angles and camera movement of each shot, with an indication of sound/voice-over.

The production storyboard is a detailed working document and may be given to most members of the crew and creative team. It contains descriptions of scene (interior/exterior) character action, camera movements and angles, shot links and scene transitions, plus an indication of the soundtrack.

The presentation storyboard's purpose is usually to help 'pitch' the narrative idea to a sponsor or client who will be financing part/all of the production. Each scene is depicted with a high level of detail and finish (fig. 7.20).

The Leica reel

Sometimes known as a 'story reel', this is a video of the storyboard frames filmed to the basic soundtrack.

Its purpose is to help the director to gain a better idea of pace and timing. At this stage there are often minor changes that are added to the storyboard, e.g. additional shots inserted, timings changed, or changes to camera angles.

The animatic

This is similar to the Leica reel in that it is a rough cut version of the storyboard – filmed to the important parts of the soundtrack. It will contain low resolution graphics (to give a general idea of movement only) filmed with the camera angles and movements indicated by the storyboard. For example, if the character is meant to skip from point A to point B in the final animation, the animatic may show a 'blocked in' character merely covering the distance in small jumps. Model and movement detail will be added later.

The previz

This is a refinement of the animatic and is used, for example, by FrameStore CFC (see Chapter 6) as a blueprint for the final animation with accurate camera angles, a clear idea of the style of animation and accurate timings.

Fig. 7.20 (right) Storyboard © 1998 West Herts College, by Barry Hodge, second year BA Media Production Management student.

49) Audio 1: A man - presumable Woody - stood meekly atop the counter, dancing before a band of rather cheerless elderly people. "I was wondering" Barry said...
 Audio 2: Cont.
 Visuals: [CG] L/S animation of store-owner Woody dancing on the counter-top. Cuts to...

50) Audio 1: ...holding up the magazine's most colourful of pictures, "do you know this man?"
 Audio 2: Cont.
 Visuals: [CG] C/U of Barry's (drawn) hand pointing at Vic on a page of the magazine. Cuts to...

51) Audio 1: "Well, I don't quitely know, y'see - maybe I does, maybe I don't. I'm a bit busied at the moment..."
 Audio 2: Cont.
 Visuals: [CG] Mid/S of Woody standing still on the counter. Cuts to...

52) Audio 1: "...I have my fans to think of."
 Audio 2: Cont.
 Visuals: [CG] L/S of Woody's elderly fans, lolling in the corner of the shop. Cuts to...

53) Audio 1: Barrington and the Mayor skulked out of the door.
 Audio 2: Cont.
 Visuals: [CG/LA] Mid/S of a chroma-keyed Barry skulking out of Woody's computer drawn door. Fades down to black, and up to...

CHARACTERIZATION

By now you may have translated a basic idea into an entertaining story. What about the characters who will bring the story to life and without whom it can't happen?

Knowing your characters and their 'back story'

Having a feel and understanding of your characters' worlds and personalities *before* you write about a particular episode in their lives will help make their actions more believable on screen. This is known as 'the back story' (figs 7.21 and 7.22).

GOODIES Fig. 7.21

Canny Tenovi

Age: 280 cycles

Special Ability:...er....moaning.

Notes: Canny Tenovi is a paranoid, boring and useless bot, who spends most of his time complaining about the troubles that the days bring and is never happy with anything in life.

He spends most of his career in dull office jobs or maybe the odd factory putting tails on toy Dwebblesnips.

He hears voices in his head telling him he is special and has some purpose in life...but he's not sure what though.

In short he's a weirdo.

Lynk

Age: 220 cycles

Special Ability: chatterbot & designer.

Notes: Lynk is Helv's lifelong partner.

She spends most of the time in the Giant Apple with Helv designing for various systems while at the same time she keeps her jaw joints lubricated by chattering on and on and on......

.....she doesn't stop. Blah blah blah blah. ...all day...usually about nothing interesting.

...she'll talk yer socks off this one.

Helv

Age: 260 cycles

Special Ability: good with words.

Notes: Helv is Lynk's lifelong partner.....

He is obsessed with words and spends all day in his giant apple making huge sculptures like 'hamster' and 'groodies'.

He lives in the Araxion Barrier, but hopes to set up his business in the city. Blessed with a smile, he can be quite a dull character...especially when he starts his rants on the origin of the letter 'o'.

Nice enough bot, nevertheless.

Bot images © 2001 Kenny Frankland.

One way of looking at characterization and narrative is that the narrative is the character in action.

In his robot inhabited worlds, Kenny has created characters with interesting, contrasting personalities. They will drive the plot providing, that is, that he makes their *motivation* very clear to his audience. Your characters' motivation is the invisible force that controls their actions, pushing them to achieve their particular goal. Their motivations must also be driven by their inherent natures. You can then sit back and your characters will take over, writing the narrative themselves.

Ripiet Nol

Age: 410 cycles

Special Ability: magician, ninja and hot lover.

Notes: Wow! this guy is tough. He used to be the top assassin, bounty hunter and general bruiser for hire in Botchester...but he made enough money to retire and do what he likes most...wooing the chicks.

His French origins make him the perfect gentlebot. All the chicks love his accent. His top client was ASHiii, who calls him again to help with his problems.

Ahnk

Age: 420 cycles

Special Ability: very strong.

Notes: Ahnk is the leader of the powerful Rhinobots. He is extremely strong, and is virtually indestructible due to his thick metal skin. The Rhinobots are tough military bots who are known as Mega Knights who are trained to kill or be killed. They will happily sacrifice themselves in order to complete a mission.

Ahnk has a very personal bone to pick with our friend Canny, and since talking about it doesn't seem to work, and a good butt kicking does, things look grim for our red and yellow robot friend. Stay clear.

BADDIES Fig. 7.22

ASHiii

Age: 830 cycles

Special Ability: psychotic.

Notes: When we first meet ASHiii he seems alright, until things don't go as planned. Then he decides to destroy the planet. A tad touchy, I know, but he is very old, very insane and very lonely...all of which create the perfect recipe for a great psychopath. He is extremely weak, and most of his work is done by his servants or droogs, Thug and Scally. The thing that makes this bot particularly dangerous is his wealth and contacts with other dodgy bots. He has a list of all the best killers, robbers and porn outlets in the city. He has a twitch...

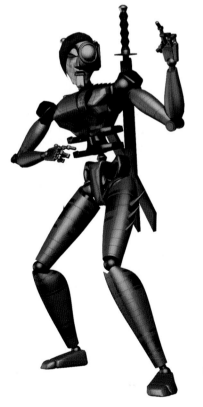

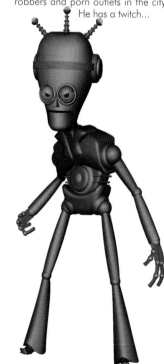

Fig. 7.23 Highly stylized, The Minota and Little Nerkin.
© 2001 Aardman Animations, by Nick Mackie.

Fig. 7.24 This is Gypsy 3W, a wireless real time motion capture system. Image courtesy of Analogus Corporation and Meta Motion.

The protagonist and the antagonist

The *protagonist* in your narrative or sequence will be the central character about whom that part of the plot revolves (this can vary from sequence to sequence in the overall narrative and there can be more than one protagonist). The protagonist doesn't have to be a heroic Hollywood style character who always triumphs; it could just as easily be a wimpish character like Steve in *The Creator* who meets a sticky end. The *antagonist* is the character that causes conflict and tension within the plot, in this case, the teapot. You need both to create a drama that engages your audience.

STYLIZATION AND REALISM

In much 2D animation, and some 3D, the characters are highly stylized. They are cartoons, i.e. exaggerated caricatures. This type of stylized character is appropriate for comedy and will be reflected not just in the characters' appearance (see the bright colours and stylization of Little Nerkin (fig. 7.23)), but in the way they are animated: their actions and reactions to events in the narrative. An important point to bear in mind is that if the appearance of the characters is highly stylized, their actions should be animated with equal exaggeration.

Conversely, realistically modeled 3D characters are much more like virtual actors. As with their appearance, their animated actions also usually aim for realism and for that reason, may sometimes be taken from motion capture.

Motion capture ('performance animation')

This entails fitting electronic gadgetry to humans or animals (fig. 7.24)who perform the action required. The movement data of all the limbs is then fed into computers, where the animation software translates it into the movement of the given CG characters. This obviously creates extremely convincing movement. Often, it is *too* realistic, however – even for a virtual look-alike human or animal, and can be boring. The animator may need to simplify and/or exaggerate some of the movement to suit the requirements of the scene.

Full animation and limited animation

Full character animation – e.g. Disney style – will include all the important elements outlined in Chapter 1. Characters may well speak, but their personalities, motivations and actions are probably extremely well conveyed by the animation itself. In a way, the spoken voice is the icing on the cake.

Hanna and Barbera introduced a style of limited animation through the economic necessity of producing large volume TV series animation. Animation series nowadays include modern, so-called 'adult' animation, e.g. *The Simpsons, King of the Hill, South Park*. These animations are very much plot and dialogue driven. In limited animation, the characters will deliver their lines with the bare minimum of basic lip movements – and body actions.

Fig. 7.25 Larry's timing for a normal eye blink. Note that the eyes are in closed position for six frames and the last frame is held for eight frames.

Keeping a character alive

Larry Lauria, animation tutor and ex head of The Disney Institute, early in his career met Bill Littlejohn, a master animator. Over breakfast one day, Larry asked him what jewel of animation wisdom Bill could pass along to him. Bill told Larry: 'if you ever get in trouble (with a scene) … make the character blink.' Here are some of Larry's tips on eye blinks.

Fig. 7.26 Here, Larry shows the timing for a typical double blink, i.e. there are two closed sets of eyes, each held for only two frames.

CGI COMBINED WITH LIVE ACTION

Character *interaction*. At the production stage of animation, when one is struggling with the technical problems of making the CGI item 'act', it is easy to lose sight of the fact that not only must it act, but also *react* to the live action meant to be taking place in the scene at the time.

The live action will probably be shot against a blue or green screen which will be 'keyed' out to be replaced by other elements such as the CGI (computer graphics imagery) at the post-production stage. Turn to the case study (Chapter 6) to see examples of this (figs 6.39, 6.40 and 6.41). The whole only comes together at the post-production stage, when it is usually too late to make either animation or acting changes. On stage, or on a film set, this interaction happens naturally when actors appear together in a scene. A clear storyboard given to actors and crew goes a long way to help them visualize the scene and it also aids the director in explaining the final outcome on screen.

Fig. 7.27 This is a snap blink, meant to be very quick with no inbetweens – just open, closed and open again. Note how Larry draws the closed position of the eyes at an angle. This is because of the muscle tension of a quick close movement.

© 2001 Larry Lauria.

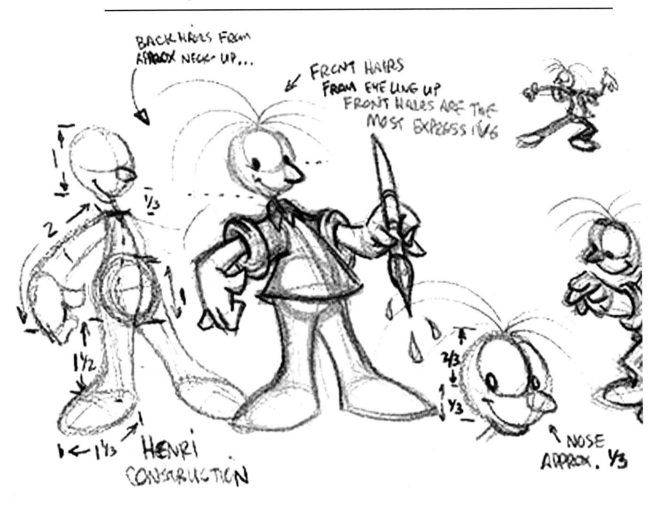

BACK HAIRS FROM APPROX NECK-UP...

FRONT HAIRS FROM EYE LINE UP FRONT HAIRS ARE THE MOST EXPRESSIVE

HENRI CONSTRUCTION

NOSE APPROX. ⅓

Fig. 7.28 Henri. © 2001 Larry Lauria.

Fig. 7.29 Henri and the fish.

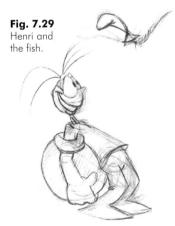

CHARACTER CREATIONS

Designing your characters. Begin with character sketches on paper. Refine the design so that you know what your character looks like from many angles with a wide variety of poses and expressions (figs 7.28 and 7.35). Eventually the design will be produced on character sheets to show the character and its relative proportions from all sides (character turnarounds: fig. 7.30) together with typical poses, facial expressions, clothing and colouring/material guide. These will be used as reference for other animators who may be working on the project. Sometimes the character will be required in both 2D and 3D formats. Study the following illustrations by Larry Lauria to see how characters and heads can be based on simple spheres and triangle/pyramid shapes. Also read Chapter 5 for more on creating characters for use in computer games.

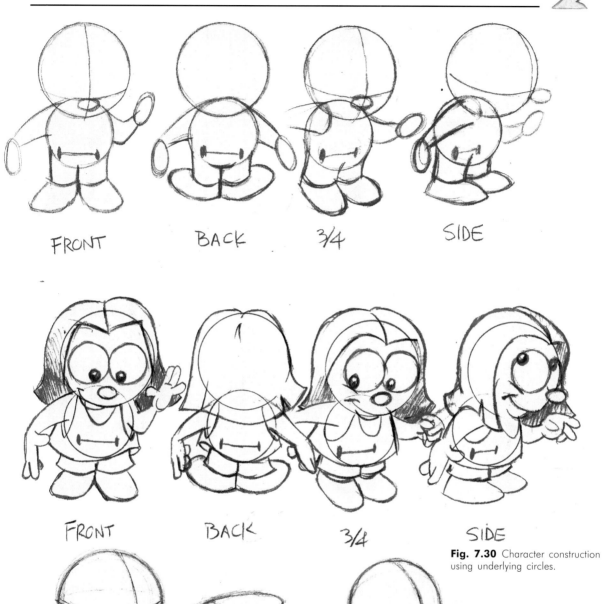

FRONT BACK 3/4 SIDE

FRONT BACK 3/4 SIDE

Fig. 7.30 Character construction using underlying circles.

Fig. 7.31 Character construction using underlying circles, triangles and combinations.

Here are some typical character construction techniques, courtesy of Larry Lauria. Notice how the head overlaps the body on a squat character.

© 2001 Larry Lauria.

1.
CIRCLES

2.
TRIANGLE

3.
COMBO

Basic head construction based on spheres for cartoon-style characters

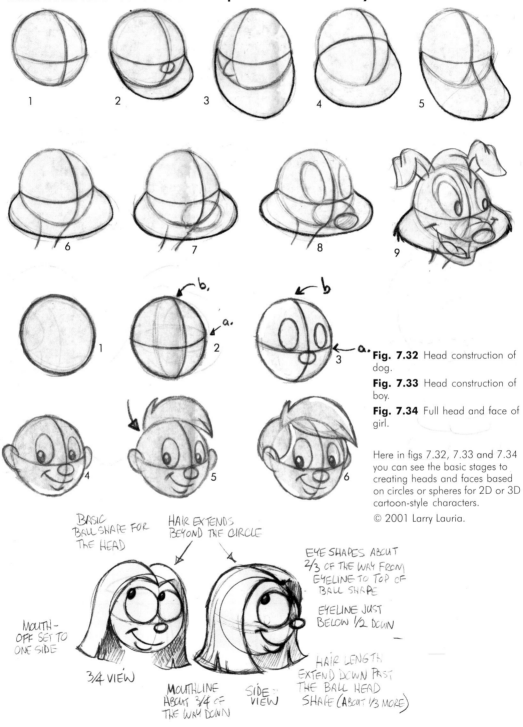

Fig. 7.32 Head construction of dog.

Fig. 7.33 Head construction of boy.

Fig. 7.34 Full head and face of girl.

Here in figs 7.32, 7.33 and 7.34 you can see the basic stages to creating heads and faces based on circles or spheres for 2D or 3D cartoon-style characters.

© 2001 Larry Lauria.

BASIC BALL SHAPE FOR THE HEAD

HAIR EXTENDS BEYOND THE CIRCLE

EYE SHAPES ABOUT 2/3 OF THE WAY FROM EYELINE TO TOP OF BALL SHAPE

EYELINE JUST BELOW 1/2 DOWN

MOUTH- OFF SET TO ONE SIDE

3/4 VIEW

MOUTHLINE ABOUT 3/4 OF THE WAY DOWN

SIDE VIEW

HAIR LENGTH EXTEND DOWN PAST THE BALL HEAD SHAPE (ABOUT 1/3 MORE)

MAKING YOUR CHARACTERS TALK

We all know that to make a character speak, we need to match the lip positions of speech to the spoken word. These positions are called **'phonemes'**. In phonetic speech, combining phonemes, rather than the actual letters of the word, creates words. For example, in the word 'foot' the 'oo' sound would be represented by the phoneme UH. The phonetic spelling of the word foot would then be F-UH-T and the mouth shape would be the central UH. There has been a great deal of work done to classify and code these phonemes. The important thing to remember is that phonemes should be assigned to the actual sounds you *hear*, not the text on the page. Applying phonemes is the key to success in lip sync.

Fig. 7.35 Created by Dan Lane of Aardman Animation, this part of the character sheet explores some typical expressions and phonemes for the mouse on the following pages.
© 2001 Aardman Animations, by Dan Lane.

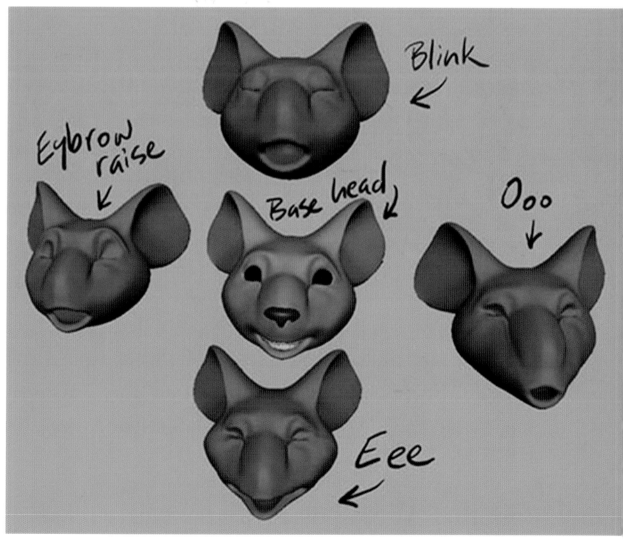

Fig. 7.36 'The aim here was to produce a character mouse as a test but create naturalistic fur that behaved in a realistic way. Maya Fur was instrumental in this and the project also brought into play various mapping techniques for colour, baldness and density of the fur and also the use of Maya Paint Effects for the mouse's whiskers. The head was modeled out of one object so that the fur reacted to everything, even when the mouse blinked.'

Fig. 7.37 This shows the use of Maya Fur's Dynamic Chain Attractors used to set up the realistic mouse fur.

All mouse images © 2001 Aardman Animations, by Dan Lane.

Fig. 7.38 First stage of construction: moulding a single object for the head.

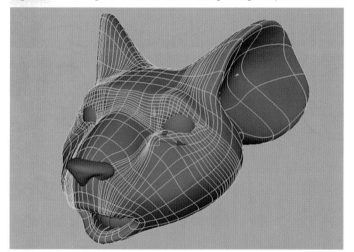

Fig. 7.39 More detail has been added at this stage to allow for expression.

Creating facial expression in CGI (3D)

Typically, a library of facial expressions will be developed for a character. These expressions can be given to heads that are simply replaced during animation: the technique used in stop-frame model animation. Alternatively, sections of the face, e.g. eyes and eyebrows, can be blended from one shape to another to create additional variations of expression.

Blended facial expressions is standard on the latest versions of 3D software packages such as 3DS Max, Lightwave and Maya. It enables you to divide the face into separate, independent sections, e.g. eyebrows and forehead/eyes/ nose and cheeks/mouth and chin.

Each expression or section of an expression can then be animated, usually by means of a % slider, from neutral to full extreme of pose, e.g. smiling upturned mouth to the negative downturned shape. The permutations and combinations of blending different shapes give endless expressive possibilities.

Dan Lane:

'To animate the mouse, we used a combination of traditional stop motion techniques as well as tools like Maya's Blend Shapes. A virtual armature was created for the mouse and some simple facial expressions were sculpted as replacement heads, the same way stop motion animation uses them. The two combined along with using Blend Shapes enabled us to bring life to the mouse and animate him, with lip sync, to a short soundtrack. To animate the fur, we used Maya Fur's Dynamic Chain Attractors. This gave us reactionary movement in the fur whenever the mouse moved his head.'

Fig. 7.40 The virtual armature (bones) inside the mesh. When the mesh is bound to the bones, and the bones are animated, the mesh body deforms like real skin.

Fig. 7.41 There is no mistaking the emotion expressed by this wide awake character. He exudes happiness and energy through his pose. See more on posing and other animation techniques in Chapter 1.

© Larry Lauria.

OBSERVATION AND INSPIRATION

When deciding on the overall 'look' of a character, you are the casting director while at the same time, you are already beginning to put yourself into that character's skin. When you begin to animate, you *become* that character.

The first rule for any actor is to observe the behaviour of those around him/her. Become aware of other people's mannerisms – the tug of the ear, the scratch of the head – so wherever you are, stop and look (but don't stare too much or you may be arrested!). An excellent habit to get into is to analyse films and videos: study the movement of the head and eyes for example – when and why does the head move, when does it tilt, when do the eyes move – when do they blink? Animation is the art of exaggeration, but first you must know what it is you're trying to exaggerate. Notice behaviour in the real world and you'll be better able to animate in a fantasy world.

Very often, the best person to observe is yourself. *You* know the expression you are trying to convey through your characters, so always have a mirror in front of you when animating and use it!

CONCLUSION

Ensure the narrative, no matter how short, has a structure with a beginning, a middle, a climax and an end.

Create clear identities for your characters, but remember that you can't assume your audience knows anything about them other than what is shown on screen (but it helps if *you* know their 'back stories' as this will help you develop your narrative writing and characterization skills).

Before embarking on any form of narrative animation, it's important to do all the necessary pre-production planning. This includes preparing a synopsis of the narrative, the back story, treatment, script and storyboard for your animation.

When scripting and storyboarding, visualize the script in terms of camera angles and any necessary camera movement to maximize the impact of your story and clarify the action for your audience. Check for expressive posing for the important keyframes of each shot.

It's also a good idea to create an animatic (to include draft soundtrack) from the storyboard to gain a better idea of pace and timing before beginning the actual animation production.

chapter 8

project briefs, self-tests,
tutorials and resources
compiled by Marcia Kuperberg

Chapter 8

compiled by Marcia Kuperberg

Project briefs, self-tests, tutorials and resources

INTRODUCTION

The aim of this book has been to give you a broad-based platform of information and knowledge to build upon so that you can make better use of the animation software of your choice. Many topics have been covered (briefly of necessity as this is an introductory text to a broad field) and you will no doubt wish to explore further into the areas that interest you most. We have therefore included a list of related websites where you can obtain software specific tutorials, free demos and downloads, job lists, and a wealth of other useful resources.

If you are interested in using this book to help you gain a validated UK qualification, a Professional Development Diploma in Digital Media Production, through building a showreel and portfolio of your creative work, contact The Manager, Flexible Learning Unit, Watford Campus, West Herts College, Watford, WD17 3EZ, UK or email: flexiwhc@westherts.ac.uk

How much have you learned? The seeing is in the doing! Why not test yourself and have a go at some of the general exercises and suggested project briefs in this chapter. These are equally suitable for independent use or for classroom-based work. When tackling these self-tests, we suggest you answer what you know first, and then refer back to the relevant chapter to check on anything you're unsure of.

Start building your personal showreel or CD-ROM now.

SELF-TEST BASED ON CHAPTER 1

1. What is meant by *Persistence of Vision*?

2. How many frames per second are there in the US system of television transmission (NTSC)? And in the European system (PAL)?

3. Which three areas of understanding needed to come together to bring about 'movies' as we know them today?

4. Name at least three people whose work advanced the knowledge needed to create movies.

5. Write a brief description of what they did or how their contributions influenced animation or the movies.

6. What is meant by 'digital convergence'?

7. Give a practical example of how digital convergence has affected you in your daily life (work or leisure).

8. What are Newton's Laws of Motion?

9. Give two examples of how these laws can be used in creative animation.

10. What is meant by 'keyframing' in computer animation?

11. How did the term originate?

12. Give three examples of how *squash and stretch* can be used in animation.

13. What is meant by *overlapping action*?

14. In CGI what is meant by *inverse kinematics*?

15. What was the first full-length feature animation film?

SELF-TEST BASED ON CHAPTER 2

1. Give one way in which a computer monitor differs from a television.

2. Which would look the best, an enlarged bitmap image or an enlarged vector image?

3. What type of still image could usefully be saved using Run Length Encoding?

4. What is the difference between a 32-bit image and a 24-bit image? When would this be of use?

5. How much disk space would a 640 by 480 pixel uncompressed 24-bit image take up?

6. How much disk space would one minute of uncompressed 320 by 240 pixel 24-bit 15 f.p.s. digital video take up?

7. What data rate would allow you to fit 60 minutes of digital video onto a CD-ROM?

8. Why can't you play full screen uncompressed video on a standard desktop PC?

9. What can you do to an animation to make maximum use of temporal compression?

10. You need to create an animation featuring a forest in the background. How could you use Macromedia Flash to keep the file size really small?

11. What techniques are there for converting a 2D shape into a 3D object in a 3D modeling package?

12. What factors affect the rendering time for a photorealistic 3D scene?

13. If I want to make a 3D door open what do I have to do to its pivot point?

14. What would happen if I placed a photorealistic digital video animation file intended for playback from CD-ROM onto a website for downloading?

15. What would happen if I tried to use the same animation in a TV programme? How could the problems be resolved?

3D MODELING PROJECT BASED ON CHAPTER 3: CREATING A ROOM

Using your own 3D software, create a room with at least three different pieces of furniture based on modified primitives that have been grouped. Use additional modeling techniques according to your experience. Include floor, ceiling, three walls (as in a real movie set, you'll need room to move your virtual camera around so your fourth wall can be movable or simply not there), at least one window, light fitments, ornaments and table crockery.

Try to use materials and textures to both enhance the room and save modeling time.

Light the room with virtual lights including both 'omni' (multidirectional) lights and spotlights. Create one or more virtual cameras and view and render three distinctly different views of the roomset that you feel show it to full advantage.

Note. Before tackling this exercise, it would be useful to read the exercises on characterization in case you can model a room suitable for one of the suggested scenarios. Eventually, you may wish to place some characters into your

room and animate the characters and/or your virtual camera(s). See suggestions for this later in this chapter.

To summarize, for this exercise you will produce:

• Colour printouts of three different rendered views (as seen through camera viewports) of a 3D room constructed as specified and including a range of items as specified. It should make effective use of materials, textures and lighting.

SELF-TEST BASED ON CHAPTER 4

1. In terms of interactive multimedia what is a *rollover*?

2. What does the term *affordance* mean in terms of multimedia design?

3. What is a *keyframe*?

4. How many colours can a GIF animation have? Give your answer in both the number of colours available and the *bit depth* this requires.

5. 'Hypertext' is a common enough term nowadays – but who first came up with the phrase in 1968?

6. What is meant by the term *motivated object*?

7. Images on web pages are usually in .JPEG or .GIF format – which one of these is best suited to photographic type images?

8. What is a *sprite*?

9. In interactive multimedia what does the term *agency* refer to?

10. Tim Berners-Lee devised HTML, the language of web pages – what does HTML stand for?

11. What does *GUI* stand for?

12. JavaScript, Jscript and ActionScript are languages that give added functionality to web pages and Flash movies – how do they relate to ECMAScript?

13. What kind of experience does the user get when viewing a QTVR image?

14. What does *VRML* stand for?

15. How is the user's experience of a virtual reality different from their experience of viewing an animation in the filmic tradition?

WEB TUTORIAL ROLLOVER PROJECT BASED ON CHAPTER 4

In this project you will create a web page that is initially blank – then as the mouse is moved and the cursor rolls over parts of the image – a clown's face appears. Clicking on the clown's nose brings up a second web page where rollovers are used to create animated eyes and mouth.

This project can be realized using either a web authoring package like Dreamweaver, FrontPage or GoLive, or through HTML and JavaScript programming. It makes use of the ideas inherent in rollovers to create an interactive plaything. The principles of this project can be applied elsewhere to create entertaining and engaging interactive artefacts that include rollover changes as a form of animation.

Step 1

You will need to create or scan an image of a clown's face about 400 × 400 pixels in size. If you scan an image use .jpg format to save the image. If you are creating it from scratch using bitmap paint tools then .GIF may be more appropriate.

Create a directory or folder to hold this image and all the images and .htm files you are going to create later.

Using an image editor (Paintshop Pro, PhotoShop, Fireworks) you have to cut the image into a number of separate parts – just how you do this is up to you but you will need to have the two eyes and the mouth as separate images (saved as *righteye.jpg, lefteye.jpg* and *mouth.jpg*, or with .gif extension if appropriate). Save all the smaller images with filenames which describe them – *rightear.jpg, forehead.jpg, rednose.jpg,* etc. As you do this bear in mind you will be reassembling the image from these smaller parts – so think about using horizontal slices that can be sub-divided vertically.

Now, working with the images of the eyes and mouths in a bitmap image editor modify them – maybe making the mouth sad, the eyes closed, moving the pupils so they are looking cross eyed. Save these images as *righteye1.jpg, lefteye1.jpg* and *mouth1.jpg* (or with .gif extension if appropriate).

For all of the smaller images create a plain black image the same pixel size – these can be saved as one-bit GIF files, and name them as *mouthblank.gif, righteyeblank.gif, rednoseblank.gif*, etc. as this will make handling them easier later.

Step 2

Create a basic web page by hand coding or by using the New menu item in an authoring package (such as Dreamweaver, GoLive, FrontPage).

You now need to rebuild the original image from the smaller images you cut out. If you are using Dreamweaver, or a similar authoring package, you only need to import the images in turn and add a carriage return between the horizontal lines of the image.

If you are hand coding the page then it should work well if you list the images using with a
 tag at the end of each line of images.

Both of these approaches may mean there is a thin line of background colour between the lines of the images. Don't worry about this.

Once you have recreated the face image from its part-images save this web page as *facebase.htm*.

Step 3

Now you need to replace each of the component images with its equivalent *blank* image – this is where it is probably easier to use hand coding as all you need to do is type in *blank* into the filename for each image.

You now have to create rollovers so that when the cursor moves over a blank version of the image it changes to the image itself – but it must not change back to the blank image when the cursor moves off the image.

The JavaScript code to do this is outlined in a simple exercise at the end of this brief; you should be able to modify the code to work the way you want it to using cut and paste techniques.

Doing this in an authoring package like Dreamweaver or FrontPage should be relatively straightforward – but do not use the tool for creating *rollovers*. That tool will automatically create both the change when the cursor rolls over the image and the change back when it rolls off the image. Instead use the tools that allow you to define actions or behaviours based on the onMouseOver command.

Now save this page as *face1.htm*.

Step 4

Open *facebase.htm* and save it without any changes as *face2.htm*. This gives two versions of the page, one with the complete assembled image, the other with assembled blank images.

Open *face1.htm* and make the image which contains the nose a link to *face2.htm*. Again, if you are hand coding, an example of the code to do this is given in the exercise, later.

Save *face1.htm* and close the file.

Step 5

Open *face2.htm* and for the eyes and mouth create rollovers which display the *mouth1.jpg*, *righteye1.jpg* and *lefteye1.jpg* images on rollover and return the *mouth.jpg*, *righteye.jpg* and *lefteye.jpg* images when the cursor moves off the image.

Make the image which contains the nose a link to *face1.htm*.

Save *face2.htm* with these changes.

Step 6

View the files in a browser (Internet Explorer or Netscape). In *face1* move the mouse around to make the image appear. Click on the nose to go to *face2*. In *face2* move the mouse to animate the eyes and mouth.

Using these techniques you should be able to create a displaced rollover – that is make it so that when the cursor is on the right eye the left eye image changes, or the mouth changes, or the hair changes, the tongue pokes out, an ear wiggles (an animated GIF that plays on rollover?).

The code to do this can be worked out from the exercise. Using the actions and behaviours tools in a package like Dreamweaver should enable you to play with these ideas creatively and imaginatively.

Hand coding: the exercise

This exercise prepares you for the project if you are going to use hand coded HTML and JavaScript.

Creating HTML pages by hand coding is straightforward and there are a lot of web-based tutorials that will provide detailed instructions. If you are going to work with web pages then picking up some HTML and JavaScript is well

worthwhile. Creating rollovers means using JavaScript – the code given here will create rollovers. It is not very elegant code, and certainly not a model of good practice, but it works and works well. When you create rollovers in an authoring package like Dreamweaver or FrontPage the JavaScript is created for you. By viewing the code in the HTML window you will be able to identify the JavaScript instructions that the software made for you.

To follow this exercise you will need to create four GIF images – simple squares 100 × 100 pixels will do – which are distinctly different and are named *red.gif, blue.gif, green.gif* and *yellow.gif* (those filenames may give you some ideas for the content). Save these images in a new folder or directory, and when you come to do so save the HTML/JavaScript code files to the same folder.

Type in the code given below using a plain text editor (Notepad on Windows, Simpletext on Macintosh) taking care to get spaces and punctuation marks correct. You must make sure that you save the file in plain text format and use a .htm extension (e.g. name your file *test.htm*). If your file is not plain text then the browser will not be able to interpret it properly and will not display the page.

Save the code as *test.htm* in the same directory as the images, and then use a web browser to view the page – the code uses HTML 3.2 and JavaScript 1.3; it should work in all contemporary browsers.

```
<HTML>

<HEAD>

<TITLE> rollover rollover for all the fun of the circus </TITLE>

</HEAD>

<BODY TEXT="black" link="red" vlink="red">

<H1>rollovery</H1>

<BR>

<A HREF="#";
onMouseOver="document.images[0].src='blue.GIF';"
onMouseOut= "document.images[0].src='red.GIF';"
><IMG SRC = "red.GIF" BORDER="0"></A>
```

This red rectangle is an image swap rollover using onMouseOver and onMouseOut commands

```
<BR>

<A HREF="#";
onMouseOver="document.images[1].src='green.GIF';"><IMG
SRC = "blue.GIF" BORDER="0"></A>
```

This blue rectangle only changes once; using onMouseOver to 'permanently' change the screen, use the browser reload to view it again

```
<BR>

<A HREF="#";
onMouseOver="document.images[2].src='yellow.GIF';
document.images[3].src='green.GIF'" onMouseOut=
"document.images[2].src='green.GIF';
document.images[3].src='yellow.GIF'" >

<IMG SRC = "green.GIF" BORDER="0"></A>

<A HREF="#";
onMouseOver="document.images[0].src='yellow.GIF';"
onMouseOut=
"document.images[0].src='red.GIF';"><IMG SRC =
"yellow.GIF" BORDER="0"></A>
```

Rolling on this green rectangle changes both itself and the adjacent yellow one, onMouseOut restores the original images; this is partly a displaced rollover – rolling over the yellow rectangle changes the red rectangle at the top of the page but does not change itself – this is a displaced rollover

```
<BR>

</BODY>

</HTML>
```

The important parts of this, as far as the rollovers are concerned, are the *onMouseOver* and *onMouseOut* commands. These are included in the hyperlink tag with a null marker (the "#"). If you wanted the rollover to be a link to another page this is where the URL would go. So to make a link to a page called *face1.htm* on a rollover image the code would read something like this

```
<A HREF="face1.htm";
onMouseOver="document.images[0].src='blue.GIF';"
```

onMouseOut= "document.images[0].src='red.GIF';"
>

The text after the <A HREF="#" is the JavaScript code. Note the use of " (double quotes) and ' (single quotes) in the correct places to mark out file names and JavaScript strings. If you get these punctuation marks in the wrong places the code may not run or may run in a strange and unpredictable way.

In the document.images[x].src code the number in square brackets refers to the images in the HTM page in the order in which they are included, starting with 0. This means that you can refer to any image quite readily, but if you insert another image, or delete an existing one, then you would need to change all the square bracketed numbers accordingly. More properly JavaScript code defines and uses a name to refer to the images, but doing this would make this example much more complicated.

The BORDER="0" code included in the HTML tag means that although the images are notionally links they are not marked as such by a border in the link colour.

SELF-TEST BASED ON CHAPTER 5

1. Name three next generation games consoles.

2. What does USP stand for?

3. In the computer games industry, what is a milestone?

4. Give an example of a localization difficulty that a game might encounter during its development period.

5. Think of an example of programmer created animation and an example of animator created animation. Now think of a real world animated object – if it was computer generated, would it use programmer created animation or animator created animation?

6. What do the terms FK and IK stand for?

7. Think of two reasons why a game might use Morph Target Animations to display character animation.

8. What is the most senior position an artist can hold in a computer games developer?

9. Think of two examples of animation types that an animator

should have in their portfolio.

10. Give three examples of textures that could tile repetitively in a game world without the player being aware of their repetition.

11. Why are PS2 textures usually saved as 8 bit?

12. What is the main benefit a game gets from using vertex colouring in its artwork?

13. Think of two good resources for level designers when they are planning the look of a level.

14. What are the benefits obtained from modeling and animating seamless skin characters, compared to doing the same process with segmented characters?

15. What task should you always do before you model or texture anything?

EXERCISES AND 3D MODELING PROJECT TUTORIALS BASED ON CHAPTER 5

Exercise one: building a street

In this project you will create a model of a street using low polygon models and textures. The street could be based in any era or location, but for ease of work it might be best to work using a city street that you know well or can relate to on a personal level to keep the aesthetic look of the street correct.

The first task is to gather information about the street. Get a camera and spend the day in a city looking at different street types (shopping streets, residential streets, modern streets, etc.). Take photos of the different types of buildings you see – you should take both wide shots of streets as a whole to get an entire environment feel, and also detail close-up shots. These are best shot as flat on to the building fronts as these sorts of photos are the easiest to adapt for texture usage.

Once you have got the photos developed or printed out, it can be a good idea to create a 'mood board'. This can be a large sheet of cardboard to which you stick all the images you have gathered which you feel fit the type of street you want to model. You should constantly look at this while creating models and textures to keep your experience of a city fresh in your mind.

Try to make very simple 3D models – just boxes of various sizes – and cover them in textures to represent the fronts of buildings. Make a single 3D street of these boxes and adjust their position and distance from each other to change the feel of the street. Place a camera at what would be pedestrian level in the scene to check out how the street would look when viewed from a game player's position.

Once you are happy with the structure of the street, create textures based on the buildings you saw. Use the guidelines given in Chapter 5 for the size and bit depth of these images. Now apply them to the models in the scene and see how many times you can reuse some of the textures before the repetition becomes noticeable. When you are happy with the scene, add some lighting and make some renders for your portfolio.

Exercise two: modeling trees

A good test of any 3D modeler is the creation and texturing of a tree. Trees are one of those real world objects that everyone recognizes instantly upon seeing, and so always stand out badly if not textured or modeled well. In computer games there are generally two types of tree: the flat and the full 3D. In this exercise you will make the same tree twice, once for each style.

Flat trees are just a quad polygon that is placed in the game and given a special property that means no matter where the game camera looks, the tree polygon faces it full on, all the time. This technique is usually used in large landscapes where the game needs to display a lot of trees at the same time, and there is not the polygon budget to have cross flat or full 3D trees. All you need to do to model this tree is to create a square polygon with the same dimensions as your texture. Use a 256×256 texture with an alpha channel to surround the tree pixels, so that the tree appears to have a totally transparent area around it. Make sure you look at a real tree, plus as many photos of the same species as you can before you create the texture. You need to consider that the tree may be repeated many times across a landscape so you need to create a stereotypical tree of that type, one that doesn't have any particular distinguishing features. To test whether your tree works well, make 50 copies of it and scatter them across a terrain and look at them. If your texture is drawn well, your eye will see a mass of trees. If drawn

badly, the eye will notice the glaring repetition of a feature in the texture – i.e. a branch that sticks out too far to one side.

The other tree type is the full 3D tree. Using the reference you gathered from creating the flat tree, make the same tree in 3D. Allow around 1000 polys, and model all the major limbs and trunk as full 3D, and attach 2-sided flat polygons to each branch to contain leaf textures. Use two textures for this tree – a 256 × 256 repeating texture of the bark of the tree, and a 256 × 256 texture with alpha channel to represent a mass of leaves and smaller branches that could project from one branch. The hardest part of modeling this style of tree is the placing of the flat polygons so that they appear to give the tree a rounded, organic look, while still giving it a fractal, natural profile, even though the tree is made of hundreds of flat, separate polygons! Make sure that the trunk tapers as it rises, and splits into a crown of major limbs (if this is correct for the species you chose). It really is a very good idea if you can find a real tree of the type and size you want to make and go and stand under it to see how it has grown into its form. This will give you the best understanding of how to replicate the structure in 3D.

EXERCISES AND PROJECTS BASED ON CHAPTER 7

An animator embodies many roles including that of artist and actor, so it is important to try to develop an inner visualizing eye like that of a director. When a director reads a script or movie treatment, the narrative begins to play itself out in his/ her mind's eye as if already shot, animated and edited. These visualizing skills usually come after years of experience of directing and/or editing. Carrying out these exercises will help you develop *your* director's eye.

Exercise one to develop your 'director's eye'

1. Analyse edited sequences

2. Practise writing a synopsis of action

3. Practise writing a shooting script

4. Practise storyboarding a script

Analysing film. Videotape a short film sequence from TV (no more than a minute or two). In one or two short sentences, describe the action shown in the sequence. For the purpose of this exercise, we'll call this the synopsis, even though it only describes a small section of the action within a scene.

Using the pause button on your remote control, analyse the sequence, shot by shot, noting camera angle, camera movement and the action of the character(s). From this, write a shooting script as described in Chapter 7. Referring to your script only (not the original videotape), storyboard the sequence. Don't worry about producing detailed character drawings for your storyboard; aim to show clearly whether the shot is a close-up/long shot etc. and the camera angle. Use a black biro or felt tip pen for boldness, simplicity and ease of photocopying.

To summarize, for this exercise you will produce: a videotape of a short sequence taken from a TV film or soap opera, a short synopsis of what has been taped, a shooting script (describing the individual shots videoed) and a rough storyboard showing the action videoed (this to be done referring only to your shooting script, not the tape).

When carrying out this exercise, it's as well to remember that each sequence is, of course, a part of a larger sequence, which is in turn, part of the film as a whole. The way the film is shot must be in context with the narrative as a whole.

EXERCISES IN CHARACTERIZATION BASED ON CHAPTERS 1, 5 AND 7

Exercise one: creating characters

Basing your drawings on circles, triangles or a combination, create character turnarounds for one or more of the following: a fat businessman (the boss), a puny character (new recruit to the company), a bully, a timid character, a femme fatale, a real baddie, a hero, a gawky teenager, a cheeky child.

If you are eventually planning to animate using a 2D package you might like to read *The Animator's Guide to 2D Computer Animation* by Hedley Griffin (Focal Press, 2001).

If you want to animate in 3D, we recommend George Maestri's *Digital Character Animation 2 volume 1 – essential techniques* (New Riders, 1999). Before creating your character model sheets (turnarounds) you need to plan how you will construct your character and have an idea of how you might eventually animate it, e.g. will it be a jointed character where the jointed limbs are hierarchically linked and animated by FK or will you be attempting IK (refer back to Chapter 5) or perhaps a combination of both methods? Or will it be a single mesh that will be deformed by its

'bones' when animated, like the examples in Chapter 5, Dan Lane's mouse in Chapter 7 or the Cingular logo man in Chapter 6? You will recall from these examples that 'bones' are an internal skeleton structure that you create, rather like a virtual armature used when making a model for stop-frame model animation. When you animate the internal 'bones' using either FK or IK or both, you animate the mesh character whose skin deforms in a similar way to real world creatures. Be warned! Creating and animating 3D characters effectively requires much patience and experience.

Exercise two: posing your characters

Having drawn concept model sheets for one or more characters, your next exercise is to draw some typical poses for them – say four for each of the characters you created for your turnarounds, e.g. for the businessman, you might have him 1) sitting behind his desk, 2) talking angrily into the telephone, 3) standing up and bawling out the new recruit, 4) swinging so far back in his executive chair that he falls over.

Don't forget to rough in the main 'line of action' before filling in the details of the pose.

Next: check out Martin's 3D character modeling and texturing tutorial on the book's website.

Before developing your 3D character concepts on paper, take a look at Kenny's and Martin's illustrated tutorials on modeling and texturing a character for computer games by logging onto the website for this book www.guide2computeranimation.com. We have also included a great resource list of 3D sites in this chapter where you will find links to loads of software specific tutorials on character modeling and animation amongst a multitude of other topics.

Exercise three: animating your characters – using the principles outlined in Chapter 1, particularly anticipation and overlapping action

Have a go at animating some of the action of the poses you've just drawn, render your work and lay it off to either CD or videotape. If you have some character animation plug-ins for your 3D software (e.g. Character Studio for Max) this will be easier.

Fig. 8.1 Log onto the book's website www.guide2computeranimation.com for tutorials showing you how to model and texture (a) a full body and (b) a head for a character. No hair creation plug-ins have been used on this head, modeled and textured by Martin Bowman.

USEFUL ONLINE RESOURCES

www.AWN.com This site will lead you deeper into the world of animation. Loads to explore: job & careers section (you can post up your résumé/CV to the site so it is equally useful for those seeking employment or those seeking employees – people, profiles, galleries, news, reviews, tutorials and software downloads.

http://download.cnet.com website for free downloads useful to artists, designers, animators and editors.

Websites for games designers

www.gamasutra.com

www.gamasutra.com/education/

The best source of information about the computer games industry; written for computer games developers. The second link contains information that is particularly useful to students wishing to get into the industry.

www.VFXpro.com This website is only concerned with film and TV CGI, but it is a very interesting place to read about new techniques and ideas that eventually filter down to the computer games industry.

www.cgchannel.com An excellent all round 3D graphics website. Covers games, films, animations, technology and jobs. Has an excellent tutorials section that is of interest to artists of every level of experience.

www.planetquake.com/polycount The website that teaches how to create artwork for the Quake family of games. It contains excellent resources, sample models and textures and is full of useful tips and information for potential games artists.

2D animation software

www.macromedia.com for Flash and Director

www.animo.com for Animo cartoon animation system

www.adobe.com/products/livemotion/ Adobe livemotion

www.toonboom.com 2D cel type animation software

www.creatoon.com free demo and tutorial manual

www.divideo.it/toonz

www.retas.com Japanese 2D animation system

Fig. 8.2 Martin Bowman's and Kenny Frankland's character modeling and texturing tutorials can be found on the book's website: www.guide2computeranimation.com. The effect of a change of lighting can be seen here.

3D modeling and animation software

www.discreet.com for 3DS Max

www.softimage.com for Softimage

www.aliaswavefront.com for Maya

www.newtek.com for Lightwave

www.realsoft.fi for Realsoft 3D modeling and animation

www.cinema4d.com/ for CINEMA 4D

www.curiouslabs.com for poser character animation system

www.corel.com Bryce landscape modeling system

www.rhino.com NURBS modeling tool

www.realviz.com for MatchMover – adding 3D to live-action
footage, and ImageModeler – 3D models from photographs

www.d-vw.com D sculptor 3D sculpting tool

www.pixologic.com Zbrush 3D sculpting

www.electricimage.com amorphium 3D sculpting tool and
Electricimage Modeling and animation tool

www.digimation.com animation plug-ins for 3DS Max
including metaballs and character animation

www.maxon.de/ bodypaint 3D painting software

www.inkworks.com cartoon shader plug-in for Maya

www.informatix.co.uk for Piranesi, a 2D/3D painting tool

3D data sources

www.viewpoint.com Viewpoint data labs 3D geometry sales

Video editing, compositing and video effects tools

www.adobe.com Premiere NLE software, After Effects software

www.avid.com AVID NLE system

www.pinnaclesys.com NLE hardware and video capture
boards
www.apple.com/quicktime/ Quicktime editing software

www.2-pop.com the Final Cut Pro information site

www.discreet.com Flame, Inferno, combustion video effects

www.media100.com video editing and streaming

www.art-render.com hardware for speeding up 3D rendering with additional software plug-ins for speedier raytracing and special FX

3D animation on the web

www.cult3D.com real time 3D on the web

www.vrml.org/

www.adobe.com/products/atmosphere/ Adobe Atmosphere real time 3D on the web

www.macromedia.com/software/director/ Shockwave real time 3D on the web

www.erain.com/ swift 3D plug-in for creating Flash swf files from 3D sequences

www.vecta3D.com/ plug-in for creating Flash swf files from 3D sequences

DHTML animation on the web

www.Adobe.com/products/golive Golive DHTML editing software

www.macromedia.com/products/Dreamweaver Dreamweaver HTML and DHTML editing

Vector art tools

www.adobe.co.uk Adobe Illustrator

www.corel.co.uk Coreldraw

www.deneba.com Deneba Canvas

www.creaturehouse.com Creature House Expression

www.macromedia.co.uk Macromedia Freehand

www.xara.com Xara X

General graphics tools

www.adobe.com Adobe Photoshop

www.jasc.com PaintShop Pro

www.corel.com Painter

www.extensis.com Portfolio

www.corel.com KnockOut

www.alienskin.com Eye Candy (collection of effects)

Virtual realities

www.web3d.org/vrml/vrml.htm

www.cai.com/cosmo/

www.parallelgraphics.com/products/cortona/

arttech.about.com/library/weekly/aa091798.htm

www.immersence.com/osmose.htm

QTVR

www.qtvr-movie.com/

www.letmedoit.com/qtvr/qtvr_online/course_index.html

www.iqtvra.org/

Rollovers

More details and tutorials for 'proper' JavaScript programming of rollovers:

www.webreference.com/js/column1/

www.jsworld.com/tutorials/rollover/

www.vortex-webdesign.com/help/3rdimageroll.htm

Authoring software to create the project pages

Dreamweaver: www.macromedia.com/support/dreamweaver/downloads.html

FrontPage: www.microsoft.com/frontpage/evaluation/default.htm

GoLive: www.adobe.com/products/golive/main.html

GIF animation

www.stars.com/Multimedia/Animation/GIF/

General 3D sites and other computer graphics sites for tutorials and resources

www.adigitaldreamer.com an extensive graphic design, web design, and 3D design resource broken down into 20 categories.

www.3Dcafe.com product and current project information, great free downloads (software, plus literally hundreds of free meshes, textures, clip art, photographs, fonts, sound effects wav files etc.), classifieds where you can sell your models, textures, software and hardware online (no cost to advertise),

games (free games and demos), software tutorials with links to other artists and animators' websites, forums to get answers to 3D related questions, employment opportunities, galleries to show your work, contests and more.

www.the3dstudio.com although it sounds like it, this site is not affiliated to the product vendors or distributors – Autodesk, Kinetix or Discreet. It terms itself a 'one-stop-shop' for free 3D resources, especially those related to 3D Studio Max. Resources include pretextured models in Max and 3DS formats, seamless and tileable texures, matching bump maps, tutorials, gallery images, categorized and ranked links.

www.renderosity.com possibly the largest online community of 3D artists. Has tutorials, galleries, artists' chat rooms and e-commerce.

www.3Dalliance.com aimed mainly at professionals, has industry and software development news, forums and a digital art museum.

www.planet-3D.com forums, tutorials and art galleries organized in categories such as abstract, people and nature.

www.3dgate.com a huge 3D learning resource – stacks of useful tutorials.

www.Pixeljunction.com for the graphic design community: tutorials on PhotoShop, Dreamweaver, Poser, Bryce and Flash. Tips and techniques to drive traffic to your website. Free WebPages, graphics, interfaces; flash loops all for your customization. Guide to commercial and freeware graphic filters and plug-ins that can be viewed alphabetically by filter, type or platform.

www.about.com technical articles and news, product reviews and downloads, links to package specific tutorials, and other resources for computer graphics, image morphing and font software.

See more of Kenny's Bot inhabited worlds

www.tinspider.com see those bots in action!

Keeping up to date with movie-related industries and projects

www.CreativePLANET.com helps you keep your finger on the button of what is happening worldwide in the various movie related industries; it is worthwhile visiting the creativePLANET

network of websites (you can elect to have automatic daily emailed news updates from them if you wish):

www.Cinematographer.com the cinematography community

www.DesigninMotion.com the motion design community

www.DirectorsWorld.com the directing community

www.EditorsNet.com the film and video editing community

www.goodstory.com the electronic literary marketplace

www.inHollywood.com/ih the website for working Hollywood

www.MovieMagicProducer.com the production solution site

www.Planetpoint.com the resource for creative buyers

www.Postindustry.com the post-production industry

www.VFXPro.com the visual effects community

MAGAZINES

Games Developer published by CMP Media LLC www.gdmag.com – the essential reading of any artist who wants to work in the games industry. Although half of the magazine is aimed at programmers, it is worth reading to gain an understanding of how games work as well as how to make art for them. Also has a good jobs section for North America.

Edge published by Future Publishing www.edge-online.com – for information about the games industry and in-depth interviews with developers, but mostly for its jobs pages, which always have the largest number of positions available in Europe of any magazine.

Cinefex published by Don Shay www.cinefex.com – while not concerned at all with the games industry (it is a magazine about how special FX in films are created), it is often an excellent source of inspiration for how to solve a particular art problem.

National Geographic – www.nationalgeographic.com one of the best visual resources any artist can get his hands on. If you can afford it, they publish every issue on CD, which is well worth the cost in terms of easily searchable reference material.

3D Design – www.3d-design.com a very interesting magazine devoted to creating 3D artwork. It often has advanced tutorials on subjects useful to the games industry.

3D Artist – www.3dartist.com more of a hobbyist's magazine, but always has at least one article worth reading that may help you overcome a particular 3D problem. Extremely useful to the **beginner 3D artist.**

Digit Magazine – www.digitmag.co.uk covers full range of graphic design, 3D, video, multimedia, web, DTP and animation. CD with each monthly issue.

CGI Magazine – www.cgimag.com leading business and technology magazine for film, TV, video, games, multimedia and web designers.

Computer Graphics World Magazine – http:// cgw.pennwellnet.com includes 3D modeling, animation, visualization, rendering, simulation.

BOOKS

The Animator's Guide to 2D Computer Animation by Hedley Griffin published by Focal Press (2001).

Producing Animation by Catherine Winder and Zahra Dowlatabadi published by Focal Press (2001).

Timing for Animation by Harold Whitaker and John Halas published by Focal Press (1981).

The Encyclopedia of Animation Techniques by Richard Taylor published by Focal Press (1999).

Storyboards: Motion in Art (2nd edition) by Mark Simon published by Focal Press (2000).

The Art of the Storyboard: Storyboarding for Film, TV and Animation by John Hart published by Focal Press (1998).

Creative After Effects 5.0 by Angie Taylor published by Focal Press (2001).

Digital Character Animation 2, volume 1: essential techniques (with CD-ROM) by George Maestri published by New Riders (1999). Covers all important modeling techniques for character creation: polygonal, patch and NURBS surfaces for heads, hands and bodies in addition to basic character animation techniques.

Animating Facial Features & Expressions by Bill Fleming and Darris Dobbs (with CD-ROM) published by Charles River Media (1999). Explains the whole process of matching visual 'phonemes' to facial expressions.

From Myst to Riven by Richard Kadrey published by Hyperion Books (1997). This is a wonderful book that explains the process of creating the Myst and Riven games from first concept to finished product, detailing every step along the way. Although the style of the artwork is more in tune with Film and TV CGI, the thought processes involved in creating the art are the same for any game.

Surfaces by Judy A. Juracek published by W.W. Norton Publishers (1996) 0393730077.

Soft Surfaces by Judy A. Juracek published by Thames and Hudson 050001969X. Both of these books are among the finest texture resources it is possible to get. *Surfaces* covers around 1000 full colour photos of rocks, bricks, concrete, glass, metal etc. Id (the creators of Quake) used many textures from this book. *Soft Surfaces* covers fabrics, papers, plastic etc. If you can only afford one, buy *Surfaces*. If you wish to buy the books in Europe, make sure you are getting the American editions as the European versions are supplied without the CDs that contain scans of all of the book images.

Digital Lighting and Rendering by Jeremy Birn published by New Riders (2000) 1562059548. Martin says it is quite simply the greatest book about 3D graphics he's ever read. Although it does not relate exactly to the games industry, if you have ever wanted to create photorealistic renders or even beautifully stylized ones, this book will teach you how to do it. The information in here can dramatically improve the visual effect of your portfolio.

Abstraction in Art and Nature by Nathan Cabot Hale published by Dover Publications 0486274829. This is a brilliant book that explains to the artist how the forces of nature work, and how to draw them. If you've ever needed to draw convincing water, fire, clouds or rock textures, this book will explain the physics behind their appearance, and describe how to go about drawing them.

Exploring these resources, not to mention working at some of the suggested projects, should keep you busy for some time (!) but if you find a moment to spare, I'd welcome your feedback. Log onto www.guide2computeranimation.com

Dynamic Figure Drawing by Burne Hogarth published by Watson Guptill Publications (1970) 0823015750. This book explains how to draw exciting, dramatic figures. It has a huge amount of excellent drawings of the human figure in motion, and describes how a non-traditionally trained artist (most people in the computer games industry!) can draw such figures. Highly recommended.

index